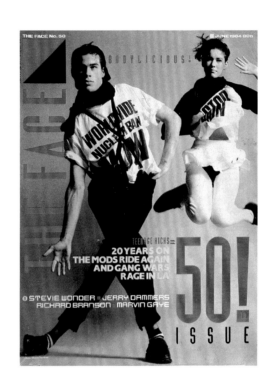

YOLANDA ZAPPATERRA

ART DIRECTION
+ EDITORIAL DESIGN

Abrams Studio
Abrams, New York

For Laurence King
Designers: Mark Holt and Corinna Farrow

For Abrams
Cover Design: Sarah Gifford

Frontispiece: Neville Brody, *The Face* no.50, June 1984

Typeset in ITC Garamond Book and ITC Officina Sans

Library of Congress Cataloging-in-Publication Data

Zappaterra, Yolanda.
 Art direction + editorial design / by Yolanda Zappaterra.
 p. cm.
 Includes index.
 ISBN-13: 978-0-8109-9377-8 (pbk.)
 ISBN-10: 0-8109-9377-5
 1. Graphic design (Typography) 2. Magazine design.
 3. Layout (Printing) I. Title.

 Z246.Z37 2007
 686.2'252—dc22
 2007015738

First published in 2007 by Laurence King Publishing Ltd.,
London, in association with Central Saint Martins College
of Art & Design.

Published in North America in 2007 by Abrams Studio,
an imprint of Harry N. Abrams, Inc.

Printed and bound in China
10 9 8 7 6 5 4 3 2 1

HNA
harry n. abrams, inc.
a subsidiary of La Martinière Groupe

115 West 18th Street
New York, NY 10011
www.hnabooks.com

Editorial design and its objective I

What is editorial design?

It is impossible to begin an examination of editorial design without first defining what it is and how it differs from other forms of design. A simple way of defining editorial design is as visual journalism, and it is this that most easily distinguishes it from other graphic design processes such as marketing or packaging design, which tend to be about promoting a single point of view or product. An editorial publication can entertain, inform, instruct, communicate, educate, or be a combination of these things. It is usually a mix of text and images, but it might be made up solely of one or the other. It is not unusual to have varying opinions in a publication, although they tend to be from one school of thought—newspapers are a good example of this. In this book, the focus will be largely—but not exclusively—on periodical publications delivered on paper.

The aims and elements of editorial

The vast majority of editorial has at its heart the idea of communicating an idea or story through the organization and presentation of visuals (including information graphics and graphic devices such as rules) and words (arranged into display and body text). Each of these fulfills a different function: In a magazine a headline will usually have been written and laid out to grab the reader's attention, while a diagram will usually be there to clarify or support a point made in the body copy.

The function of editorial design

The design of editorial matter has many different functions, such as giving expression and personality to the content, attracting and retaining readers, and structuring the material clearly. These roles have to coexist and work cohesively together to deliver something that is enjoyable, useful, or informative—usually a combination of all three if it is to succeed. At its very best, design for editorial is an exciting and constantly evolving research lab and launch pad for stylistic

Below Different types of publications have very different looks: Everything from format, cover design, typography, and stock will be determined by whether the title is a newspaper supplement such as *FT The Business* (**1**), a newsstand weekly listings magazine such as *Time Out* (**2**), or a newsstand monthly such as *Paper Sky* (**3**).

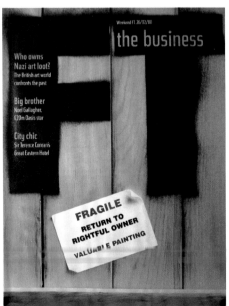

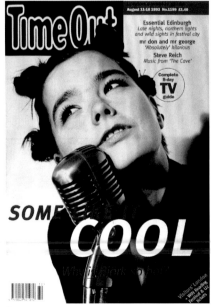

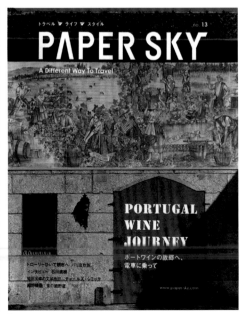

1

2

3

innovations that are often then enthusiastically taken up in many other areas of visual communication.

But editorial design does something else, too: It acts as a vivid cultural snapshot of the era in which it is produced. The 1960s magazines *Nova* and *Oz*, for example, not only brilliantly evoked the visual vibrancy of the decade, but also captured the spirit of an age that celebrated experimentation, innovation, and new directions.

The different forms of editorial design

If there is a pecking order in the status of editorial design, the highest position undoubtedly goes to magazines, newspapers, and supplements. The design of online publications—both stand-alone titles and online versions of existing media —as well as catalogues and books, are, of course, all technically forms of editorial design, but our focus is on those periodical publications—magazines, newspapers, and supplements—that set and dictate the trends for the rest to follow.

Newspapers

Harold Evans, editor of *The Sunday Times* from 1967 to 1981, wrote a series of seminal books on newspaper editing, layout, and typography that are still used in journalism schools. In *Book Five: Newspaper Design*, he said:

> *A newspaper is a vehicle for transmitting news and ideas. The design is an integral part of that process. We begin with a blank sheet of newsprint and a mosaic of ideas we want to communicate, and it is the function of newspaper design to present that mosaic in an organized and comprehensible way. To do this, the newspaper designer uses text type, display type, photographs, line work, white space, and a sequence of pages in the most fitting combinations.*

" Editorial design is the framework through which a given story is read and interpreted. It consists of both the overall architecture of the publication (and the logical structure that it implies) and the specific treatment of the story (as it bends or even defies that very logic). *"*

Martin Venezky, art director, *Speak*

Below Although these are all newsstand titles, they have an individual look, tone, and feel. This is in order to convey effectively the brand's message: *Vanity Fair* (**4**) is an intelligent, lively monthly for people who like to be connected with the current zeitgeist through well-written, engaging content. By contrast, *Vogue Paris* (**5**) is sure of its position in the market and has no need to shout through cover lines, instead offering shelf-shout through its imagery, for which it is rightly famous. Weekly gossip title *Heat* (**6**), on the other hand, is unsophisticated but fun and young.

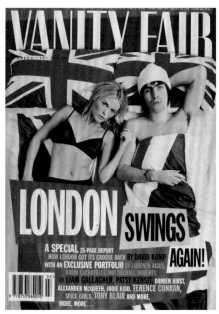

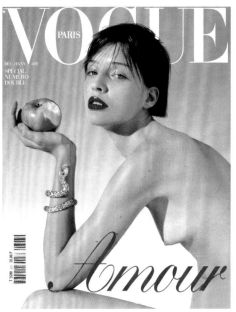

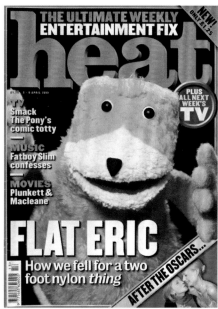

4

5

6

Newspaper sizes

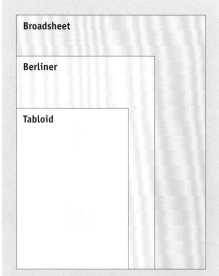

Although there are many other sizes for newspapers (in particular, a number of European newspapers publish in sizes between a Berliner and a broadsheet), the majority of papers worldwide use one of three formats: tabloid, Berliner, or broadsheet. Dimensions are as follows: **Broadsheet** (or Nordic/Nordisch) approximately 22 x 17 in (56 x 43.2 cm) **Berliner** (or midi) approximately 18.5 x 12.4 in (47 x 31.5 cm) **Tabloid** (also known as Half Nordic or Compact) approximately 14 x 12 in (35.5 x 30.5 cm)

Opposite Independent magazines targeting niche consumers, such as culture and style title *Amelia's Magazine*, can afford to be bolder and more original and individualistic than traditional consumer titles. They tend to have fewer competitors, often sell in outlets where there are fewer magazines on the shelves clamoring for the potential reader's attention, and have a much clearer sense of their readership and, therefore, a stronger sense of how to communicate with them. Design is to the fore.

This is probably as succinct and accurate a description of newspapers as you will find anywhere. But Harold Evans didn't have to contend with the Internet and mobile media. The immediacy of these delivery media has now forced newspapers to provide a different service to their readers, and required designers to respond accordingly. As Mark Porter, creative director at *The Guardian*, explains:

> *Many papers are now less concerned with simply reporting and more with providing background, perspective, and interpretation. Rather than just telling readers what happened, these papers now have to help them understand the significance of events, and encourage them to think. Design has to respond to this in a number of ways. As stories get longer and more complex, rational and readable page layouts and typography become increasingly important. And visual journalism—intelligent use of photography, infographics, and layout—has also become an essential tool for editors.*

Mainstream consumer magazines and newsstand titles

Check out a bookshop in New York or London, a newsstand in Barcelona, or a magazine outlet in the Far East and you will find hundreds of consumer magazines all screaming for the customer's attention through a combination of their choice of cover image, cover mounts, cover lines, brand recognition, and appeals to reader loyalty. For a medium whose imminent death was widely predicted with the growth of the Internet, the magazine market remains both international and vibrant in its appeal, led by innovative publishers in what is still a massively competitive arena. The majority of consumer titles—including women's, men's, business, leisure, news, style, special interest, and microzines—can be broken down further into different areas, interests, and genres, each with its own target audience and often appearing in different regional editions, where they attract that country's leading design consultants.

Microzines

The worldwide appetite for not only consuming magazines but also creating them seems to be insatiable, and nowhere is this more clearly visible than in the rise of independently published microzines and special interest publications (SIPs) catering to niche audiences worldwide, all hoping to offer consumers something that the mainstream titles, in pursuit of huge circulation numbers, don't. Microzines are particularly interesting because, while their subjects and content are as broad as their price, approach, and style, what they all share is independence, which impacts on both their content and design. At one end is the super-slick, ultra-stylish, and reassuringly expensive *Visionaire*, at the other the fanzinelike, antidesign style of *Arty*. In between are thousands of titles that hold visual journalism in high esteem. They are seen as a powerful force in emerging graphic trends, crossing over into other areas such as art, architecture, photography, fashion, and music.

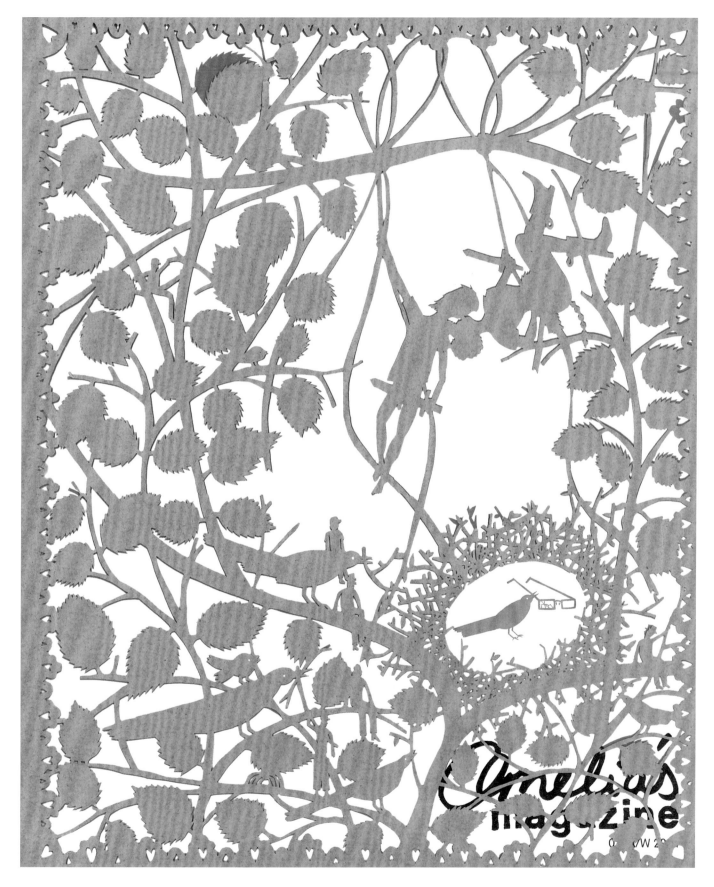

Supplements

Below Using elements from parent titles for supplements may seem the only way to ensure a brand is consistent, but international design consultant Mario Garcia believes that "beyond placing the logo somewhere, supplements should have a life and identity of their own; readers are smart and will know the parent publication. Supplement design should be adventurous, and the typography more relaxed and not that of the newspaper. Photos should be bigger, more color, better quality paper." *San Francisco Chronicle Magazine* (**1**), (**2**) takes this on board, with great use of full-page illustrations and wide columns to differentiate its tone and style. *Le Figaro* (**3**), (**4**) has color photos and delicate illustration in its culture section, giving it a lighter feel than its news counterpart, but keeping the brand's attributes.

When *The Sunday Times* launched a full-color glossy magazine with its newspaper in 1962, a whole new form of publishing was born. Supplements had been around in the U.S. since the end of the nineteenth century, but the sheer pizzazz, gloss, and production values of this new form of magazine made them an instant success. They quickly came to have a cachet and regard in design circles that matched those for the highest quality magazines, and in their forty-five-year history they have attracted some of the world's best designers, delivering some of the world's best editorial design. The need to brand and express a title as part of a much bigger family—the newspaper it comes with, which has a particular tone, stance, and readership—yet give it a distinct identity of its own, is a

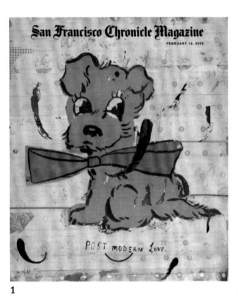

1

2

3

4

Profile: *The New York Times Magazine*

Not to live (or die) by your newsstand appeal is a great position for an editorial designer, but even better is to have a ready-made reader who is culturally, intellectually, and visually literate . . . the reader of *The New York Times* newspaper, for example. Art director Janet Froelich is in such a position on the newspaper's weekend supplement, and enthusiastically concedes: "It's such a huge pleasure to have this reader, and not to be dependent on newsstand sales. We are able to avoid so much of the commercially driven, celebrity-driven content of other magazines." In design terms this means she is also able to play to the strengths of such a reader, and says that while she has "no proof of the role of design in reader loyalty, I imagine it is huge. Design is at the forefront of establishing a relationship with the reader. It telegraphs the content, spirit, and forward-thinking qualities of the publication and gives the reader an instant relationship with the spirit of the magazine." As can be seen here, the relationship fostered by Froelich is one that makes demands of its readers (big

blocks of text and drop caps that present an element of discord in the harmonious layouts), but also rewards them for their effort with stunning imagery and layouts that immediately draw them in through the use of the design elements. For this annual issue on design, the theme was the roots of inspiration.

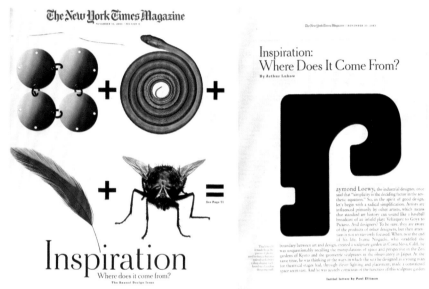

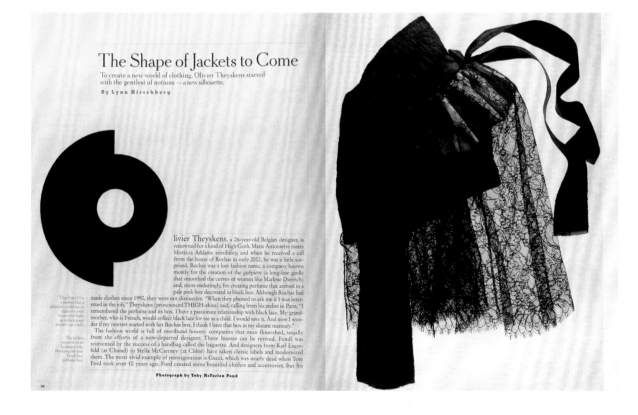

The marketplace:
what's out there?

- Each month, over 30 million copies of magazines are bought through subscription or newsstands in the U.S.
- In 2004 American magazines numbered 18,821 titles.
- The average American supermarket carries 700 titles, and may have 300 to 400 of those titles on the shelf at any given time.
- There are over 120 Asian-American magazine titles published in the U.S.
- In 2002 Germany saw 224 newsstand launches and more than 200 customer magazine launches.
- The U.K. has around 3,000 magazines, with about 200 of these accounting for more than 90 percent of the total sales.
- Each year in the U.S. around 1,000 titles are proposed, of which around a third make it to a launch issue.

U.S. STATISTICS from the Magazine Publishers of America and Audit Bureau of Circulations (ABC), based on 2002 sales/circulation. U.K. STATISTICS from Nielsen BookData.

// Editorial design is the design of publications—printed magazines that come out more than once, normally having a look and a feel that are distinctive and unique. //

VINCE FROST, ART DIRECTOR, *ZEMBLA*

particularly exciting challenge for designers, who can experiment with elements such as fonts, layouts, and formats with greater freedom than the designer of newsstand titles. Add to this good budgets (because newspaper proprietors know that readers will buy their paper if they particularly like the magazine or supplement), and designing newspaper supplements becomes one of the best editorial design jobs there is.

Customer magazines

Customer magazines are available exclusively to users of a particular telecom network, digital TV package, store card, upmarket department store, or airline. It used to be the case that a supermarket's in-store magazine would be full of nothing but special offers and recipes made from products available in the store, but, increasingly, brand marketers understand that for a customer magazine to work well, the content has to be informative and entertaining, and any brand promotion subtle and understated. These dual needs mean that much more is expected of a designer in customer publishing, maintains Jeremy Leslie, creative director of John Brown Citrus Publishing:

> *There is little difference in terms of design skills, but much in terms of strategy, thinking, and broader creativity. Consumer magazines need to stand out on the shelf, but cannot risk alienating their existing audience as they seek to attract new readers. Customer magazines are interested in standing out in every and any way they can. They have to demand the attention of the reader in an appropriate way for the brand or service they are promoting. So there is far more emphasis on ideas and conceptual thinking—what can a magazine be?*

The people who make it happen

Key to successful editorial design is the working relationship between the designer and the editor, but equally important is the designer's relationship with the rest of the publication's staff. The designer will often be second only to the editor in the number of staff he or she interacts with on a daily basis.

Key staff in editorial

Depending on the type of publication, the size of the team, and how it has been organized, the individual roles of the team may vary. But while a magazine editor will probably have commissioned the bulk of the material to appear in the publication, it is the art director, design director, or lead designer who will be responsible for the way this is organized and presented to represent the magazine's identity.

It would take a whole book to explain the various roles and relationships of everyone working on a newspaper or magazine, and these will also differ vastly depending on the style, size, and circulation of a publication—an independent magazine produced biennially will have staffing needs that are very different

from those of a daily newspaper. Here is a guide to the staff that an editorial designer will almost certainly encounter and work most closely with over the course of a career.

Editor: ultimately responsible for the publication's content. Works most closely with the art director and the tier of editorial staff immediately below him or her, including features editor, picture editor, and production editor.

Art director/art editor: responsible for the organization and ordering of all the content, including commissioned and in-house articles and all imagery, to a timescale set by the production manager or production editor. He or she commissions illustrators and, sometimes, photographers (*see also* picture editor, below). Works closely with his or her team of designers, the editor, picture editor, studio manager, production manager, and section editors.

Production manager/production editor: oversees the physical compilation of all the material by setting a production schedule. This works backward from the publication date to determine receipt of copy and imagery, editing, subbing, design schedules, and dates on which the sections need to go to the printer. The production manager is also responsible for producing, updating, and circulating the flatplan. Works most closely with the art department and the printer, particularly in overseeing all special print requirements.

Chief copy editor, proofreaders: responsible for proofing and copy editing the copy to ensure stylistic coherence, correct spelling, grammar, punctuation, etc., writing all display copy, rewriting any badly written copy, cutting excess copy, and sometimes laying out pages. Works closely with the editor, art team, features editor, and, depending on the structure of the particular editorial team, the writing staff.

Picture editor: usually responsible for commissioning photographers and copyright clearing on imagery, but also, in conjunction with the art director and editor, for ensuring the quality of photographic material used throughout the magazine. Works closely with these individuals, but also with picture agencies, photo libraries, and repro houses.

Designers: responsible for laying out the publication according to the art director's instructions. The way designers work with their art director and how much autonomy they have in laying out the material will be determined by a number of factors, including levels of seniority, the working practice of the particular art director (some like to be very hands-on and oversee every detail of the publication; others are happy to delegate and sign off on pages once they've been laid out), the ratio of staff to the number of pages, and the lead time to publication—often, the shorter a lead time, the more responsibility will be given to designers.

"The best thing about working on a newspaper is the opportunity to work with such a wide range of incredibly intelligent and knowledgeable people. The worst is the lack of control over the detail. Most newspaper pages are not laid out by trained designers. This is very difficult for magazine-trained art directors to adjust to!"

MARK PORTER, CREATIVE DIRECTOR, GUARDIAN GROUP

Right, below, and opposite Two magazines published by John Brown Citrus Publishing are *Carlos* (**1**), (**2**), for first-class passengers of Virgin Atlantic, and *M-real*, for paper specifiers, shown here with a front cover (**3**) echoed by its inside front cover and contents page (**4**). According to Jeremy Leslie, the group creative director, "One of the problems faced by *Carlos* is that its visual identity is so strong. This is its strength—being easily recognized—but also its weakness; it is defined as much by what it does not do [no photography, no full color] as by what it does. The rules are black and white, making it awkward to develop and change. *M-real* faces the opposite challenge. Every issue changes completely, with the exception of the page size, the grid system, and a diagonal corner pattern at the start of each feature. These elements present a small level of familiarity, while the majority of the design elements provide newness. As before, this continual change becomes familiar, becomes the identity."

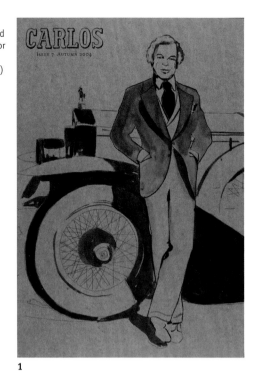

1

2

> **"** What's fascinating about magazines generally is their organic nature; unlike books or other print media they are a constantly evolving thing that changes slightly with each issue. **"**
>
> JEREMY LESLIE, GROUP CREATIVE DIRECTOR, JOHN BROWN CITRUS PUBLISHING

3

4

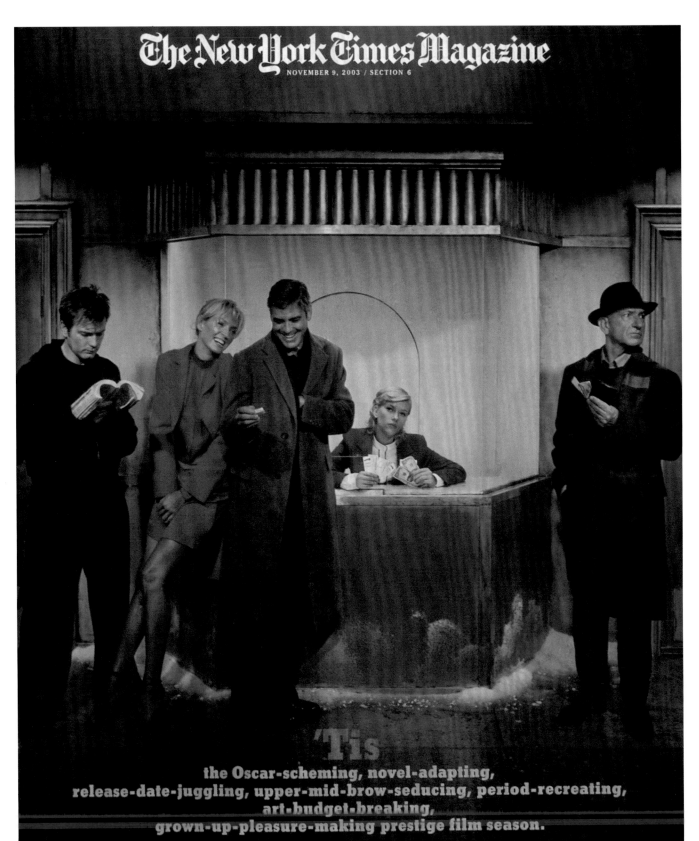

The New York Times Magazine

NOVEMBER 9, 2003 / SECTION 6

'Tis

the Oscar-scheming, novel-adapting,
release-date-juggling, upper-mid-brow-seducing, period-recreating,
art-budget-breaking,
grown-up-pleasure-making prestige film season.

The Annual Movie Issue

Studio manager: not all publications have a studio manager, as the project management aspects of the job mirror that of the production manager to some degree. But a studio manager is a great facilitator to an art studio, acting as a coordinator and handling the everyday interaction between art studio, picture desk, and production. He or she ensures that everything is going according to plan and is on schedule, and that all the differing elements that go to make up the page layout are in place and as they should be.

Writing staff (feature writers, reporters, commissioning editors): senior writing staff will often have some initial input into layout discussions—depending on the management style of the editor—to ensure that visual treatment of the text is appropriate to the subject.

Advertising staff: depending on the type of publication, ad managers and senior advertising sales staff can have an enormous impact on the magazine's look. It is not unusual for the advertisers to determine not only exactly where their ad will be placed, but what editorial will be put next to it. They therefore have a very real impact on the pagination and layout of a publication.

What attributes should an editorial designer have?

Tibor Kalman once famously said that it is the job of the art editor to get the editor fired if he or she believes the job is not being done properly. By this he meant that an editorial designer should take as much interest in the content of a publication as the editor, because designing a magazine is unquestionably an extension of editing it. Both roles are creative ones that are rooted in and part of a creative process, and how they function together will nearly always determine the success or failure of an editorial publication.

So, if editorial designers should "become" editors, the converse is equally true, and editors should "become" editorial designers—or at the very least they should understand each other's attitudes, roles, and areas of expertise in order to build the necessary trust that creates a first-rate publication. All the great editorial designers and editors have expressed this, some of them even bringing other skills and backgrounds to the mix. Mark Porter, who designed *Colors* and *Wired* before becoming design director of *The Guardian* newspaper, studied modern languages rather than graphic design. Dylan Jones, editor of *GQ* magazine, but also past editor of *i-D* magazine, *The Face*, *Arena*, and *Arena Homme Plus*, trained as a graphic designer. Willy Fleckhaus, art director of the seminal 1960s German magazine *Twen*, was a journalist. And David Hillman, Pentagram partner and designer of *New Statesman and Society* and *The Guardian* newspaper, was both art director and deputy editor on *Nova*. He has said, "Art direction isn't about establishing a grid or styling a masthead, or even about a good-looking juxtaposition of image and text. In its best form, it involves the art director having a full and in-depth understanding of what the magazine says and, through design, influencing how it is said."

> *"Magazine content is basically built around the idea that editorial breaks up the advertising, which, for a lot of magazines, is what it's all about: selling ads."*
>
> VINCE FROST, ART DIRECTOR, *ZEMBLA*

Opposite For the cover of this movies issue of *The New York Times Magazine*, editor Gerry Marzorati came up with the idea of a ticket line comprised of several of the high-powered celebrities featuring in that year's Hollywood movies. Says *Times Magazine* art director Janet Froelich, "It was a huge job to pull off. For reference, we looked at old movie lines from the 1930s and 1940s. We built the set and it was up to the photographer, Dan Winters, to find a way to light and frame it so that it felt like a classic Hollywood scene, with all those narrative photographic values we associate with the heyday of the movies."

Profile: *The Guardian*

In 2005 the U.K.'s *The Guardian* newspaper became the first large-circulation British daily to have front-to-back color, something that its creative director, Mark Porter, says was necessary because "real life is in color, and in an age when we are in competition with TV and the Internet as news providers, it's crazy to attempt to do it without full color. That is a twentieth-century approach which readers found very frustrating."

Unlike many of the U.K. broadsheets, which have adopted a tabloid format to respond to modern users' changing needs and relationship with their daily paper, *The Guardian*'s redesign incorporated a move to a brand-new format—the Berliner format used by *Le Monde* newspaper. It's not surprising that the newspaper is forging its own path with a format that Porter says "has a unique ability to combine convenience for the reader with serious journalism, a contemporary approach to design, and the demands of advertisers." Its approach to design has always been intelligent and forward-thinking; in 1988 a radical redesign by Pentagram's David Hillman split the newspaper into two sections, unveiled a new masthead and, most importantly, introduced the idea of "white space" to newspaper design, a concept previously restricted to magazines. "Everything changed with the Hillman redesign.

It wasn't just a new look; it was a whole design philosophy, probably the first time any newspaper really had one," says Porter. "The designers who followed (Mike McNay, Simon Esterson, and myself) have had a very strong set of principles to work with," he adds. These principles were adapted in the 2005 redesign by following Hillman's own clear vision of how a newspaper should work—a vision "that was based not on journalistic habits and traditions, but on sound design principles."

WHAT LIES BENEATH

Is she brilliant? Shallow? An artist? A bully? However you look at Anna Wintour, she is more than just the editor of American Vogue. In a rare interview, the empress of fashion talks to Emma Brockes

Mark Porter

Mark Porter, creative director of *The Guardian*, came to the paper in 1995, having worked on *Wired*, *Colors* and other magazines. His work has been recognized in the U.K. and the U.S., and he has won awards from British Design and Art Direction (D&AD) and the Society of Publication Designers, New York. The fact that he did not study design, instead reading languages at Oxford University, lies at the heart of his approach, as he explains: "I approach editorial from the reader's point of view. Good editorial design is, firstly, about making people want to read, and then about telling stories; most readers aren't interested in design, and when they look at a page they should see ideas, people, and places, not graphic design. It may also be that having been to university makes it easier for me to communicate with editors, as they tend to share the same background. Newspapers are full of very smart journalists, which is a constant intellectual challenge for me; if I can't make a clear, convincing case for my design, then I will just get shot down. Languages themselves haven't been that useful in my work (apart from doing projects overseas), but I believe that design is a language too, and, like any language, of no real value in itself; it only becomes useful when you have something worthwhile to say."

Right This page from *Zembla*, designed by Vince Frost, is a strong example of design at the conceptual level: Not only does it look arresting through its decorative use of typography and layout, but, in playing with scale and typographic symbols, it provides a convincing underlying concept for the literary magazine.

One of the most brilliant and radical artists of the twentieth century, Marcel Duchamp forever revolutionized the way we look at, and indeed think about, art. A cross-dresser, he shocked the world in 1917 by showing a white urinal signed R. Mutt, known simply as *Fountain*. His work was consistently controversial, though he produced very little. He virtually abandoned painting from around 1913, and used unconventional materials as he became interested in the ready-made. Pointing out that anything could be art, he became a legend in his own lifetime, a man with a keen sense of irony and humour, who turned around notions of art, language and beauty.

Marcel Duchamp

Here, for the first time since his death in 1968, he gives a frank and revealing interview to a kindred spirit, novelist Michel Faber.

by { Michel Faber

Portrait
Manolo Blahnik

[88] zembla magazine *september_two thousand and three*

Vince Frost, who currently designs literary independent magazine *Zembla*, but has worked on a wide range of editorial matter, including *The Independent* newspaper, a Nan Goldin monograph, a weekend supplement for the *Financial Times*, and a range of customer magazines, goes further:

The most important thing is to have fun. There is no point in designing a magazine issue after issue if you don't like the subject matter. I have to have great content to be inspired. I like contributing to the content with stories and headlines. I am also interested not just in the mag but all its touch-points—business cards, advertising, Web site, and so on.

Martin Venezky, designer of *Speak* magazine, agrees:

"An art editor and editor need respect and love for each other, but they also need to be prepared to fall out, have sulks, get together . . . it's a marriage."

JEREMY LESLIE, GROUP CREATIVE DIRECTOR, JOHN BROWN CITRUS PUBLISHING

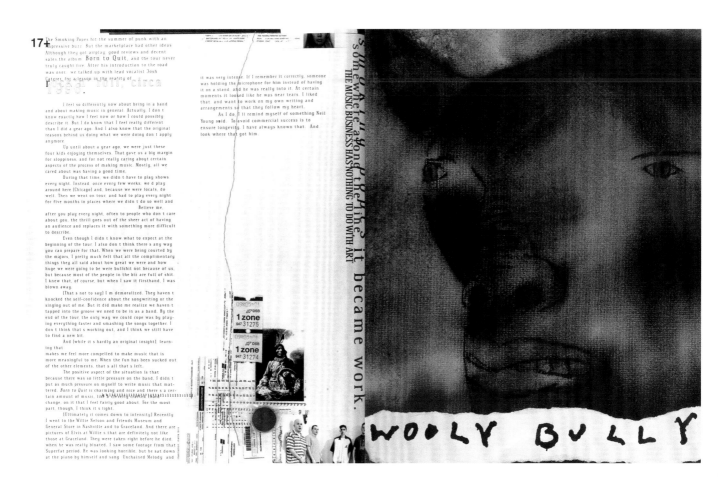

The Smoking Popes hit the summer of punk with an impressive buzz. But the marketplace had other ideas. Although they got airplay, good reviews and decent sales, the album *Born to Quit*, and the tour never truly caught fire. After his introduction to the road was over, we talked up with lead vocalist Josh Caterer, for a lesson in the reality of...

I feel so differently now about being in a band and about making music in general. Actually, I don't know exactly how I feel now or how I could possibly describe it. But I do know that I feel really different than I did a year ago. And I also know that the original reasons behind us doing what we were doing don't apply anymore.

Up until about a year ago, we were just these four kids enjoying themselves. That gave us a big margin for sloppiness, and for not really caring about certain aspects of the process of making music. Mostly, all we cared about was having a good time.

During that time, we didn't have to play shows every night. Instead, once every few weeks, we'd play around here (Chicago) and, because we were locals, do well. Then we went on tour, and had to play every night for five months in places where we didn't do so well and

Believe me, after you play every night, often to people who don't care about you, the thrill goes out of the sheer act of having an audience and replaces it with something more difficult to describe.

Even though I didn't know what to expect at the beginning of the tour, I also don't think there's any way you can prepare for that. When we were being courted by the majors, I pretty much felt that all the complimentary things they all said about how great we were and how huge we were going to be were bullshit not because of us, but because most of the people in the biz are full of shit. I knew that, of course, but when I saw it firsthand, I was blown away.

(That's not to say) I'm demoralized. They haven't knocked the self-confidence about the songwriting or the singing out of me. But it did make me realize we haven't tapped into the groove we need to be in as a band. By the end of the tour, the only way we could cope was by playing everything faster and smashing the songs together. I don't think that's working out, and I think we still have to find a new bit.

And (while it's hardly an original insight), learning that makes me feel more compelled to make music that is more meaningful to me. When the fun has been sucked out of the other elements, that's all that's left.

The positive aspect of the situation is that because there was so little pressure on the band, I didn't put as much pressure on myself to write music that mattered. *Born to Quit* is charming and nice and there's a certain amount of music that stands up. I wouldn't really change, on it that I feel fairly good about. For the most part, though, I think it's light.

(Ultimately it comes down to intensity) Recently I went to the Willie Nelson and Friends Museum and General Store in Nashville and to Graceland. And there are pictures of Elvis at Willie's that are definitely not like those at Graceland. They were taken right before he died, when he was really bloated. I saw some footage from that Superfat period. He was looking horrible, but he sat down at the piano by himself and sang 'Unchained Melody' and

it was very intense. If I remember it correctly, someone was holding the microphone for him instead of having it on a stand, and he was really into it. At certain moments it looked like he was near tears. I liked that, and want to work on my own writing and arrangements so that they follow my heart.

As I do, I'll remind myself of something Neil Young said: To avoid commercial success is to ensure longevity. I have always known that. And look where that got him.

somewhere along the line it became work.

THE MUSIC BUSINESS HAS NOTHING TO DO WITH ART

WOOLY BULLY

Without an active engagement with the material, I'd think the job would be minimally rewarding. You need a willingness to read the material, to discuss it thoughtfully and passionately, and to develop visual components that expand the read while still working within the publication's architecture.

The tempo and deadlines

In editorial design there is an ever-changing body of work to interpret and organize, so good planning is key to making day-to-day tasks work to the advantage of the creative process. These tasks and the tempo of the work vary depending on whether the publication is a daily, weekly, or monthly. Broadly, these are as follows:

Daily publication

Prepublication work (one-off and regular updating): establishing a style (typography, color, graphics, use of pictures) and setting up templates and a rule book or style guide to ensure consistent implementation. On newspapers this stage is particularly important; as Mark Porter says:

At this stage it's important to be realistic about what is achievable, as most newspaper pages are laid out by nondesigners; the usual solution will be a

Above *Speak* designer Martin Venezky's fiery relationship with editor Dan Rolleri is well documented (*see* p.154): "In the early days it was sometimes confrontational," admits Rolleri. "In addition to giving Martin a good deal of creative freedom, I had guidelines as well, some important (the text must be readable), some personal (I preferred muted colors over, say, lime green), and I would look at Martin's layouts during their very early stages, which created some unnecessary tension. Plus, Martin was in the habit of learning where the lines were drawn, then purposely taking a step or two beyond them. It was an important part of his process in knowing that he was pushing things as far as he could; but for me, in an already tense environment, it was sometimes frustrating. Over time, our dynamic changed to such a degree that we essentially worked as partners. I came to trust Martin entirely and, even if I wasn't crazy about a particular spread, even if it had a splash of lime green, I usually let it go."

What makes a brilliant publication?
Vince Frost's ten-point plan for editors and art directors

- ■ Relentless passion and energy.
- ■ An endless determination to get it right.
- ■ A great relationship between editor and art director. This is vital.
- ■ Being prepared to work long, long hours and give up weekends to send things off to print and start all over again!
- ■ Vision is important.
- ■ The aim is to make the best publication in the world.
- ■ Ideas, ideas, ideas, contacts, and a head full of images.
- ■ The ability to make something out of nothing: It's 4 a.m. and you've got a late story that has been allocated four pages and the text fits one and there are no illustrations in sight.
- ■ Constantly thinking about the end user's experience with the content when it is printed.
- ■ An unspoken respect for each other, as neither can do it alone.

kit of parts, which can be used in any number of combinations to give a totally flexible response to editorial demands. Clearly, news pages will be fairly constrained, while features pages and magazines, which generally have trained designers on staff, will be more open.

Prepublication work (daily): overseeing the output of all the different designers on the paper, as well as the picture and graphics departments. Also, art directing special projects (usually one-off magazines and supplements).

Publication work: overseeing the daily page makeup, a task usually performed by copy editors. The art director will oversee their work and ensure that text and visuals combine to make a successful layout.

Weekly and monthly production cycles

Prepublication work: meeting photographers, illustrators, going to exhibitions, knowing who and what's hot, so that when it comes to commissioning visual artists (between six and two weeks before publication) you know who to use and why. Regular meetings with the editor and features editor to discuss content ideas and their visual organization.

7–10 days before publication of a weekly title (15–30 days for a monthly title): gathering together features material, development of initial design ideas and direction, cover consideration based on incoming material.

4–7 days (10–20 days) before publication: layouts for features to be worked up (based on flatplan), proofs distributed and edited. Gathering together news and non-feature pages material, beginning layout of these pages with priority given to pages needing to go to printers earlier as determined by flatplan. Work up cover ideas.

2–4 days (3–10 days) before publication: feature proofs corrected, color features and agreed flatplan sections to printer, high-resolution printer's proofs checked by necessary staff, pages signed off on. Nonfeature pages are now being laid out, edited, proofed, corrected, sent to repro, corrected, and signed off on.

1 day (1–3 days) before publication: finalize cover decisions, cover lines written, and pages sent to repro, corrected, and signed off on (most magazine covers will have been proofed, with copy all but decided, by this stage).

 With all editorial cycles, there will be occasions when major rethinking takes place—covers going through huge changes, features reheadlined, new features introduced, layouts redone, and pagination changed right up to the final deadline. In extreme cases, reshoots will take place if imagery is deemed to be flawed or weak, a new cover story will be swapped at the last minute, a feature will be dropped and need replacing, or neighboring features will be extended to fill the space ... a good editorial designer will respond to all of these quickly, efficiently, and creatively.

The evolution of the printed page

AD 105 Paper is invented in China.

AD 770 Relief printing is practiced in China.

AD 868 The world's earliest dated printed book, a Chinese Diamond Sutra text, is created using woodblocks.

Early 15th century Professional writers join the ranks of monks in writing books as trading and wider education lead to more books for the upper and middle classes in Europe. In Paris, these writers form themselves into a guild—publishing has arrived.

1450 In Mainz, Germany, goldsmith Johannes Gutenberg invents movable type (also known as "foundry type" or "hot type"), and five years later uses it to begin a print run of 180 copies of the Gutenberg Bible.

1457 *Gazette*, claimed as the first printed newspaper, is printed in Nuremberg, Germany. The earliest example of color printing arrives with the *Mainz Psalter* by Johann Fust and Peter Schöffer.

1476 William Caxton returns from Cologne, Germany, with a range of typefaces and sets up a printing press in Westminster, London, having already produced the first book in the English language, *The Recuyell of the Historyes of Troye*, in Bruges.

1486 The first English, color-illustrated book is printed in St. Albans, England.

1494 Typographer, teacher, and editor Aldus Manutius establishes the Aldine printing house in Venice, Italy.

1500 Approximately 35,000 books have been printed, 10 million copies worldwide.

1501 Italic type, designed by Francesco Griffo, is first used in an octavo edition of Virgil printed by Aldus Manutius's Aldine Press.

1588 Englishman Timothy Bright invents a form of shorthand.

1605 The first regularly published weekly newspaper appears in Strasbourg, France.

1622 Nathaniel Butter, the "father of the English press," publishes *Weekly Newes*, the first printed English newspaper, in London.

1650 Leipzig, Germany, becomes home to the first daily newspaper.

1663 *Erbauliche Monaths-Unterredungen* ("Edifying Monthly Discussions"), considered the world's first magazine, is published in Germany.

1690 America's first newspaper, *Publick Occurrences Both Forreign and Domestick*, is printed in Boston, Massachusetts, and subsequently suspended for operating without a royal license.

1702 The first daily newssheet, *The Daily Courant*, is published in England.

1703 *Sankt-Peterburgskie Vedomasti* newspaper founded by Peter the Great in Russia.

1709 The Copyright Act is passed in England. *Tatler*, the first major magazine, is launched in London.

1714 Henry Mill is granted a patent for a writing machine in London.

1719 German engraver Jakob Le Blon, granted a privilege by George I of England to reproduce pictures and drawings in full color, produces

the basis of modern four-color plate printing.

1731 *The Gentleman's Magazine*, considered the first modern magazine, is published in England.

1741 Benjamin Franklin plans to publish America's first magazine, *General Magazine*, but *American Magazine* comes out three days earlier.

1764 Pierre Fournier of France develops the point system to measure type sizes. His system is further refined by François Didot, establishing consistency in type measure throughout the world.

1784 *The Pennsylvania Evening Post* is America's first daily newspaper.

1785 *The Daily Universal Register* is founded in London by John Walter. Three years later it is renamed *The Times*.

1791 *The Observer*, the country's first Sunday newspaper, is launched in England by W.S. Bourne.

1790s Lithography is invented by Alois Senefelder in Bavaria, Germany, streamlining the reproduction of images by eliminating the need for engraving or carving.

1814 An early version of the cylinder press is used to produce the London *Times* at a rate of 1,100 copies an hour, but it is not refined and taken up universally until 1830, when Richard March Hoe perfects the drum-cylinder press, capable of producing 2,500 pages per hour. By 1847 he has expanded this to a five-cylinder press.

1828 *The Ladies' Magazine* is launched to become the first successful American magazine for women.

1842 *The Illustrated London News* is founded in England by Herbert Ingram and Mark Lemon. Using woodcuts and engravings, it prompts the growth of illustrated publications.

1844 *The Bangkok Recorder* is the first newspaper published in Thailand.

1845 *Scientific American* launches in America. It has been published continuously since that date, making it the longest-running magazine in American history.

c.1845 Paperbacks are introduced in America (four years after their appearance in Germany) as newspaper supplements, and soon appear as small-size reprints of existing books.

1850 Heidelberg's first press is made by Andreas Hamm in the Palatine city of Frankenthal in southwest Germany.

1851 *The New York Times* launches, priced at one cent.

1854 *Le Figaro* newspaper is launched in Paris, France.

1856 The first African-American daily, the *New Orleans Daily Creole*, is published.

1867 The first Japanese magazine, *Seiyo-Zasshi* ("The Western Magazine"), is published.

1874 E. Remington and Sons in Illinois manufactures the first commercial typewriter, invented seven years earlier by Wisconsin newspaperman Christopher Latham Sholes. It has only uppercase letters, but has a QWERTY keyboard. The machine is refined the following year to

incorporate lowercase letters.

1875 Offset litho printing—printing onto etched metal plates from a smooth surface rather than letterpress—is introduced.

1878 In America, inventor William A. Lavalette patents a printing press that greatly improves the quality of printing, particularly in terms of legibility and quality.

In Scotland, Frederick Wicks invents the typecasting machine.

1886 The Linotype typesetting machine is invented by Ottmar Mergenthaler. Combining keyboard unit, matrix magazine, and caster in one unit, it can cast letters at the rate of 17,000 per hour by compositors pressing keys to create "slugs"—lines of matrices combined then redistributed for reuse.

1900 An estimated 1,800 magazines are being published in America, where total newspaper circulation passes 15 million a day.

1903 The first offset printing press is used by Ira Washington Rubel in America and, separately, by Caspar Hermann in Germany.

1911 Typesetting is refined further with the introduction of the Ludlow typesetting machine, developed by Washington I. Ludlow and William Reade in Chicago, Illinois.

1912 *Photoplay* debuts in America as the first magazine for movie fans.

1917 The first "op-ed" (opinion and editorial) page appears in *The New York Times*.

1923 *Time* magazine debuts in America.

1933 *Esquire* launches in America as the first men's magazine.

1936 Allen Lane's Penguin Press reintroduces the paperback book in the U.K. In America, photojournalism magazine *Life* is founded by Henry Luce for Time Inc.

1945 *Ebony*, the first magazine for the African-American market, is founded in the U.S. by John H. Johnson.

1953 The first issue of *TV Guide* magazine hits the newsstands on April 3 in ten American cities, with a circulation of 1,560,000.

Playboy magazine appears. Its cover features Marilyn Monroe.

1955 Dry-coated paper is developed at the Battelle Memorial Institute, Columbia, Ohio.

1956 The first hard disk drive is created at IBM.

1962 British national newspaper *The Sunday Times* launches a full-color magazine supplement designed by Michael Rand.

1965 Teen magazine *Twen* is launched by German publishing giant Springer. Designed by Willy Fleckhaus, it comes to be regarded as a ground-breaking example of editorial design.

In the U.K., the *Daily Mirror*'s magazine division launches *Nova*, with Dennis Hackett as editor and David Hillman as designer.

1967 The ISBN (International Standard Book Number) system starts in the U.K. *Rolling Stone* debuts in the U.S., followed by *New York Magazine*, spawning the popularity of special interest and regional magazines.

1969	Andy Warhol launches *Interview* magazine in America.
1971	Newspapers worldwide begin the switch from hot metal letterpress to offset.
1975	*Nova* magazine closes with falling sales.
1977	Apple Computer launches the Apple II microcomputer.
1980	At the European Organization for Nuclear Research (CERN) in Geneva, Switzerland, Englishman Tim Berners-Lee embarks on the first steps of a universal worldwide web by creating a software program called "Enquire Within Upon Everything" after a Victorian-era encyclopaedia remembered from his childhood.
1982	Daily newspaper *USA Today* launches. Taking its visual lead from television, it uses color throughout, features numerous graphics, and is an immediate success. Innovative techniques assist distribution, enabling the final edition to be printed in multiple locations across the country.
1983	The Apple Lisa is launched by Apple Computer, ushering in a new Graphic User Interface (GUI) that makes home computing—and publishing—accessible and affordable.
1984	The Apple Macintosh, or the Mac, is introduced, marking the first successful commercial implementation of a GUI, which is now used in all major computers.
1985	The first desktop publishing program, Aldus Pagemaker 1.0, is created by Paul Brainerd and Aldus, and released for the Macintosh. This desktop publishing program enables a new type of publishing, and puts design and editing tools into the hands of everyone.
1987	QuarkXPress is launched. Despite the release of Aldus Pagemaker two years earlier, it quickly becomes *de facto* the preeminent desktop publishing program.
1991	The World Wide Web debuts. Using Tim Berners-Lee's HTML (hypertext markup language), anyone can now build a Web site and share it with at first hundreds, but quickly millions, of people worldwide.
1994	In Italy, an A5 handbag-size version of *Glamour* is launched by Condé Nast. In America, the first beta version of the Netscape browser Mosaic is released.
1997	*The New York Times* introduces color photos to its news pages.
2004	In the U.K., *The Independent* newspaper moves from a broadsheet to a tabloid format. Within a year, *The Times* also produces a daily tabloid.
2005	*The Guardian* newspaper moves to a Berliner format and to full color.
2006	Video-sharing Web site YouTube purchased by Google for $1.65 billion in stock. Online newspaper Web sites in the U.S. attract over 58 million readers, according to a report for the Newspaper Association for America.
2007	U.K. online publication *Financial Times* reports a 30 percent increase in advertising sales.

Anatomy of a publication II

Having a proper understanding of editorial design is just the first ingredient in a complex mix. Another essential element is a real understanding of the publication and the ability to apply this to the constituent parts of the magazine or newspaper. It's not simply about design decisions, but a deep knowledge and fascination with what underpins and motivates these design decisions.

Branding and identity

On a new publication, the first thing that has to be established is the brand message, or the identity, expression, and feel of the publication. This is best explained as the editor and designer working together to construct a strong bridge across which the client—the publisher—can deliver the brand and its values to the customer—the reader. Once this has been done, the actual construction of the publication can begin, as detailed in Chapter III. With each issue, the brand must be reviewed so that it is kept fresh and vibrant, retaining the values and identity of the core brand without simply adopting a formulaic approach. Key to doing this successfully is the ability to keep a recognizable style for the publication, while making each issue sufficiently different from the last one that it is recognized by the reader or the potential reader as a new issue of a familiar, loved object.

How a targeted audience may dictate a design style

A good designer will design with a publication's readership in mind. This is not to say that the design must slavishly adhere to what comes from the marketing department, but knowing, for example, that the bulk of readers are male students aged 18 to 23 is valuable information that should feed into the publication's style and design. Thus, a magazine for the elderly, such as *Saga*, should use an open typeface at a comfortably legible size for its readership, and ensure that layout

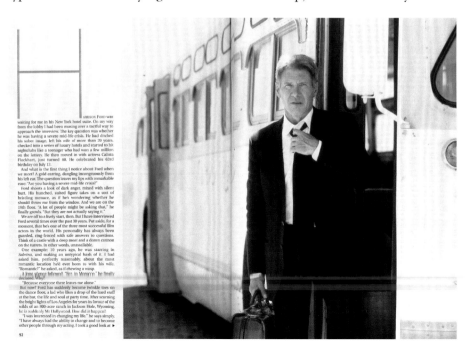

Right *Saga* magazine's readership is the over-45 age group, and, as such, its primary concern has to be legibility. But this does not mean its design has to be dull. As this spread shows, combining a strong image, a clear body of text, a large but delicate drop cap, a strip of white space that allows the whole to breathe, and a turn arrow gives the *Saga* reader everything he or she needs without looking old-fashioned or uninviting.

elements such as knockout text, colored text, or text over imagery are kept to a minimum. Because the ability to read small text diminishes with age, clarity is key with an older readership, but this does not mean the design or color palette has to be dull or unadventurous. Conversely, an "indie" music magazine should be prepared to experiment and take risks in its design, reflecting the culture it belongs to. If you want to broaden your readership beyond such parameters, how do you do so without losing existing readers? By knowing the magazine, the readers, and the potential readers you are hoping to attract.

The advantages of producing a pilot issue

In developing the feel of the publication, a key tool at the designer's disposal is the pilot or dummy issue—a version of a publication that precedes the launch. This is circulated solely among the team of people working on it and, where applicable, management, publishers, advertisers, the marketing department, and focus groups. A publisher may produce a whole batch of dummies before launching the real thing. The role of the design during this phase is hugely important and the advantage of such dummies to the designer is obvious: They offer the opportunity to experiment with every aspect of the magazine, from format, grids, and stock to fonts, layouts, color palette, and overall visual style. Not only will the magazine's whole visual concept be set during this phase, but style sheets and a style book can be determined that will set the ongoing visual tone and elements for its future.

Color psychology and branding

Green logos and blue backgrounds don't sell. Red sells. Blondes on a cover sell better than brunettes. Yellow is often seen as an unpopular cover color choice. All these are accepted conventions in magazine design, but hard evidence for these beliefs is hard to come by, and designers and editors would do well to follow their gut instinct, which will often be based on color and its emotional impact. Remember, any color can be used to emphasize and highlight, and specific colors can be used symbolically or to trigger emotions and memories, but trying to use color to sell a publication is unlikely to work (*see* p.30), largely because color is so personal, and associations with it are dependent on so many different factors.

The cover

The first and most important part of any publication on which to stamp the brand and its values is the cover. This is the part of the magazine that will work tirelessly for the publisher, both on the newsstand, where it must get its feel across and stand out from the competition, and after purchase, where it will continue to sell the brand values on a more intimate scale to both the owner and other readers.

How covers reinforce and sell the brand

The cover of any publication has an enormous task—it must be many things to many people. The publisher has to believe it will deliver sales. It has to be striking

How design reflects and attracts a readership

The design of a publication depends completely on what it is and who it's for. Good design is dependent on the designer understanding these things thoroughly, and to prove that they do so, editorial designers should be able to:

- Define their publication easily.
- State clearly the aims and purpose.
- Define the publication's readership, not just as a market demographic, but as individuals.
- Understand the needs of that readership.
- Understand the structure of the publication, know who controls the finances, what the chain of command is, how it is sold, and how much influence the advertisers have.

Color use

While there is little hard evidence for many conventions that have grown around color use in publications, there is one area in which color use does follow hard-and-fast rules: cultural color psychology. The high visibility of red might make it appealing in the West, but in South Africa, where it is associated with mourning, it would be seen on a cover about as often as black would be in the West. Blue is generally appealing to all of us irrespective of culture because of its calming influence, but is a turnoff when used for food. It's all about context. So while it is simply useless to tell you how to use color, here's a helpful guide on how *not* to use it.

Black is complex; it can be sexy, authoritative, powerful, menacing, intriguing, rich, depressing, dull, glossy, textural, timeless . . . on many occasions it will be at least two of these at the same time. Avoid using black on the cover, where it is too widely associated with death and tragedy, but on the inside pages of a magazine its use can be striking. In color psychology, many people think that it implies submission.

White is almost as complex as black: Innocence, cleanliness, wealth, and purity are some of the associations we make with white, but it can also be sterile and neutral to the point of blandness.

Red The extreme vibrancy of red has both good and bad points: It is confrontational and can render other elements on a page almost invisible. But it will definitely attract the eye and has been proved to create a strong emotional response in a viewer, stimulating faster heartbeats and breathing.

Blue Peaceful and tranquil, blue causes the body to produce calming chemicals, but choose it carefully—it can also be cold and depressing.

Green is the easiest color on the eye and is calming and refreshing. As the color of nature, most associations viewers make are positive ones. Additionally, dark green implies wealth and power.

Yellow is the most difficult color for the eye to take in, and thus is potentially overpowering—possibly why it's seen as an unpopular color choice for covers.

Purple Used in the right way, purple has associations of luxury, wealth, romance, and sophistication, but it can also appear overly feminine or gauche.

Orange Our associations with orange are good ones: exciting, vibrant, and joyous. But it can be a difficult color to use—too red and it can overpower; too yellow and it can appear washed-out.

Brown Another "nature" color with good associations: Light brown implies genuineness, while dark brown suggests wood or leather. The combination of these makes them appealing for men's subjects.

and stand out from the crowd, drawing the reader to it rather than to its competitors. If it is a periodical, it has to be familiar to regular readers but look sufficiently different from its predecessor so that those readers recognize it as being a new issue. It has to appeal to potential new readers without alienating existing readers. It has to express the publication's character as well as its content. It then has to entice potential readers to look inside. So it's no wonder that many publications and designers spend almost as much time, money, and energy on this one page as on the rest of the publication.

Research and psychological studies by publishers and decades of marketing-led wisdom would have us believe that the most successful magazine cover in Western culture will have a large, clearly legible logo across its top, under which sits a large-scale, good-looking face, probably a woman, smiling and making eye contact with the viewer with the pupils at a set distance apart. This person in women's magazines represents a mirror image of the reader's aspirations. In men's magazines she represents the ideal mate. The only figurative alternative to this recognition of self is the use of the celebrity picture. Whoever the figure is, he or she is often surrounded by a barrage of cover lines breathlessly trying to convince potential readers that inside they will find bigger and better content than the competition. This conservative approach has become an almost

Profile: *Wired*

Wired magazine, launched in San Francisco in 1993, is that rare thing in print publishing: a magazine whose design is perfectly attuned to its times and subject matter. As a general interest magazine that specialized in the rise of technology as a cultural force, it replaced traditional, technology-related severity in design and visual expression with a layout, structure, and aesthetic that challenged readers with their frenetic pace, and an inventive and Web-inspired content and design format. It made eye-popping use of color, which, through the placement of tinted text on a background of the same color, often frustrated as much as it excited. In giving readers a very real sense of how amazing this emerging medium and technology was, and of its potentiality, it demanded much, but an intelligent, knowledgeable readership understood the connections immediately and responded enthusiastically as circulation soared. When the dot-com bust came, most magazines folded; *Wired* slimmed down but survived. Overall creative direction, design, and typography for *Wired*'s first five years were by John Plunkett and his partner Barbara Kuhr, of Plunkett+Kuhr. Their designers included Tricia McGillis, Thomas Schneider, and Eric Courtemanche.

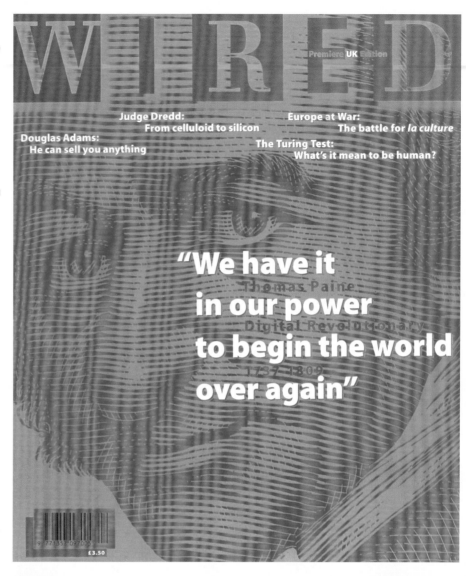

WIRED

Premiere **UK** Edition

Judge Dredd:
From celluloid to silicon

Europe at War:
The battle for *la culture*

Douglas Adams:
He can sell you anything

The Turing Test:
What's it mean to be human?

"We have it in our power to begin the world over again"

Thomas Paine
Digital Revolutionary
1737–1809

£3.50

Right There is a simple guiding rule to cover design: Appeal to the reader's interest. The image is the first point at which design does this, but it is by no means the only element of the cover that does so. Covers are, in fact, made up of four elements:

• format—size, shape, and design characteristics;
• logo or title and other regular page furniture (tagline, date, and barcode);
• image(s);
• cover lines and headlines.

In the 1990s, "lad mag" *Loaded* used all of these to great effect. Targeting its readership with a tagline that read "for men who should know better," its design and editorial approach was an exuberant "we're off our heads" one that was completely in tune with the sex-, lager-, and drug-fueled, frenzied lifestyles its readers were—or wanted to be—living. Editor James Brown said at the time that it was "for the man who believes he can do anything, if only he wasn't hungover." In design terms this attitude was successfully interpreted through art director Steve Read's clever devising of a style that looked undesigned but was full of energy and motion, with its excellent use of color, typefaces, images, and layout construction. Cover lines and headlines were big, bold, active, and funny.

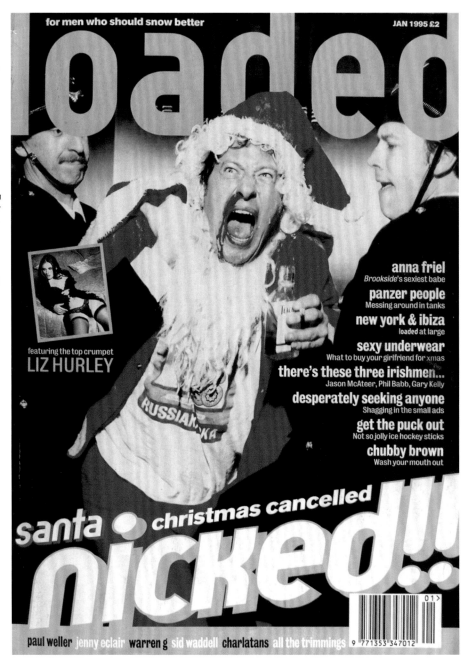

Opposite For this special British style issue of U.K. *Vogue*, art director Robin Derrick used a close-up shot of model Kate Moss by Nick Knight that is near-perfect in its composition, scale, and crop. While many women's newsstand titles would have chosen to use numerous cover lines on the cover, *Vogue* boldly chose not to. "All the rules dictate that you wouldn't eliminate cover lines on a newsstand title, particularly as so many standard women's—and increasingly men's—titles are putting more and more cover lines on, but there are other effects that are more creatively interesting and can push aside the rules," says Jeremy Leslie, creative director of John Brown Citrus Publishing.

stifling constraint in the glossy magazines of mass-market publishing, where competition is fierce in an overcrowded field. But independent magazines, less dependent on newsstand sales, are leading the way in new directions. As Jeremy Leslie, creative director of John Brown Citrus Publishing, says:

> *There are some interesting things happening in terms of magazines that are outside the monthly Cosmo or Company routine, magazines which don't have to conform to the industrialized distribution network that dictates that a magazine has to be A4, upright, and so on. It's increasingly easy to break out of that and produce something different.*

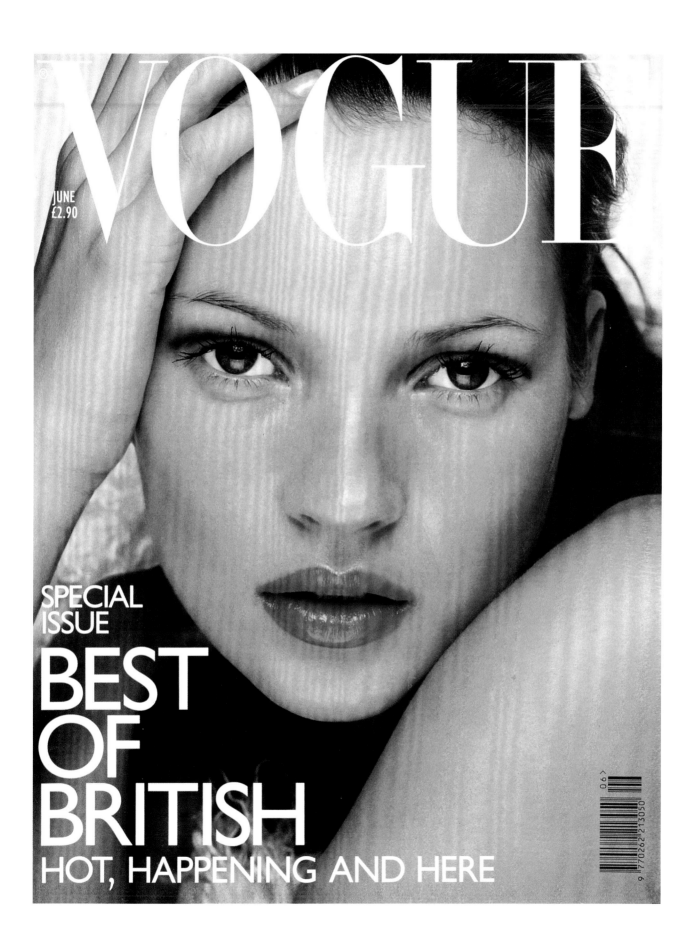

VOGUE

JUNE
£2.90

SPECIAL
ISSUE

BEST
OF
BRITISH

HOT, HAPPENING AND HERE

1 2

Above Concept covers can be particularly arresting. Pearce Marchbank at *Time Out* (**1**) in the 1970s used such covers to great effect, employing photography, illustration, collage, and typography skillfully to "sell" difficult concepts such as Dadaism and envy. Vince Frost achieved equally striking results with his covers for *The Independent on Saturday* newspaper magazine supplement (**2**), which used abstract cut-out photography on white backgrounds with wit and elegance to intrigue readers and suggest a broad concept of a story, rather than explaining it literally. Both these designers knew that the key issue in designing a cover is to approach it as a poster, as that is, in effect, what it is. First and foremost, it has to be striking and draw in the viewer.

The different types of cover

There are many different approaches to cover design, but, broadly speaking, covers can be categorized under three headings: figurative, abstract, and text-based. The latter are rare now as editors shy away from text-dominated covers and graphic puns, but the very fact that they *are* rare creates its own impact.

Figurative covers

The traditional face or figure shot can be made more engaging by approaching it with some element of originality; for example, by replacing the smiling face shot with a face displaying an emotion such as anger, fear, or elation. The degree to which this kind of treatment can be attempted depends on the conformity of the publication's readership: Readers of anticonsumerist magazine *Adbusters* are unlikely to be repelled by a negative figure image, while the readers of a weekly women's magazine probably would be. Wit and humor can often attract readers, and an action shot with a sense of adventure invites us to join in the fun. Even a regular face shot can be made interesting. Style magazine *i-D* has always shown its cover faces winking, aping the "winking face" created by its logo. With full-figure shots there is a greater flexibility, a fact that *Dazed and Confused* plays with inventively. *Carlos* magazine uses illustration to depict cover figures, enhanced by

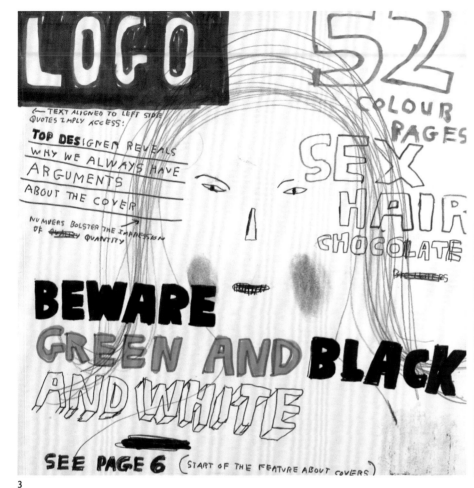

3

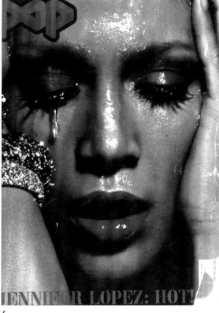

4

a striking splash of metallic ink. Fashion magazines can use illustration effectively, too; an illustration of a garment can convey an emotional sense of the material, rather than the literal representation of photography. And illustration has the advantage of enabling words to be incorporated in a way that is different from photography's clear boundaries, which make it distinct from any surrounding or superimposed text. Montage is an old device that can bring another dimension— that of metaphor—to figurative covers, and can be used most effectively to make incisive comments.

Abstract covers

Abstract covers are rare in publications that rely heavily on newsstand sales, but feature regularly in special interest and subscription-only publications, news weeklies, or newspaper supplements. These often have the luxury of minimal or no cover lines and the freedom to place the logo wherever it best suits the design, since shelf visibility isn't an issue. This can result in highly original designs, but it is important to remember that the brand and its message must be maintained through a clear design direction and approach. *Wired* has always been particularly skillful at doing this (*see* p.31). From the magazine's inception, its designers John Plunkett and Barbara Kuhr made frequent use of abstract

Above Two very different interpretations of the usual close-up head shot. On *M-real* (**3**), creative director Jeremy Leslie playfully undermined the idea of the close-up female head shot making eye contact. *Pop* (**4**) did the same thing with a Jennifer Lopez cover using a very different technique. By not making eye contact with the viewer and suggesting an emotive and expressive state as opposed to a passive, nonspecific one, Lopez's image marks itself out as different from its competitors.

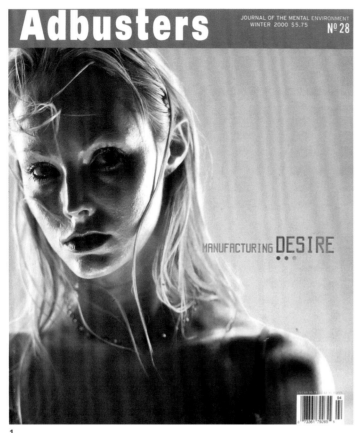

1

2

Above A figurative cover can be inventive and original if a publication's designer, editor, and publisher have the courage to counteract the perceived notion of what is acceptable, popular, or sellable as seen in these examples from *Adbusters* (**1**) and French magazine *WAD* (**2**). *Adbusters* in particular slyly undermines traditional notions of a cover's salability by showing a traditional head shot of an attractive blonde woman in a very confrontational and unconventional way.

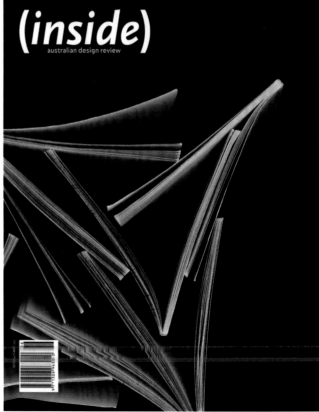

Right For this cover of *Inside* magazine (**3**), the theme was leisure. The magazine's art director, Jeffrey Docherty, says, "Choosing a single representation of 'leisure' provided an artistic challenge. To capture a particular essence of 'leisure' I created an image using several novels, which I arranged dynamically on a flatbed scanner. This assisted in crafting a three-dimensional feel; from afar the image has strong architectural qualities, while, close up, it holds finer details that draw the eye in deeper."

3

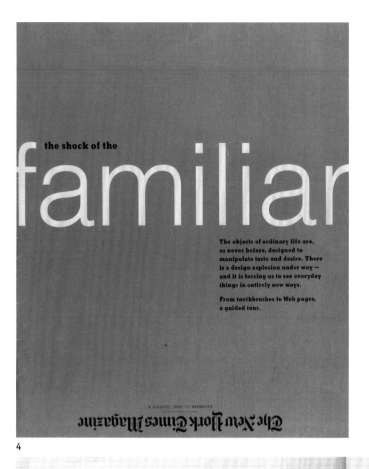

the shock of the

familiar

The objects of ordinary life are, as never before, designed to manipulate taste and desire. There is a design explosion under way — and it is forcing us to see everyday things in entirely new ways.

From toothbrushes to Web pages, a guided tour.

ɘnizɒᵷɒM ꙅɘmiT ʞɿoY wɘИ ɘʜT

Left and below Says Janet Froelich, art director, of *The New York Times Magazine*, "This was our first 'design special' issue, and we treated it as a primer, an advance-guard explanation to our readers of all the places where they would find good design. We decided to involve them slightly in the process, and made the cover into a graphic design competition in which we invited six great graphic designers from varied backgrounds to create a concept. We printed all six solutions (5). When we opened Jennifer Morla's contribution (4), we knew right away it was the winner—it was so simple. 'The Shock of the Familiar' was in bold, simple Helvetica, like signage, on a plain silver background. But *The New York Times Magazine* logo was upside down and at the bottom. It made you turn the cover upside down, and [be] aware of the cover as an object. And the shock factor was there as well. Its absolute clarity was riveting. It was also fun to read about the other five solutions inside, and begin to understand the way designers think and how they go about solving problems."

Variations: A Cover Story
Six ways to solve the same problem.

T o come up with a cover, the magazine tried an experiment, asking some of the country's top designers to solve the same design problem — to capture in one "poster" the message of its special issue: the shock of the familiar. The teams — experimental and traditional, from "packaging," corporate-image creation, print advertising, television and CD design — were told the theme and given the headline the editors had written. Below are six cover ideas, including the winner, and the thinking behind the solutions. In the end, the editors and the art director chose the one with no image at all — just an unadorned type cover that by inverting the logo forced the reader to see the cover, itself a familiar object, in an entirely new light. While the magazine found much to admire in the other submissions, the Morla design told the story in the simplest, most pleasing way. You might disagree; the fun of these pages is letting you decide for yourself.

 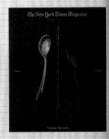 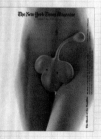 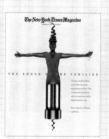

Jennifer Morla
Morla Design

In a brainstorming session with her creative team, Jennifer Morla, whose sensibility has ranged from the slyly retro to the trimly modern, composed several covers using different objects, but then landed on one that she felt best suited the issue. "I wanted to make the cover the object itself," she says. "You have to turn the magazine upside down and right side up in order to figure out how to open this very familiar object. The cover is literally the object being shocked." John Underwood, a graphics designer who works with Morla, came up with the idea of putting the word "familiar" in white 1950's Univers type on an iridescent silver background. "This makes the cover a high-designed object, precious," he says. "And then we flipped it."

Morla has helped develop corporate images for companies like Levi's and Apple Computer.

Tibor Kalman
M & Co.

"Brands have become such a dominant force in our society," says Tibor Kalman, who has earned a reputation as "the bad boy of graphic design" and is perhaps best known for his irreverent timepieces. With his design assistant Diane Shaw, he created several new "brands" for the cover—a baby bearing a Martha Stewart logo, a sunset brought to you by Coca-Cola, a Louis Vuitton egg. But they settled on a package of Calvin Klein chicken parts—great legs, nice breasts. "The original notion of brand was quality, but now brand is a stylistic badge of courage, and an expensive one at that. This, to me, is the shock of the familiar."

Kalman is the founder of M&Co., a design group that popularized the now de rigueur graphic-language.

Jeffrey Keyton, Stacy Drummond
Design partners

Jeffrey Keyton, who has helped define MTV's visual personality, and Stacy Drummond, also a designer and his wife, sometimes collaborate. Their cover was inspired by the spoon collection of their 9-month-old son. "In order to illustrate the shock of the familiar," Keyton says, "Stacy and I decided to juxtapose these two designed objects, one high, one low." A Gucci baby spoon costs about $250, but a plastic one from Gerber can be had for about $1.49 at most supermarkets. Drummond and Keyton find both equally beautiful.

Keyton is a creative director at MTV. Drummond runs her own design firm, Naked GD.

Margaret Youngblood
Landor Associates

"Even things that weren't intentionally designed are now being considered designed objects," says Margaret Youngblood, a giant of traditional design who has helped many major corporations establish their identities. "Even the most simple image, Eve and her leaf," says Eric Scott, Youngblood's senior design director, "is now part of our designer world." Consequently, to emphasize the shock of the familiar, they asked Eight Inc.'s industrial designer to come up with a bold, modern leaf. They then softened Eve's curves and gave her a pure white background, suggestive of eternity. Her modesty, however, is now symbolized by an updated designer accessory.

Youngblood has helped create the logos and corporate identities for FedEx and Lucent Technologies.

Stefan Sagmeister
Sagmeister Inc.

"I am not what you'd call a minimalist," says Stefan Sagmeister, the Austrian-born designer known for his discordant, iconoclastic style. "I may be the only designer in the music business who actually prefers the CD format to the album cover. What you lose in size, you gain in density." For his cover, Sagmeister says, "I asked myself how to interpret the notion that design is everywhere and came up with what I believe is the epitome of 20th-century object design: the chair. I drew 30 or 40. Then I got the idea of adding a pet, something that symbolizes living design in many people's homes. By covering the cat with a layer of the chair pattern, I was able to create a futuristic designer world, which the cat is in looking out onto another designer world—our own."

Sagmeister has designed CD covers for the Rolling Stones, Lou Reed and Aerosmith.

Bill Oberlander
Kirshenbaum Bond & Partners

"My job," says Bill Oberlander, the advertising *Wunderkind*, "is to inspire, to shepherd, to help cut through the communication clutter out there and make a clear statement, tell a story." For the art director Julian Pugsley and the copywriter Andrew Bruck, who worked with Oberlander on his cover, the task was to come up with something graphically jarring that would convey the idea that design is not only everywhere but in fact is us. "And that's how we came upon the corkscrew woman," Oberlander says. "She's the morph — the offspring of a human and a designed product. The familiarity is shocking: you see half of her, you see half of the corkscrew, and you do a double take and think, Huh, is this telling me that high design and humanity are now this interchangeable?"

Oberlander has created national advertising campaigns for Target, Hennessy Cognac and Rockport shoes.

PHOTO CREDITS ON PAGE 141

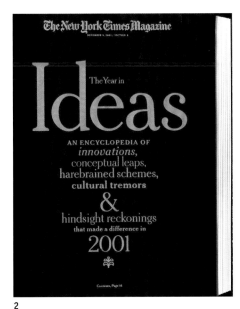

2

3

II: Anatomy of a publication **39**

Opposite and left The directness of text has an appeal and impact that sometimes simply cannot be conveyed by an image, as in this *Esquire* cover (**1**) by George Lois. It can also work as a conceptual tool, as in this *New York Times Magazine* cover (**2**) for the "Ideas" issue, the annual end-of-year compendium of the year's best. "Our approach was to present the best ideas, inventions, and schemes in an encyclopedic fashion, using the alphabet as a construction device. To that end, we created a template that resembled both a dictionary and an encyclopedia, in its use of thumb index, the illusion of thick pages, the wide columns, the little drawings in the margins, and the somewhat stuffy, dictionary-style typographic conventions. The cover was designed as an old-fashioned book cover, with the texture of fabric and embossed, gold lettering. It was then photographed in three dimensions, with the depth of the pages on the right forcing the image into a slightly narrower format," says Janet Froelich. Scott King's use of words on youth culture magazine *Sleazenation* (**3**) took its cue from a T-shirt design and was a direct, witty joke slyly poking fun at its readers, magazines, and fashion.

cover illustrations in order to communicate complex concepts in simple ways. *Adbusters* also uses this method, while *Tentaciones*, the *El País* supplement designed by Fernando Gutiérrez (*see* p.172), moves the logo around the white space of the cover at will, unrestrained by anything other than the fact that, because the magazine is printed on newspaper presses, it cannot use full-bleed photos, so instead floats images on white backgrounds to give the illusion of bleeds.

Text-based covers

Text-based covers are rare in contemporary periodicals, but many designers, including George Lois on *Esquire*, Herb Lubalin on *Fact*, and Scott King on *Sleazenation*, have used text-based covers to brilliant effect. Pearce Marchbank often took this option for his *Time Out* covers in the 1970s, for instance eschewing photography for an issue on Japanese movies, choosing instead a graphic treatment of a bleeding Japanese flag with a single, pithy cover line. A more recent issue, featuring an Amsterdam guide, opted for a typographic approach because, as its art director Jeremy Leslie explains, "Amsterdam lacks an iconic location, building, or event, so a typographic solution was used to express the buzz of the city."

There is no doubt that text-based covers work, but in a culture that is now so visually oriented their use is minimal—which, of course, can be useful for the editor and designer looking to make an impact or stand out: hence their use when tragedy strikes or a famous person dies.

A final word on covers: The term "cover" comprises the outside front cover (or OFC), the inside front cover (IFC), the outside back cover (OBC), and the inside back cover (IBC). In most periodicals all but the OFC will be given over to lucrative advertising, but if they are not, it's worth remembering that these pages are infinitely more valuable than any other available pages, apart from the main cover.

Below A weekly magazine has to look very different from issue to issue—the reader needs to be aware that the one on the newsstand is new. Moreover, it is possible for two issues to be on the newsstand at the same time (as is the case with *Time Out*, which overlaps by a day). Consequently, *Time Out* makes the most of the ability of text to stand out in a way that a succession of images can't. For this cover, it's hard to imagine anything working as well as the type does. Micha Weidmann's solution (**4**) to an issue on whether north or south London is better was innovative and original; rather than simply show a photo or illustration of the Thames river, he devised two covers: Dependent on which side of the river you bought your copy, either "north" was the right way up or "south" was—an ingenious and simple solution to a difficult concept.

Profile: *Adbusters*

Quarterly Canadian magazine *Adbusters*—subtitled "the magazine of the culture-jamming revolution"—is an excellent example of the relationship that a special interest publication can develop with its target audience (in this case, 120,000 of them). Editor Kalle Lasn brought a documentary film background to the publication, which played a large part in the development of the magazine as an intelligent, design-literate publication that not only delivered a meaningful message but also married each issue's theme to coherent, relevant design issues. Each issue deals with one theme and is treated as a mini-book, enabling a completely different look each quarter. This is heightened by occasional guest art directors, such as Jonathan Barnbrook, who are brought in to deal with the visual journalism of a particular theme. The fact that it doesn't carry advertising means that the magazine's flow and pace present interesting problems for designers used to ad pages that, while generally seen as a design evil, can be effectively employed to the designer's and magazine's advantage by breaking up spreads to create variety in the flow and enabling a feature occasionally to start on a right-hand page.

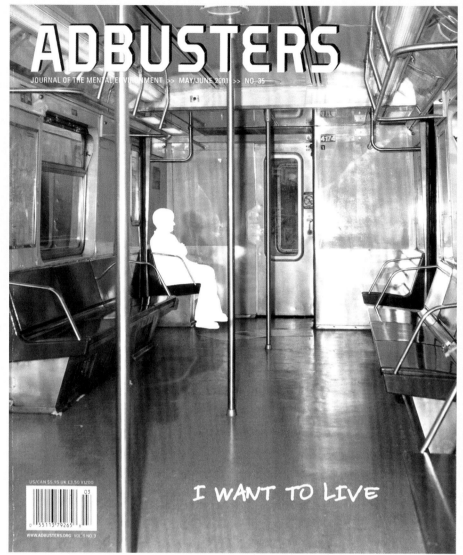

THE BLONDE ISSUE

1

Left and below Style magazine *Flaunt*'s covers are always highly original in both production and design terms, and always include an inside and outside front cover. This one features a teasing two-part cover that has an unrecognizable color-by-numbers front (**1**). Only when readers turn the page do they see that it's Reese Witherspoon (**2**). According to creative director Jim Turner, "Where other magazines would use a simple card cover, *Flaunt* always goes the extra distance. Cover ideas are discussed with the photographers many times prior to shooting the inside cover, but the majority of the time we find a particular artist who has a gallery show opening, or recently opened, or just someone whose work we like, and let him or her run with it. It's also great when you find an art director/designer/illustrator group all-in-one situation to work on the cover—that's only happened a couple of times."

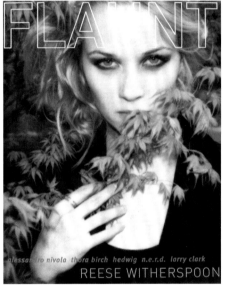

alessandro nivola thora birch hedwig n.e.r.d. larry clark
REESE WITHERSPOON

2

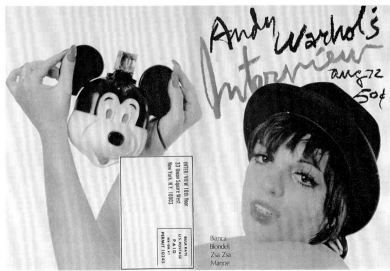

Left On *Interview* magazine (**3**), Andy Warhol often employed both front and back covers to present a portrait in full frame. On the front it would look like the traditional star close-up, but the back gave readers greater insight into the shoot and the subject.

3

D

E

1

2

Above Newspaper designers, who lack luxuries such as huge images, color, or glossy stock, have to make a title appealing in a very different way to magazine designers, as these examples from the *Boston Sunday Globe* show (**1**), (**2**). "Typography is the key to look and feel—what readers perceive in the first ten seconds when their eyes land on a page. It is through the feel of typography that one conveys seriousness, youthfulness, playfulness, and so on. The color palette is the second important criterion. We react instantly to the combination of type and color on a page, and, as a result, white space and its allocation within the architecture of the page play the third most important role," says Mario Garcia.

Newspaper covers

News no longer sells newspapers. The Internet and mobile media have made newspapers redundant as the preferred media for breaking news, and newspapers have had to reposition themselves accordingly. "The old definition was: News is what I find out today that I did not know about yesterday. My definition of news today, which I share with my clients, is this: News is what I understood today, which I found out about yesterday," explains Mario Garcia, design consultant on a global range of newspapers. Consequently, the early years of the twenty first century have seen a great number of newspaper redesigns, and this is apparent, above all, on the front page where, for publications across the board, the desire for impact has become all-consuming. As Mark Porter explains:

It is no longer just downmarket tabloids that strive to create a dramatic or surprising presentation of a single story on the front every day. But this can be a dangerous strategy, as it leaves nowhere to go when a truly powerful or dramatic story breaks. Many newspapers still prefer to carry a range of stories calmly presented on the front page, as this conveys a sense of the diversity of the day's events, and credits readers with the intelligence to make up their own minds about what to read and think.

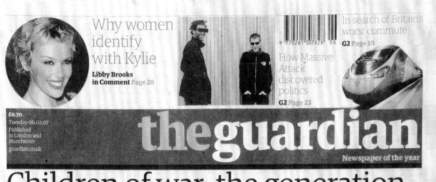

Left *The Guardian* newspaper (**3**) dedicates the central bulk of the front page to one or two stories, but also strips four or five turns across the bottom of the page. These are not ideal, as they force the reader to go back and forth from cover to news pages, but the designer must find a balance, which should be predicated on the brand: A quality newspaper, in particular, will always want to present a number of stories on its cover. As Mark Porter says, "Turns enable us to get a presence for a wide range of stories on the front page, which is essential for a newspaper that aims to give a broad and balanced view of the day's news."

Opposite A great example of visual confidence in the brand that might be misplaced if the brand was not well known. *Harper's Bazaar* or *Vogue* would still be recognized with barely any of its logo showing; a less well-known magazine would not be.

So, finding the right balance is important, and key to this is a good production system and underlying, flexible grid. Mario Garcia adds that newspapers have to offer readers "good stories that surprise, with photos that have not been shown on television and the net for the last twenty-four hours. It's all about redefining news, offering surprises, and not just reaffirmation."

The logo as ambassador for the brand

A publication's logo—the graphical representation of its title—is the first and often the most important element of its cover. While the publication's title may be as important as the way it looks, for the majority of designers this is something that will already have been decided. A logo is intended to capture and impart the publication's character, subject, stance, and attitude to its intended readership, often in a subliminal way, and, while its primary function is to appear on the cover of the publication, it also needs to work on all of the brand's representations. Thus, it will appear on stationery, on promotional and marketing material, and on the Web site, and all these uses should be considered. If a magazine is successful, then its logo will be around for a very long time and its treatment, manipulation, and positioning, along with any obscuring of the logo, become significant.

Playing with the logo

A logo is a publication's calling card and should therefore be visible. Publishers are not happy with the logo of their title being obscured (by a photo or an illustration), but there have been many examples of a title being covered or partially covered and still selling very well; the trick is to show just enough of the title to make it instantly recognizable. There are many instances when obscuring a logo strengthens a concept that would otherwise be weakened if the logo had to be visible in its entirety: Henry Wolf's cover for the March 1959 issue of *Harper's Bazaar* (right) interwove gloves with the magazine's title to create a riveting cover that looked three-dimensional and offered a seamless, completely integrated image.

Nest, the U.S. interior design magazine, changed, happily, both the design and position of its logo for a while, as did David Carson for *RayGun* (see p.46). This conceit was copied by sister title *Blah Blah Blah*, designed by Substance, while *FT The Business* magazine (see p.46) played decorative and visual tricks with the logo each week, treating it as a movable graphic element that was an integrated and witty part of the image and stood out boldly from it. Others stuck with a good thing. *Nova*, with its elegant logo set in an old wood type, Windsor, worked brilliantly with just the logo and an expressive single theme on each cover, using just one cover line to sell it (see p.177). *Interview*, too, with its hand-drawn logo by illustrator Mats Gustafson, rarely played around with the logo or cover lines, which remained minimal. It played to its strengths—a large format, a unique logo, and a visual style of tight, harsh crops of celebrities that was all its own.

HARPER'S
BAZAAR

March 1959 60 cents

Eyes
on
Paris
and
America

1

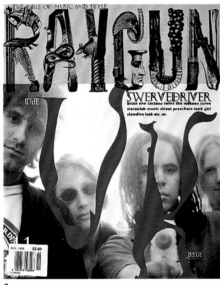

2

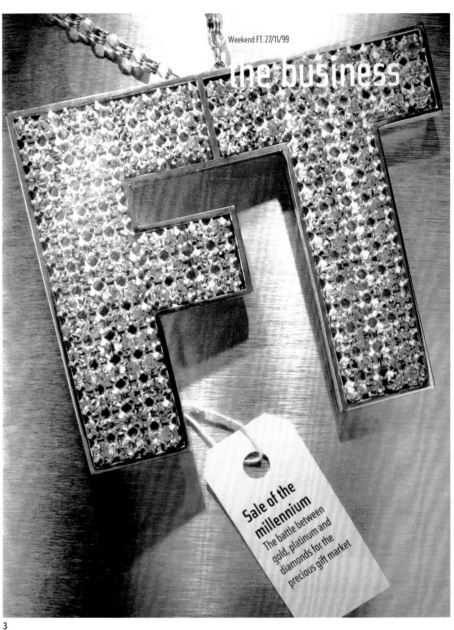

3

Above Playfulness, experimentation, and an irreverent approach to the logo can not only "fit" a publication well, as designer David Carson realized on alternative music magazine *RayGun* (**1**), (**2**), but can also enable the designer to link a logo to the cover's concept, as designer Gary Cook frequently did on *FT The Business* magazine (**3**). He says, "About once a month I tried to do a concept cover, not one based on a portrait, and I did everything from making the logo into a piece of 'bling' jewelry, to sprinkling it on a cappuccino. This helped develop the magazine as a brand and strengthen its position next to the paper. I try to use wit in my design work as much as possible and when appropriate, like here, where I think the concept covers worked well."

Spines

While book designers know the value of spines as a design area, this little band of space is generally ignored by periodical publishers, beyond using it to show the title and publication date. This is a shame for two reasons: First, the spine has excellent sales value as, when stacked, it is more visible than the cover, and second, because this strip is an excellent place in which to reinforce the brand and style of the title, a fact not lost on the designers of titles such as *Arena*, *Loaded*, *Vanidad*, and *wallpaper**. Rather than simply list title information, the first two of these use the spines to build up arresting narratives that make readers feel they are buying part of a series and not just a single issue, thereby encouraging loyalty and the desire to build up a whole set. *Vanidad*, designed by Fernando Gutiérrez, echoes *Arena* by having the separate spines (opposite, next to *Loaded*)

combine to create the upside-down "A" that is the title's logo, while *wallpaper**
uses it to carry a list of key contents—an excellent indexing feature. Separating
what's important from what's not can be achieved by using different weights and
sizes of fonts: The title logo and date should attract from a distance, drawing the
potential reader closer to finding further, more detailed information.

Inside the publication

A publication is broken down into areas that largely follow an established format
for its particular type. Thus, a magazine breaks down into three areas: the news-led
first third (called the front of the book), a middle third housing the features (called
the feature well), and a back third (called the back of the book), which is usually
where information-based content—reviews, listings, directories, and so on—is
located. A newspaper can be similarly broken down into areas of content: hard
news (the unpredictable, including international news and business); analysis
and opinion of the news; expected content (television, stock market information,
reviews, weather, sports, etc.); and irregular features.

A flick through any newspaper or magazine will reveal that the different
areas are often signposted by varying layouts or grids: Column widths, headlines,
fonts and their weights, images, and so on are all likely to differ subtly from each
other, identifying departments and making navigation easier for the reader. There
is, of course, no reason why designers should not deviate from these formats, but
if they do, they should use consistency in flow and navigation to compensate for
the reader's lack of familiarity with the structure. This is particularly true for
popular and predictable content—TV listings, weather forecasts, letters,
crosswords, horoscopes, and so on.

Contents page

What does the contents page of a magazine do? Contemporary readers use the
contents page in a number of different ways: to find the cover story, browse the
entire content of the publication, find favorite sections, or find a story they vaguely
remember reading years earlier. Some people don't use the contents page at all;
others read or flip from back to front, making the contents page at the front fairly
redundant. But the contents page remains very important because, after the cover,
it is the only device that can literally guide the reader deeper into the publication
and signpost a way through and around its content. Because of this status, contents
pages are often located on the right-hand side, since this is the page most easily read.
However, precisely because of this, right-hand pages—and particularly those near
the front of a magazine—are more appealing to advertisers and therefore may be
sold, forcing contents pages onto the left-hand side of a spread.

Designing the contents page

First and foremost, the contents page—and particularly the essential information
it contains—should be clear to read, simple to follow, and easy to find. While
traditionally it is placed as close to the cover as possible, its position isn't as

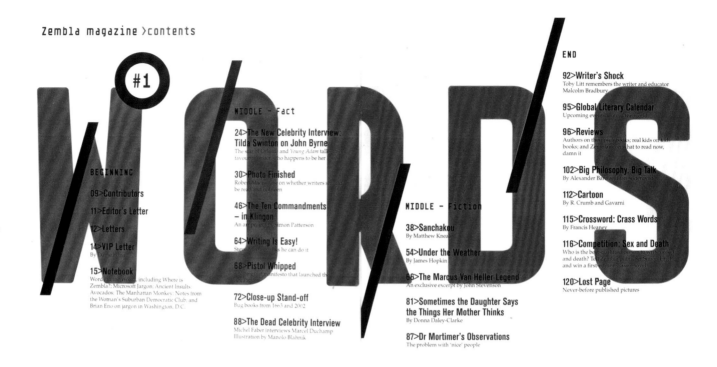

1

2

Above and right Contents pages have to list everything in the publication, but there is no reason why their design cannot be handled inventively, as these examples from *Zembla* (**1**) and *The New York Times Magazine* (**2**) demonstrate. For the latter's annual issue on inspiration, art director Janet Froelich found inspiration at the Cooper Hewitt Design Museum's biennial. "I saw the wonderful 'Alphabits,' which designer and writer Paul Elliman constructs from scrap materials, found objects, and bits of industrial waste, including bottle tops, computer components, engine parts, and so on. As such, they are a perfect embodiment of the question of where inspiration comes from. His letterforms are powerful graphic objects and they made our pages look fresh and inspirational. They were so much fun to work with," says Froelich.

3

4

5

6

Above and left Contents pages can be designed well as lists, as illustrated by these examples from *Twen* (**3**), *Sleazenation* (**4**), and *About Town* (**5**), which use strict underlying grids and a Swiss formalism to make the text matter-of-fact and informative while retaining a graphic elegance. But there are many different ways of representing the navigation of the magazine. In *Metropolis* (**6**), "The map on the table of contents is a graphic device that was created by Paula Scher when she redesigned the magazine in 1999. It provides a framework to show the reader where the stories appear in relation to each other. Although the table of contents has gone through many design variants over the last five years, the map has remained, and has actually become a more significant element in the design of the page," says *Metropolis* art director Criswell Lappin.

important as consistency of positioning. Every issue of the same magazine will put the contents page in the same place. Regularity leads to familiarity. This, in turn, fosters the sense of a publication being a friend. The arrangement and organization of a contents page should be attractive, lucid, and quick to absorb and navigate—to find the cover story, for example, or a favorite regular section. It should highlight individual features and important section stories through the use of type, imagery, and graphic devices such as rules and icons, and it should summarize main stories to tempt the reader to them. After all, someone reading the contents page may not have bought the magazine as yet. Finally, it should echo the arrangement of the contents that come after it; so, if there's a news section followed by a feature well (*see* p.53) and a directory, this should be reflected in the contents page.

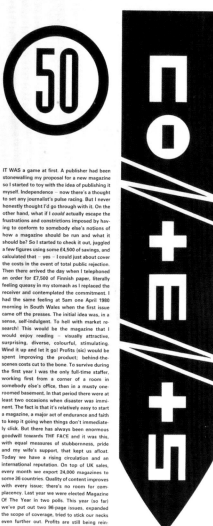

IT WAS a game at first. A publisher had been stonewalling my proposal for a new magazine so I started to toy with the idea of publishing it myself. Independence – now there's a thought to set any journalist's pulse racing. But I never honestly thought I'd go through with it. On the other hand, what if I *could* actually escape the frustrations and constrictions imposed by having to conform to somebody else's notions of how a magazine should be run and what it should be? So I started to check it out, juggled a few figures using some £4,500 of savings, and calculated that – yes – I could just about cover the costs in the event of total public rejection. Then there arrived the day when I telephoned an order for £7,500 of Finnish paper, literally feeling queasy in my stomach as I replaced the receiver and contemplated the commitment. I had the same feeling at 5am one April 1980 morning in South Wales when the first issue came off the presses. The initial idea was, in a sense, self-indulgent. To hell with market research! This would be the magazine that I would enjoy reading – visually attractive, surprising, diverse, colourful, stimulating. Wind it up and let it go! Profits (sic) would be spent improving the product; behind-the-scenes costs cut to the bone. To survive during the first year I was the only full-time staffer, working first from a corner of a room in somebody else's office, then in a musty one-roomed basement. In that period there were at least two occasions when disaster was imminent. The fact is that it's relatively easy to start a magazine, a major act of endurance and faith to keep it going when things don't immediately click. But there has always been enormous goodwill towards THE FACE and it was this, with equal measures of stubbornness, pride and my wife's support, that kept us afloat. Today we have a rising circulation and an international reputation. On top of UK sales, every month we export 24,000 magazines to some 36 countries. Quality of content improves with every issue; there's no room for complacency. Last year we were elected Magazine Of The Year in two polls. This year (so far) we've put out two 96-page issues, expanded the scope of coverage, tried to stick our necks even further out. Profits are still being reinvested. Not just me, but all of us at THE FACE would like to thank the readers, contributors, advertisers, associates and friends of the magazine for their generous and continuing support. And we're still independent!
NICK LOGAN

ISSN 0263-1210

AMERICA ● AUSTRALIA ● CANADA ● DENMARK
FRANCE ● GERMANY ● GREECE ● HOLLAND
HONG KONG ● ITALY ● JAPAN ● NEW ZEALAND

The World's Best Dressed Magazine

The Face ● 4th Floor, 5/11 Mortimer Street, London W1, England

Publisher/Editor ● **Nick Logan**
Assistant Editor ● **Paul Rambali**
Designer ● **Neville Brody**

Features ● **Paul Rambali**
Intro/Features assistant ● **Lesley White**
Accounts/subs ● **Julie Logan**
Design assistant ● **Ben Murphy**

New York Editor ● **James Truman** (212 989 4579)
Ad Manager ● **Rod Sopp** (01-580 6756)

+ Peter Ashworth/Janette Beckman/Max Bell/Ian Birch/Chris Burkham/Julie [illegible] Anthony Denselow/Robert Elms/Anthony Fawcett/[illegible] Hardy/David Johnson/Marek Kohn/Neil Matthews/John May/Joe McKenna/Jamie Morgan/Neil Norman/Steve Pyke/Derek Ridgers/Dave Rimmer/Helen Roberts/Sheila Rock/Fiona Russell Powell/Chris Salewicz/Jon Savage/Kate Simon/Carol Starr/Jay Strongman/Kevin Sutcliffe/Steve Taylor/David Thomas/Paul Tickell/Steve Tynan/Elissa Van Poznak/Jane Withers/Patrick Zerbib

THE FACE 7

Right On alternative style magazine *The Face*, editor Nick Logan and designer and typographer Neville Brody recorded a postpunk era by taking typography, layout, and design in new directions, which drew on the politics and visual aesthetic of Russian constructivism. However, the layout of the contents page was still clear, and remained fairly traditional in its design.

Some publications don't bother with a contents page at all. Chris Dixon, former art editor at *Adbusters*, did away with the contents page because he and the editor, Kalle Lasn, agreed that it segmented the magazine too much and dictated the approach. Instead, navigational tools, including color bars and color stock, were used, the former signifying the length and variety of the section's contents by their width, color selection, and length. This is an extreme solution to a design problem and one that, in any case, can only be applied to certain types and sizes of publications; a news weekly or listings magazine with no contents page would quickly annoy its readers, while a publication with 300-plus pages simply has to be navigable in a practical way.

The front sections

Magazine editorial department pages—pages into which all the editorial departments on the publication will feed, whether culture, fashion, sport, music, travel, or interiors, and so on—will generally have well-structured style sheets and templates that are based on a selected range of fonts (size and weights), colors, and page furniture (including graphic icons, rules, and keylines), all laid out across a well-defined grid. Design has a part to play in the masthead and editorial comment, too, where the way in which information is laid out sends strong clues as to the style and tone of the publication. This is

Below *Zembla*'s letters page is a good example of a well-defined structure that always looks original but has a very distinct brand identity—and, with the physical use of letters, a gentle wit, too.

LOU V.
MARC JACOBS
FOR LOUIS VUITTON

VERUSCHKA
VALENTINO

FIGO
DONATELLA VERSACE

TOY 01
HEDI SLIMANE

SATURNA
MIUCCIA PRADA

THE EGO-TRIP
KARL LAGERFELD

BOLDUC
JEAN-LOUIS DUMAS
FOR HERMÈS

MINTER
ALEXANDER McQUEEN

LOLA
DOLCE & GABBANA

VIKTOR & ROLF
VIKTOR & ROLF

JEUX D'ADULTES.

Le plus expérimental des fashion magazines, **Visionaire**, s'amuse à jouer à la poupée. Son nouveau et 44e numéro décline une dizaine de petits personnages comme de mini-robots tout ronds, chacun habillé par un créateur – Lagerfeld, Hermès, Dolce & Gabbana, Prada, Viktor & Rolf… – et chacun accompagné d'accessoires adéquats et indispensables – mobile, verre de Martini, fleur, appareil photo… Évidemment, le tout est d'un graphisme ultra-créatif, ludique, oui, mais abordé avec le plus grand sérieux. *VISIONAIRE*, ISSUE 44 : TOYS. *[SR]*

Sublime INFINI

Fin 2002, dans le hall des turbines de la Tate Modern, à Londres, **Anish Kapoor** avait installé *Marsyas*, œuvre gigantesque couleur rouge sang. Blanche et à la taille plus réduite – 36 m de long pour 6,80 m de haut –, la pièce que le sculpteur déploie, cette fois, à l'intérieur du Magasin aux foins du Grand-Hornu fonctionne néanmoins sur le même principe. *Melancholia* ressemble à deux corolles mises bout à bout et constituées d'une membrane de PVC tendue à l'extrême. Que l'on plonge le regard par l'une ou l'autre extrémité, on est soudain pris d'une douce sensation de vertige, un sentiment sublime de l'infini. HORNU (BELGIQUE). TÉL. 00 32 (0) 65/65 21 21. *[CS]*

Psyché-IDYLLIQUE

Ça se passe à San Francisco, au milieu des années 60. L'époque est à la contestation et à son langage de prédilection : le rock. De cet air du temps naît alors un mouvement artistique singulier, dit «psychédélique», incarné en particulier par des affiches de concerts, et vite repris par le monde de la publicité. Couleurs vibrantes, effets d'optique, lettrages forts, arabesques et fleurs Arts déco… **Un vocabulaire visuel** qui peut aujourd'hui paraître daté, mais qui continue de symboliser un souffle de paix et de réjouissante liberté. En témoignent les quelque 200 affiches proposées au musée de la Publicité. JUSQU'AU 27 MARS. WWW.UCAD.FR *[SR]*

Pilier du bar

Ils boivent du café, fument des cigarettes, refont le monde ou non, parlent ou se taisent, s'amusent ou s'ennuient : *Coffee and Cigarette* de **Jim Jarmusch** sort en DVD, et c'est l'occasion de voir ou revoir ce film, succession de moments, comme autant de séquences indépendantes mettant en scènes anonymes et stars – Roberto Benigni, Tom Waits, Cate Blanchett, Bill Murray, Iggy Pop… – autour de tables de bistrot façon *diners* à l'américaine. Ce n'est pas, loin de là, le meilleur film du cinéaste, mais le côté excentrico-insolite de l'ensemble constitue un intéressant et poétique exercice de style. *[SR]*

Opposite and left Two very different approaches to news-page design. *Vogue Paris* (**1**) shows a classic, structured page with all the stories clearly delineated from each other by white space. *Wired* (**2**) takes a more cluttered, frenetic approach with varying column widths, boxes, and colors, but individual stories and departments on the spread are still clearly visible.

particularly true of the editorial comment, which should deliver the editorial tone of the publication very clearly.

Contemporary news pages (and the writing for them) have learned much from Web design, which uses boxes, colors, and a variety of font weights and sizes to make pages lively and energetic. *Wired* and *Business 2.0*, in particular, pioneered this approach, which was picked up by Gary Cook at *FT The Business*. In an effort to make the *Wired* news pages busy and energetic, designers used an abundance of overlapping boxes, shades, tints and colors, fonts, photos, and shapes. White space, which would add an unwelcome sense of calm to the layout, is completely obliterated.

A newspaper's front section shares certain aspects with magazines in that it contains the most up-to-the-minute content laid out across flexible templates on a well-structured grid. The bulk of unpredictable content—breaking news stories, developments in current news stories, and so on—is contained here.

The feature well

Features are the most important textual element of a magazine's branding. Whether it be the handling of a celebrity interview that every other publication is running that month, an in-depth analysis of an event, situation, or topic that is currently hot, or a scoop that no one else has, the style, content, and tone of the writing and layout are what will make it stand out from competitors.

Many publications use a standardized house style or "look" for features, and employ design to distinguish them from other editorial content through elements such as wider columns, more white space, different typefaces, larger headlines, and longer standfirsts or kickers beneath them. If the feature begins on a spread, it will often open with a full-bleed image—a head shot, figure, or illustration—facing the feature opener, which usually consists of the text (a headline, standfirst or kicker, body copy, and pull-quotes) and perhaps further images that will tie the full-bleed

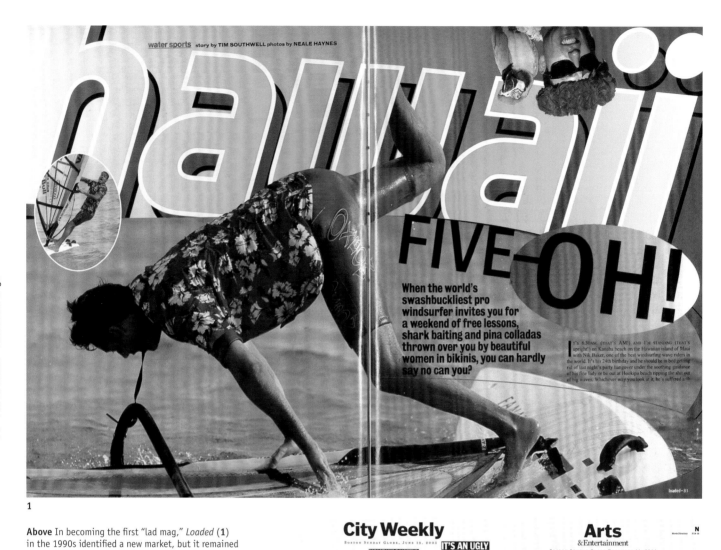

water sports story by TIM SOUTHWELL photos by NEALE HAYNES

FIVE-OH!

When the world's swashbuckliest pro windsurfer invites you for a weekend of free lessons, shark baiting and pina colladas thrown over you by beautiful women in bikinis, you can hardly say no can you?

It's 6:30AM (THAT'S AM), and I'm standing (that's upright!) on Kanaha beach on the Hawaiian island of Maui with Nik Baker, one of the best windsurfing wave riders in the world. It's his 24th birthday and he should be in bed getting rid of last night's party hangover under the soothing guidance of his fine lady or be out at Hookipa beach ripping the shit out of big waves. Whichever way you look at it, he's suffered a...

1

Above In becoming the first "lad mag," *Loaded* (**1**) in the 1990s identified a new market, but it remained successful because the features and how they were written both tuned in perfectly to that market. Here were great writers expressing all the things their readers wanted to be doing, thinking, seeing, having, and being. Its design also brilliantly conveyed and illustrated the energy, mayhem, and anarchy expressed in the writing. Art director Steve Read achieved this by developing an "undesigned" style that suggested features had been thrown together. The combination of vibrant color, big full-bleed action shots, huge headlines that were manipulated to convey movement and depth, and body copy printed out of the image created an effect of sheer *joie de vivre*.

Right The *Boston Sunday Globe* features pages (**2**), (**3**), designed by associate design director Greg Klee, retain the vertical feel of the news pages in the city section, designed by Lesley Becker, but use imagery in place of typography to create a more leisurely, less urgent tone.

2

3

Below On *Vogue Paris* (**4**), art director Fabien Baron uses both black and white space to construct spreads that reference the underlying grid and accentuate display text. As seen on this *Paper Sky* spread (**5**), white body text printed over a picture can be very effective, but must be used with care; a serif that is too fine, stock that is too porous, or an underlying picture whose tone is too varied can render text illegible. Willy Fleckhaus's bold use of white space in this issue of *Twen* (**6**) from 1968 is an unexpected treatment for the subject matter, and is therefore an elegant surprise, both visually and conceptually.

4

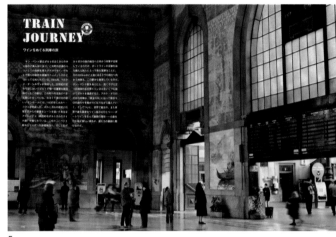

5

Das Hippie-Musical „Hair" macht den Broadway verrückt. Seine Rock-Musik ist laut und unverschämt, seine Texte sind drastisch und wahr. „Hair" riecht nach Schweiß und Blumen. Es keucht vor Liebe und ist authentisch.

6

Right French style title *WAD* (**1**) shows how important it is to use scale and space in the normally crowded back-of-book section. Page after page of small items would become repetitive and dull, but by throwing in an occasional picture-led, large-scale item, a lively pace is achieved. At *Inside* magazine (**2**), Jeffrey Docherty says type craft is key to making individual departments in the magazine sufficiently distinct from each other but still recognizably part of a brand. "I try to keep my type usage to a minimum—a separate face for body, one for headers and titles, and a third face, which may be in complete contrast to the others. This third typeface can change the mood of the magazine. However, what I find to be key in maintaining harmony throughout the mag is adhering to the grid," he explains.

Below Here, *Flaunt* magazine (**3**) comes up with an innovative solution to the design of the horoscope page: "Bar Code Astrology" makes a wry comment on the value of astrology, takes a sideswipe at consumer culture, and creates a page that stands out visually at the back of the book—and contains horoscopes, too.

1

2

image to the feature (if no such imagery is used, the headline usually does this instead). If the feature begins on a single page facing a full-color ad, a bleed image in black-and-white to contrast with the ad next to it, or judicious use of white space, can create a distinction between the two pages and draw the eye away from the ad toward the editorial. Using white space formed part of a move away from the excessive overdesign of the 1990s toward a clean simplicity, a move whose popularity has, unsurprisingly, continued well into the new century. One way of ensuring consistent use of white space is by incorporating it into the grid or templates: For example, in top or bottom margins, or in the relationship between headline and kicker, in "blank" columns, and in space around pull-quotes.

Back sections: reviews, listings, commentary

As with the front of the publication, elements that come after the feature well (for instance, reviews, listings, letters, and horoscopes) are often laid out by junior designers and have a fairly well-determined structure and grid. A color palette is usually in place, as are font selections, weights, and styles. Imagery is all-important in these pages: Good use of illustration and photography will determine whether the pages are lively, and, indeed, which individual story on the page is read. Equally, layout is crucial: Using cutouts on white backgrounds will make an image stand out and allow the page breathing space, something that can be difficult to achieve on editorial department pages, which are often crammed with stories and imagery. Very few people will read all the stories, but they may be tempted to do so if faced with a page that surprises and excites them, a fact that is true for all editorial design, even listings pages, where the intelligent use of typefaces and rules is crucial if the page is not to look gray overall. Of the back section, the most valuable page is that facing the inside back cover; readers flicking from back to front will see this page first, which is why some titles use it for high-volume or popular content such as horoscopes, letters, or the masthead.

3

4

5

Left and above This section opener for *The New York Times "T:Travel" Magazine* (**4**) reinforces the brand through the use of the hand-drawn Fraktur font of *The New York Times*, and the concept of the content through lettering in sand, while also presenting an image that is both original and inviting. The section opener for "Metropolis Observed" in *Metropolis* magazine (**5**) is equally inviting through its use of a textured image that gives a sense of depth and space, while simultaneously acting as a mini contents page.

Section openers

Section openers are often an indulgence in a periodical publication, but a welcome one for the reader. In content terms, they are generally unnecessary spreads with an eye-catching image and a minimal amount of text, but they do allow breathing space and, if used as a spread, offer a rare opportunity for a landscape, image-led layout, which can be used to create a much greater design impact than a portrait (though ensuring that you have an image of good enough quality and impact to repeat this regularly can be tricky). Because they generally stand out in a memorable way, such openers can act as useful "markers" for the reader looking for an article in a particular section. If this is their primary use, it can be helpful to create a distinct format that the regular reader can recognize and use to navigate the publication.

FT The Business, a Saturday glossy supplement that ran for three years with the *Financial Times* newspaper, was designed by Vince Frost and art directed by Gary Cook, who had previously designed both *Creative Review* and *Time* magazines.

Editor Michael Watts chose Frost from their work together on *The Independent on Saturday* magazine, which Watts edited. The result was something that a magazine designer would not have come up with, believes Watts. "The thing about Vincent is that he's not really a magazine designer; he's a graphics designer, which you must take on board when you work with him. His great contribution was the huge *FT* logo that occupies the mag's front—typically the invention of a graphics designer, although it made it very difficult to write cover lines in the downward strokes of the 'F' and the 'T' —a mag designer would never have come up with the thought. Nonetheless, it was a brilliant and distinctive invention. He came up with it right away. He also wanted Tasse, a rather purist typeface, which was fine by me. Together, we thought of setting the page idents vertically—a mistake, I think, in retrospect. A case of overdesign," he recalls.

Frost and Cook worked together on the first two issues. This allowed the art director to develop an understanding of Frost's design aims for the magazine, which Cook describes as "based on the premise that the magazine was the cheeky young brother of the *FT* proper. The line that we used when trying to express it was 'alley cats, not fat cats.' Briefly, this was supposed to suggest that although we stood on the shoulders of a giant in a sense, the magazine itself was composed

of features that would not necessarily have made it into the paper." Loose influences included publications such as *Fast Company* and *Wired*—Cook "tried to pick up on their 'speed' but inject it into a supplement design." In his covers, Cook communicated the "slightly cheeky attitude" he strove for particularly well. "The idea of personalizing the *FT* logo itself comes from a different medium altogether: the BBC's logo for BBC Two," and in particular, the eye-catching and inventive approaches that designer Martin Lambie-Nairn came up with for it.

A lot of stories in FT The Business *were about young entrepreneurs who had made a lot of money with Internet ideas or the like—money from businesses that had not, or could not, have existed ten years earlier. The design had to reflect that, and my idea was that it should become as visual as possible. The graphics we used, the excellent photography (commissioned by photo editors Caroline Metcalfe and Karin Mueller), and the extra slugs of captions (which were linked to the main copy, like a link on a Web page) were all meant to suggest that this magazine was a new thing.*

Despite being closed after just three years, *FT The Business* was successful and innovative on every level, a fact Cook attributes to the editor: "Michael Watts had a clear idea of what the magazine should be. He was receptive to any ideas we had, was always pushing to do new things, and never wanted the magazine to stand still. He is as interested in the design of a magazine as the copy and ultimately gave everyone the autonomy to do their own job, while also suggesting things that could or should be changed."

Fashion conglomerates

Words by Tamsin Blanchard. Research by Vanessa Friedman

As London Fashion Week opens, it's becoming apparent that it's not who you know that counts in fashion now – it's who you own. The international fashion market, currently worth approximately $60bn (£43bn) annually, is dominated by a handful of mighty corporations, including Wertheimer, Pinault Printemps Redoute, Hermes and Vendome, jockeying to buy the great fashion houses.

The French luxury-goods conglomerate, LVMH, proudly lists Louis Vuitton, Dior, Givenchy, Celine, Kenzo and Pucci as part of its collection of famous names. The company would like to have added Yves Saint Laurent to its shopping list, but Gucci, the increasingly powerful Italian luxury fashion house, got there first. Both are said to be eyeing up Giorgio Armani, still a privately-owned company.

Another prominent predator is Patrizio Bertelli of Prada, the Italian luggage firm, whose assets now include a share in the fur-and-handbag brand Fendi, as well as Jil Sander and Helmut Lang.

Bertelli has said that fashion houses no longer need a creative designer to succeed in the marketplace. What's required is a sugar daddy and a global marketing strategy. **FT**

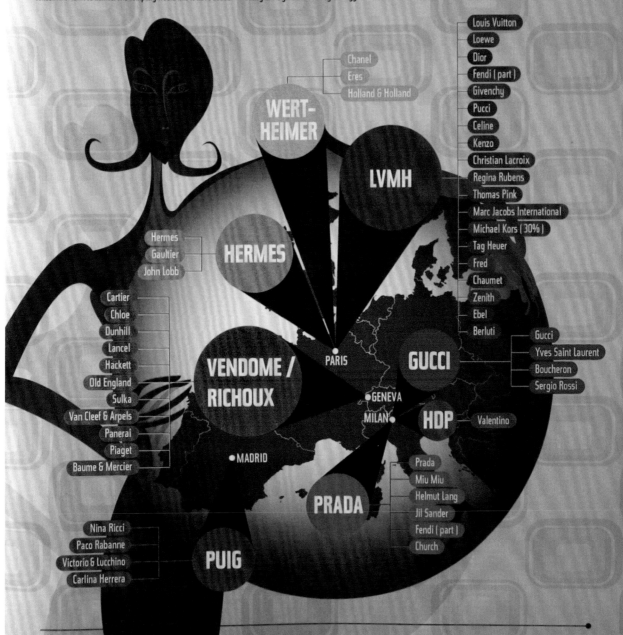

- **WERTHEIMER**
 - Chanel
 - Eres
 - Holland & Holland

- **LVMH**
 - Louis Vuitton
 - Loewe
 - Dior
 - Fendi (part)
 - Givenchy
 - Pucci
 - Celine
 - Kenzo
 - Christian Lacroix
 - Regina Rubens
 - Thomas Pink
 - Marc Jacobs International
 - Michael Kors (30%)
 - Tag Heuer
 - Fred
 - Chaumet
 - Zenith
 - Ebel
 - Berluti

- **HERMES**
 - Hermes
 - Gaultier
 - John Lobb

- **VENDOME / RICHOUX**
 - Cartier
 - Chloe
 - Dunhill
 - Lancel
 - Hackett
 - Old England
 - Sulka
 - Van Cleef & Arpels
 - Panerai
 - Piaget
 - Baume & Mercier

- **GUCCI**
 - Gucci
 - Yves Saint Laurent
 - Boucheron
 - Sergio Rossi

- **HDP**
 - Valentino

- **PRADA**
 - Prada
 - Miu Miu
 - Helmut Lang
 - Jil Sander
 - Fendi (part)
 - Church

- **PUIG**
 - Nina Ricci
 - Paco Rabanne
 - Victorio & Lucchino
 - Carlina Herrera

PARIS · GENEVA · MILAN · MADRID

The role of copy

The terminology for copy can be confusing to a designer unused to the array of terms used in editorial design. It doesn't help that many of them have different names for the same thing (*see* illustration below), but it is important for the designer to know four things when it comes to copy:

- the different terms for copy;
- what these different forms of copy are;
- how writing for editorial generally, and these types of copy specifically, differs from other types of writing;
- how this affects the designer.

Cover lines

These apply exclusively to periodicals. Newsstand titles will usually display a mass of these in a bid to show they have more and better content than the competition. The largest cover line, if the publication is using size to distinguish order of "importance," is nearly always related to the cover image. The content, use, and placement of cover lines in such titles as *Vogue*, *GQ*, *Vanity Fair*, and *Marie Claire* are generally decided by the editor and art director, but marketing and competition considerations drive this process (they often appear on the left third of the cover, as this is most likely to be visible on the newsagents' shelves). But the look and tone of the cover lines—their color, how they stand out against competitors and each other, what their number,

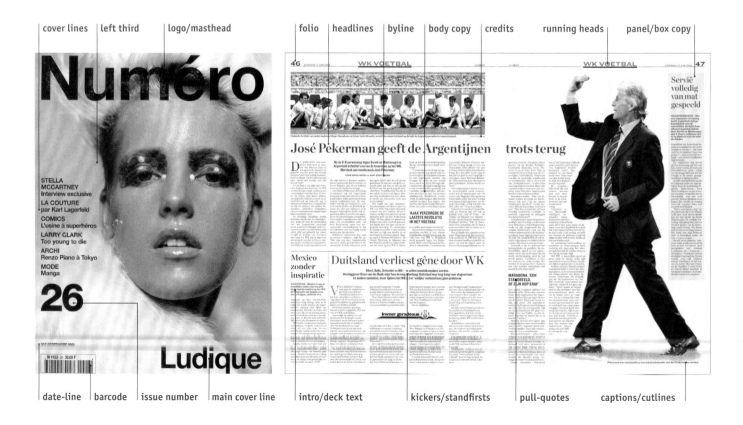

cover lines | left third | logo/masthead | folio | headlines | byline | body copy | credits | running heads | panel/box copy

date-line | barcode | issue number | main cover line | intro/deck text | kickers/standfirsts | pull-quotes | captions/cutlines

1

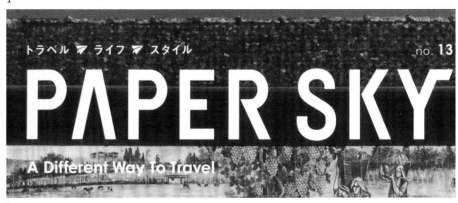

2

Left The tagline for *WAD*, "we'ar different" (**1**), works on a number of levels: It explains the title's name, is an exhortation to the reader to be an individual in their style ("wear different" being a witty reworking of Apple's "think different") and also boldly states "We Are Different." Such a strong and individual tagline is rare; more often a tagline will simply give some idea of the content and tone of the title, as seen in the tagline for *Paper Sky* (**2**).

length, and words say about the magazine and its personality—are very much the responsibility of the designer. In newspapers, too, designers have started to use the space above the banner for cover lines that highlight featured articles inside the paper and its supplements.

Taglines

Taglines or slogans under a logo can add enormous value to a publication. A well-worded tagline not only tells the reader what a title is, but also indicates tone and target audience. For regular readers, it reinforces the feeling that they are "the men who should know better" (*Loaded*), the people who care about "the stuff that surrounds you" (*wallpaper**), and the fashionistas that form part of the unusually styled "we'ar different" cognoscenti (*WAD*—illustrated above). For newcomers, it's a handy instant clue to content that they may not otherwise get.

Headlines

A copy editor will argue that the headline is just as important in persuading a reader to read a story as the layout. A headline creates a strong bond between the publication and the reader; it says, "We know you, we're like you, we share the same sense of humor/interests/cultural references, and we know you're intelligent enough to understand this headline and story." Therefore, appropriate size, positioning, and treatment is vital. This is particularly true on a text-driven newspaper, which may not have the luxury of images with which to entice the reader into a purchase.

Right and below *The Observer Music Monthly* headline (**1**) neatly refers not just to the subject of the interview (Noel Gallager of rock band Oasis) but also the equally famous interviewer, David Walliams, whose comedy sketch show *Little Britain*—and, in particular, a catchphrase from it, "yeah but no but"—was taking the U.K. by storm at the time. Thus, it manages to be clever, funny, *and* absolutely in sync with the zeitgeist. The *Flaunt* headline (**2**) is more traditional, but is still strong, clever, and insightful, suggesting as it does a self-effacing attitude to (and on the part of?) superstar actor Brad Pitt, but also promising real insight rather than half a story.

'YEAH, BUT NOEL, BUT...'

When *David Walliams* met *Noel Gallagher*. Portraits by *David Bailey*

NOEL Gallagher, we had heard, was a fan of *Little Britain*, David Walliams and Matt Lucas's award-winning comedy show. So when we were trying to think of someone novel to interview Noel ahead of of Oasis's UK summer stadium tour, Walliams's name cropped up. It turned out that they had met socially a couple of times, but only very briefly – although the comedian had once suffered a nervous encounter with Noel's brother in the toilets at an awards show (as he describes below). For this meeting, they first convened for an exclusive *OMM* photoshoot with David Bailey, who has shot all the greats of British rock and comedy.

As we were waiting for our subjects, Bailey recalled the previous time he photographed Oasis – for *Rolling Stone* magazine in late 1994. 'We were waiting for them to arrive and they had a strop and someone rang and said they're not coming. I said: "Fine, another *Rolling Stone* cover is not going to change *my* life." When they did turn up, they just argued all the time.'

Bailey had never met Walliams before. 'So he's a comedian?' he asked. 'They're always the fucking worst. They're almost always miserable bastards. The only ones that I've ever photographed that I got on with were Morecambe and Wise.' As it happens, Walliams was charm personified,

asking politely: 'Are we doing make-up?' 'Make-up?' snorted Bailey, half-mocking, half-serious, as he grasped Walliams's arm. 'Don't be such a queen! *Make-up!*'

He was similarly frank and touchy-feely with the Oasis guitarist when he arrived. 'Are you still arguing with your brother?' was his opening gambit, as if it was only the other day that he last saw the Gallaghers. 'God, he was a miserable so and so.'

'He still is,' said Noel. 'I remember when we came here. You made us stand over there and said: "So you're supposed to be the new Beatles, are you? Well, you don't look much like the Beatles." And I was a

bit like, 'Who is this guy?' And then you said: "So which one is supposed to be the genius?" and I said: "I am." And you said: "You don't look like a fucking genius."'

In the event, the shoot passed with much laughter. Then Noel and David left in a big black car for the Coronet in south London, where Oasis were playing a warm-up gig that night. Their interview began in the car and continued in the dressing-room as the band prepared for the show. They talked about Bailey – 'You have to say it's an honour,' said Walliams – and the new Oasis album, *Don't Believe the Truth*; and laughed about Robbie Williams, Viagra, and much, much more...

1

Black shirt by **Tom Ford for Yves Saint Laurent Rive Gauche Homme.**

NOT HALF BRAD

written by **Jim Turner** *photographed by* **Tony Duran**

2

3

4

Left Unlike magazines, which can alternate between the two, newspapers are either driven by illustration or text. "There is a difference between the design of a newspaper such as *Frankfurter Allgemeine* (**3**), which is very text-driven, and, say, *The Observer* (**4**), which is more photo/color/illustration-driven in its storytelling process," says Mario Garcia.

Kicker

The content of the kicker (a.k.a. standfirst, sell, deck, or intro text) is textually more important than the headline, for it sets the tone, after the headline, in informing the reader of the story's intention, and acts as the bridge or link, both textually and visually, between the headline and the body copy. As such, it must contextualize the headline, but also summarize and sell the story to the reader in a pithy, arresting way.

Pull-quotes

Pull-quotes are another very useful tool at the designer's disposal when it comes to orienting the reader and breaking up copy to improve readability and make the feature more enticing. The content for pull-quotes is pulled directly out of the copy, or is a summarized excerpt.

Subheads (a.k.a. crossheads)

Subheads can break up dense columns of copy and are most usefully employed in lengthy news items, where continuous copy can be off-putting or a reader may be looking for a particular aspect of a story. Subheads are also useful for denoting a new section, chapter subdivision, or a subject change, and they will help readers find their place if not reading the article in one sitting.

Bylines and credits

The treatment and positioning of bylines and credits should be determined largely by the publication and the importance of these elements to it: A magazine will generally want to flag contributors and staff, particularly if they are using a well-known writer, photographer, or illustrator; newspapers (which used not to have bylines at all) focus on the news, not who is reporting it, so bylines will be smaller on news pages than on feature pages.

Below More and more newspapers are using pull-quotes, a device borrowed from consumer magazines, to catch the reader's eye and also to break up dense columns of body copy, as seen here in Spanish newspaper *El País* (**5**).

5

> "A designer should have a willingness to read the material, to discuss it thoughtfully and passionately, and to develop visual components that expand the read while still working within the publication's architecture."
>
> MARTIN VENEZKY, ART DIRECTOR, *SPEAK*

Body copy

On many titles, a publication's design will draw a readership in, but if the textual content or body copy does not match expectations, sales will fall, advertisers will stop advertising, and the publication could fold. Of course, a publication's content will change to meet trends and remain relevant to its readership, but key to such change is the ability to remain true to the brand and the brand's message, and essential to this is the strength of content, its writers, and its entire staff. The designer's involvement in body copy is, therefore, twofold: He or she must deal with its main requisite and characteristic, using column and font selection to reflect and deliver the brand and the individual content of the story to the reader; but they should also contribute ideas and knowledge of cultural trends to the editorial mix, as this can lead to dynamic content.

1

2

Right Two differing approaches to body copy from two very different publications: *The New York Times Magazine* (**1**) fills the page with body copy yet retains a sense of space, light, and accessibility through its selection of fonts (Cheltenham redesigned by Jonathan Hoefler, Stymie redesigned by Cyrus Highsmith and Matthew Carter, Garamond, and Helvetica). On *Speak* (**2**), Martin Venezky shapes the body copy to create space, but also to create a sense of cohesion across the spread, unifying the various elements.

Panels, box copy, sidebars, and infographics

Panels function as short news items or adjuncts to lengthy articles, where they are used to impart data such as facts and statistics, a case study, or another element that is separate from but still relevant to the main article. Because of this, panel and box copy is usually snappier than the more discursive or in-depth approach of feature writing. This is reflected in shorter sentences, a more factual tone, lots of snippets of information, and elements that break down continuous text into lists, points, and the like. The design should, of course, visualize this snappiness.

Captions

Just as kickers act as the bridge between headline and body copy, captions bridge the image and the text, and are therefore an important design element that requires a well thought-out design solution. There are different approaches to designing captions and their placement (as outlined in Chapter III), but their design will be dependent on the designer knowing what the role and tone of the caption is in the publication.

Folios

Consisting of a page number, the publication's title, and, in some cases, a section or chapter title, folios are an indispensable part of the page furniture, helping

Below Two different successful approaches to box text from *FT The Business* (**3**) and *I.D.* magazine (**4**): Both combine white space, a strong use of eye-catching images cropped and scaled in different ways, color in text, and short paragraphs set in serifs to help create impact.

3

4

to orient the reader in the publication and strengthening the structure of the format, and therefore the brand. On a title where the content is straightforward and direct, folios will not usually be made into a design feature, but a publication whose readers are visually literate will use fonts, weights, and positioning to make folios stand out as design elements in their own right. David Carson, Martin Venezky, and Rudy VanderLans often did this on *RayGun*, *Speak*, and *Emigre* magazines. Many magazines will drop folios on pages featuring full-bleed images. There is nothing intrinsically wrong with this, but too many folio-free pages together might make production difficult for the design team and printer, and make navigation difficult and irritating for the reader. If choosing a left- or right-hand page for a folio, the right is the more visible page.

Image treatment

Imagery and what the designer does with it have an enormous impact on a publication's feel. On design magazine *Metropolis*, for example, stories are dictated by the art received. As Criswell Lappin explains:

> *A piece will not be assigned unless it meets one of three visual standards: excellent photography already exists, scouting shots are provided and we can send our own photographer, or there is enough direction in a story that an illustrator can interpret the piece for us. The last case has to be determined well in advance since it always involves a few rounds of approval. The art department maintains the right to reject a story or move it out of the feature well if we decide the art does not meet* Metropolis *standards. Stories can also originate from art. If we receive a body of work that we feel merits attention, we will assign a story based on the artwork.*

Below Image use on newspapers is becoming increasingly complex. Mark Porter observes, "Now newspapers have to think more and more like magazines in their picture editing. In the past, the priority was to find images that reported events. Now, most readers will already have seen such images in other media . . . Simple factual images can still have value—when they show scenes to which other news media don't have access, or don't wish to cover. But to engage the reader's interest, the choice and use now needs to be more surprising, more allusive, and more thought-provoking. Designers need to leverage the unique qualities of the printed image—scale and detail, and the opportunity for readers to engage with the content at their own pace." In the Dutch paper *Het Parool* (**1**), this is seen to good effect in the culture section, where strong images are placed in such a way as to create a dynamic whole. The image in the middle of the spread pulls the reader's eye into the page, but also offers an unexpected crop that surprises the reader. The photograph in another Dutch paper, *De Volskrant* (**2**), has an undeniable impact and is cropped in such a way as to create a strong narrative.

1

2

Iris Ruprecht at style magazine *soDA* is also well aware of the critical role played by imagery:

> *Our focus is visual rather than textual, which allows us, after setting a concept, to research image-based aspects of it before spending too much time reading tons of books. The image selection we then do is similar to a short trailer of our final work, which we extend and create together with authors from all fields. I think the behaviors of filmmaking and producing a* soDA *issue have a lot in common—to start with a good story or idea, followed by a good casting of authors, a nice production, and proper distribution.* soDA *strongly believes in the reading of pictures.*

Increasingly, newspapers also rely on pictures as storytelling. As more newspapers move from text-driven to image-driven content, their use of all kinds of images—graphs, illustrations, and graphic devices—is growing. But there is a key difference between the use of pictures in newspapers and magazines; as Mario Garcia puts it, "The nature of the content is different; newspapers need imagery that imparts immediacy in contrast to the more relaxing environment for the images that you'd find in a magazine." Production and budget issues are also factors, as time and money spent on images for a newspaper will be minute compared to that of magazines.

Photography

Photography functions as visual reporting or storytelling, and the huge range of contemporary photographic techniques and styles available offers the editorial designer a vast choice of reporters and storytellers. Even if photography cannot be commissioned for financial reasons, the photos that are supplied by a PR agency, or by the subject of the story, can be edited just as text is. Commissioning a visual story or style is just the beginning (*see* p.148 for successful commissioning), for although photographs are taken in a rectangular format, the designer then has the option to crop the image or change the shape, as well as alter tonal values and employ other photo manipulation techniques. All of this is visual editing; just as the editor makes selections and decisions about the copy, so art directors work with the image content of a publication.

But they can go farther than that: If an art editor wants a different perspective on a story, he or she has the luxury of not giving the photographer any information about it, possibly resulting in two very different interpretations (image and text), which can add up to more than the sum of their parts. Just as editing can shape a viewpoint, so can editorial design. The selection, juxtaposition, combination, and positioning of images and text with captions that "tell" viewers what they are seeing can strongly suggest a "truth" that may not be there at all. Added to this is the growing sophistication in photo manipulation (both in and out of camera), which literally changes truth to lies. Hence the intervention of art editor, editor, picture editor, and photographer can result in myriad representations of a story.

Michael Watts, editor of many newspaper supplements, recalls experiences on the *FT The Business* magazine for the *Financial Times*:

Roger Black's ten rules of design

(But remember, rules, once learned, are there to be broken!)

1 Put content on every page. Design shouldn't be mere decoration; it must convey information. Or entertainment. Content should come to the surface on every level. Corollary: Nobody reads anything—at least not everything. The only person who will read every word of what you've written is your mother. All other people skim and surf. So make sure there's content on every page.

2, 3, 4 The first color is white. The second color is black. The third color is red. Calligraphers and early printers grasped this over 500 years ago, and experience has proved them exactly right. White for background, black for text, red for accent and excitement. These three colors are the best. Be very careful with all other colors.

5 Don't be blown around by fashion like a hot dog wrapper in the wind.

6 Never set a lot of text type in all caps. After a while, it's just too hard to read.

7 A cover should be a poster. A single image of a human will sell more copies than multiple images or all type. Always has, always will. Think about why.

8 Use only one or two typefaces. Italian design is the model: a strong sense of a few things that work together. Avoid a free-for-all of multiple fonts/colors.

9 Make everything as big as possible. Type looks great in big font sizes. A bad picture always looks better bigger.

10 Get lumpy! The trouble with most design is it has no surprise. If you want normal people to pay attention, you have to change pace in your presentation. Monotonous rhythms of picture, headline, picture, text, ad, headline, picture, ad, etc., is like a pudding without raisins—a stew without lumps.

ROGER BLACK HAS DESIGNED ROLLING STONE, THE NEW YORK TIMES MAGAZINE, NEWSWEEK, MCCALL'S, READER'S DIGEST, ESQUIRE, AND NATIONAL ENQUIRER, AMONG OTHERS.

Sometimes there were difficulties between myself and Julia Cutherbertson, who ran the weekend paper. She wanted conventional magazine items like food and restaurant reviews, while we wanted something that was visually dynamic and new, reflecting the dot-com boom and the new, cool status of business. The trick was to subvert the genre. On the food pages we photographed food in its raw state, when everyone else was showing cooked dishes. Our picture editor, Caroline Metcalfe, came up with some great food photographers, notably Rob White. Then we illustrated the restaurant reviews—by the very witty Marion McGilvary—with a mixture of maps showing where the restaurant was located, and bills that we reproduced. The combination of all these elements made the mag highly idiosyncratic, which irritated some but pleased many more. It gave it character. And sales of the

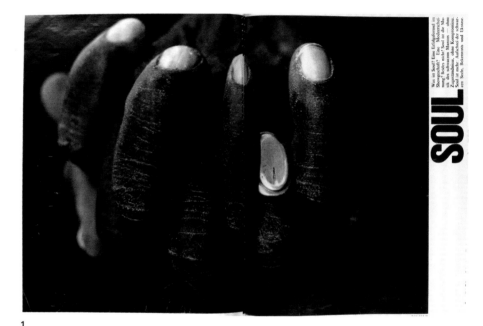

1

2

Right A great photo is the basic requirement for a great image, but equally important are sympathetic and appropriate cropping, scaling, positioning, format, and stock. This image from *Twen* (**1**) is a brilliant image, brilliantly cropped. The images from *soDA* (**2**) derive impact from positioning, stock, and high-quality printing, but mostly from their content.

The Guardian
A declaration of war


3

Left Whereas photography in magazines is as much about image as text, in newspapers imagery is very much used to support text. But aspects of magazine design are creeping in, so that a front page will often use one striking image to attract the eye immediately and communicate something that no words could do, as in this powerful *Guardian* cover of 12 September 2001 (**3**).

Below "The December 2001 issue was our first after 9/11. Because of our two- to three-month lead time, the world had been saturated with images of the Twin Towers being destroyed by the time this issue was printed. We decided not to show any images of destruction but use the space to celebrate the past and look toward the future," says Criswell Lappin, art director of *Metropolis*. This photograph by Sean Hemmerle did just that (**4**).

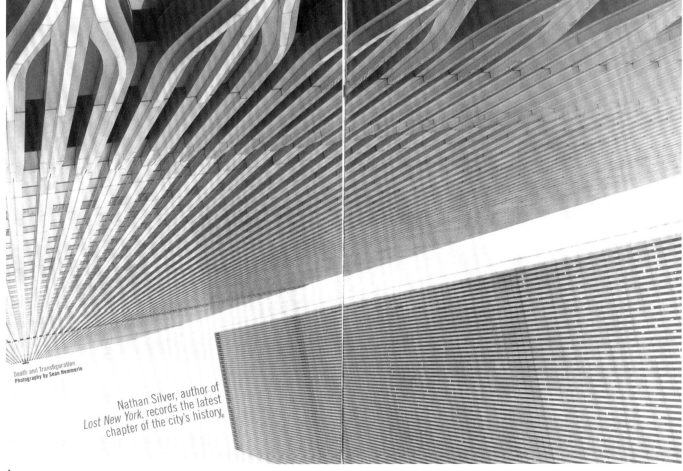

Death and Transfiguration
Photography by Sean Hemmerle

Nathan Silver, author of *Lost New York*, records the latest chapter of the city's history.

4

weekend Financial Times *rose to over the 250,000 mark in my time there —a 20 percent leap. People who never read the* Financial Times *in the week would get it at the weekend.*

Illustration

Mark Porter at *The Guardian* newspaper uses illustration because "it has always been an important part of *The Guardian* visual mix, and by introducing more contemporary illustrators, we have ensured that the paper feels fresh and modern." Other art editors use it when a story demands a conceptual or oblique

Right and below In this July 1967 issue of *Harper's Bazaar* (**1**), a piece on poetry is illustrated with a picture of the score for Karlheinz Stockhausen's "Refrain for the Players, no.11." Art directors Ruth Ansel and Bea Feitler are making the conceptual link between the elegant intricacy and visual lyricism of the score (and the music it represents) and the nature and concept of poetry. It is a brilliant visual metaphor for the article. Newspapers are also increasingly using illustration to give readers a less literal interpretation of a story, as illustrations will offer a different dynamic to a page. Marion Deuchars's illustration for *The Guardian* (**2**) gives breath and life to the page. Its composition and color contrast well with the blocks of text beneath it, while its obvious handcraftedness gives the story something a photo would struggle to do. By choosing to use illustration in place of photography, which is only used for high-gloss, full-color ads confined to two or three spreads in the center of the magazine, first-class Virgin Atlantic fanzine *Carlos* (**3**) "set out to avoid the clichéd world of celebrity-led magazine content, both editorially and visually. Or, in the words of the art director, *Carlos* is 'post-photography'!" says Jeremy Leslie.

1

2

3

interpretation, or there are no good photographic images to be used, or simply to create an interesting and constantly varying dialogue between visuals and text. Illustration can express a concept or feeling more than photography can, because readers often cannot help but attach a narrative to a photograph, particularly if it's figurative. This is because they "read" the photograph literally: "This image is made up of this figure wearing these clothes in this setting doing this thing, therefore I am being told this." But illustration is not read in this way, allowing the story, art editor, and reader to create other, often more expressive and abstract associations. Illustration can also illustrate the zeitgeist in a more obvious way than

4

5

Left Regarding an illustrated spread in *Metropolis*, art director Criswell Lappin says, "If we didn't incorporate the textiles into an illustration (**4**), then we would be left showing carpet swatches, which would be pretty dull. By having Christopher Neal incorporate the textiles into his one-color line drawings, we accomplished two things. First, we made carpet samples interesting to look at without taking away from the product. Second, the illustrations give the viewer information about the product. The environments, while somewhat tongue-in-cheek, indicate the locations that the different textiles are designed for—schools, offices, airports, and so on. I gave Christopher a rough page layout, the approximate size for each illustration and told him which environment went with each textile. Christopher came up with the content of each illustration with little direction. Once he sent me the finished illustrations, I decided to hand-letter the word 'edges' in the headline to reflect what he did."

Left Many editorial publications incorporate illustrations into their design, but none besides *The Illustrated Ape* (**5**), edited by Christian Patterson and Michael Sims, designed by Darren Ellis at See Studio, and illustrated by top illustrators such as Paul Davis, builds its whole *raison d'être* around it. Created by using open submissions from writers, artists, and illustrators, this cultural quarterly of poetry and fiction uses only illustration as its imagery—and more often than not its text, too. The resulting large-scale spreads are rich and textural, and form an intelligent, cohesive whole that always looks fresh.

photography can, and it can be used to support a brand. *The Illustrated Ape* magazine in the U.K. is famed for only using illustration, as is *Carlos*, which retains color photography solely for the ads.

Cropping an image

Cropping, magnifying, repeating, or shooting an image from unusual approaches can have a huge impact on a layout and create original and unexpected perspectives. Techniques such as cropping and magnifying can also concentrate the eye on the portion of an image that contains its essence, or create a meaningful dialogue with the text and, ultimately, a dynamic rapport with the text and layout. If more than one image is used, this rapport becomes more complex, with the need to create a narrative interaction both between the images and between the images and text. American industrial design magazine *I.D.* uses these tools to great effect: By blowing up a product to massive proportions on a page, an everyday item such as a toothbrush becomes a surreal object of beauty whose sculptural qualities are revealed, making for a visually arresting page. Tight close-ups can be equally effective, as can using images to create abstract patterns and focusing on or bringing out an unusual curve, shape, or aspect in an object.

Below On this spread from Japanese magazine *Eat* (**1**), the close-up photograph of the scales of an upside-down artichoke turn what could have been a mundane image into a sculptural, striking graphic. In *I.D.* magazine, the image of a bicycle (**2**), (**4**) works hard to pull two spreads literally and boldly together while also suggesting movement and continuity; in another issue, toothbrushes become abstract transluscent objects (**3**).

1

2

3

4

Creating layouts III

Having established what editorial design is, and how an understanding of it and its components is essential to good design and art direction, we come to a key part of the design process itself: creating layouts. Although there is no magic formula for composing a layout, there are certain considerations that condition the design of an editorial publication. Those dealing with roles, branding, and the publication's identity and readership have already been discussed, but others, such as specific factors (space, amount of copy, cost, time, purpose), required elements (type styles, weights, symmetry, images), and governing principles (styles, techniques) play an equally important part. Combined, all these elements act as guiding principles to the design. The way in which a designer interprets, applies or sets aside these guiding principles is fundamental to editorial design, as is the ability to look at content as shape forms and make the constituent parts work within the proportions of a page—another (usually rectangular) shape.

Principal components of a layout

The components of this layout are contained on two single pages, which, together, form a double-page spread (DPS). Some of these have been defined in Chapter II from a branding and identity point of view; here, they are examined from a visual and layout composition perspective. The illustration opposite shows the component parts, but it also shows the grid substructure, which consists of columns, column gutter, spine gutter, margins, folio line, baseline, and trim area.

Templates

For newspapers and news pages of magazines, flexible templates will speed up the layout and production processes, and give the pages and overall design a cohesion that might otherwise be lost in the frantic days and hours before going to press.

Right Student magazine *Fishwrap* exhibits an interesting relationship between text and image. Layouts are built around the image or text, "with a lot of experimenting with combinations of text inspiring image and image inspiring text . . . We try to hook up writers with artists and designers and encourage dialogue. In this story, the text came first and artists were inspired by the content. The opening image was made by one artist, the designer created the marks and image on the opposite page of that spread in reaction to the art, and the following pages for that story were taken from another artist's sketchbook," explains graphic designer Lisa Wagner Holley.

PLEASE DON'T HAVE SEX WITH MY GRANDMA

In about 15 minutes I'll be landing in Vegas, an hour drive from the home of my nympho grandma. She lives in Pahrump, Nevada, one of the only cities in the U.S. with legal prostitution. I secretly believe that her insurance job is a cover, that she's actually the Heidi Fleiss of Pahrump. Or even worse, that she's a call grandma. She fulfills men's granny fantasies by strapping on vibrating dentures or wearing prune-flavored panties, while they whisper hot love words into her drooping, drop-pearled lobes.

When I was in high school, our house was Grandma's pit stop on the road of potential sales. During winter it was Medical. During summer, Accidental Death. And she said any season was good for selling life. She'd appear at the front door unexpectedly and march straight to my room, where she'd line up rows of her bunion-stretched shoes, anti-aging creams and pill bottles. Each morning she would wake up hours before me to rat her hair vigorously with a metal comb and two-dollar hairspray. I'd walk

Principal components of a layout

The essential elements of a template consist of margins (blue), columns and gutters (green), baseline grid (pink), folio (purple), and bleed area. This template uses a six-column grid, allowing the option of two-, three-, or six-column layouts. The sizes of the margins are integral to creating white space on a page—their size is often influenced by advertising revenues as every extra centimeter can be sold. The baseline grid determines the variations in leading, and consequently type size, allowing the possibility for type of varying sizes to align. This baseline grid is founded on 9-point type on 11-point leading, meaning that all other type sizes need to fit on leadings that are multiples of eleven. The folio is a guide line to mark the positioning of page numbers and sections.

This spread incorporates some of the principal components of a layout. The image, headline, kicker, and pull-quote help to grab attention and provide easy, instant access to the article. The drop cap and folio help guide the reader, while the caption and credit add interest to both image and article. These components, plus color and graphic rules, create variety within the layout.

The headline of this story

This is a kicker. Intended to be read but have no meaning. A simulation of actual copy, using ordinary words with normal letter frequencies, it cannot deceive the eye or brain.

There are many other components that can be included in the design. This spread shows the added use of a subhead, a byline, and sign-off. It also demonstrates the flexibility of the same template, using two columns instead of three, and a varying headline size and color, all of which contribute to creating a different look and feel for this article.

The headline

A kicker is a short summary of the following article allowing quick and easy access for the reader. Often it includes the Author's and Photographer's Names as a byline

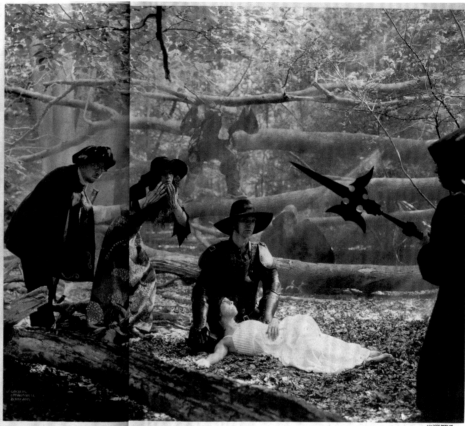

1

2

Above and right Depending on the size of the other components on the page, impact can be created by using a head that is either huge or small, and by placing the headline in dynamic relationship with other items on the page. Elements such as imagery or the content of a headline can be incorporated into the type to unify the whole layout, as with this spread in *The Observer Music Monthly* (**1**). If there is no pictorial image, the headline itself can be used illustratively and visually to create impact and focus. Key to good use of headline type is experimentation. *Fishwrap* (**2**) illustrates this well, with a range of decorative fonts that are created by illustrators making type and designers being inventive with letterform and, in some cases, designing original typefaces for the magazine.

3

Templates simplify all aspects of page makeup, but they can also be restrictive in design terms, and care must be taken to ensure that they don't make pages look too alike. Imagery plays an important part here; subject, crop, scale, and tension can all be used to distinguish pages from each other.

Headline and heading

The title of the story is usually the largest type size on the layout, as its aim is to stimulate curiosity about the feature and tempt you to read on. A headline written before the story gets to the design stage can be helpful in determining a direction for the layout, but different publications construct layouts in different ways. It may be that the designer dictates the headline space by laying out the feature first, in which case the designer may have an input into the content of the text as well as its design. Either way, the content of the headline and its visual representation are interconnected and should be handled as such.

Kicker

As with the headline, the kicker will usually be written by the copy editor and is normally around forty to fifty words in length; any longer and it defeats its purpose, any shorter and it becomes difficult to get the necessary information in and can make the page look unbalanced. It is a good idea to construct a system— or style sheets—for displaying this kind of information rather than applying it on an ad hoc basis, but flexibility and the ability to deviate from the norm when necessary are important, so style sheets should always be used as guiding tools rather than hard and fast rules.

Above This spread from *Inner Loop* (**3**) uses an oversize graphical headline as if it were part of the image. This headline contrasts strongly with the neat, ordered columns of text on the facing page. Interestingly, by aligning columns of text to a baseline, the designer has created the silhouette of an urban cityscape that echoes the facing graphic. The bleeding horizontal rule in the bottom third of the spread unifies the pages, drawing the disparate elements together.

1

2

Above These pages from *El País* (**1**) and *The New York Times* (**2**) illustrate different ways of using bylines. Incorporating such different styles into a newspaper signals to the reader the section they are in: News comment columns tend to be dense with little use of white space, conveying a sense of importance and gravity. In more general comment and debate, bylines can be more engaging through the use of white space and playful pull-quotes. The former signals news, the latter opinion.

Byline

If the name of the author or writer is well-known, it often appears alongside a picture of him or her to form a picture byline. Picture bylines are usually popular with readers and they work well in newspaper design, but in a magazine feature there is a danger they will detract from the many other elements on an opening spread.

Body copy

Text as a component of a layout can be handled in a number of ways. Columns of text are either justified (text filling the column width), aligned left with ragged right, or aligned right with ragged left. Left-aligned text is the most common in editorial because text that is centered or aligned right (ragged left) can be tiring on the eyes when reading large quantities of print. Similarly, column widths should be narrow enough to read easily (*see* Fassett's theorem of legibility, p.122), but not so narrow as to create rivers of white space, which can occur when gaps between words in adjacent lines form distracting vertical shapes. Lengthy blocks of text can be broken up, making overall readability easier, but also making the page lighter and more attractive to the reader.

Toward the end of the production cycle, when all necessary editing, cutting, and changing of copy have been completed, a good designer will manually fine-tune body copy to make it look as appealing as possible. Words may be kerned or lines tracked back to remove a single word at the end of a paragraph (widow), or a single word at the top of a column (orphan), soft returns added to create a better shape in the ragging of the column, or words taken over to improve line lengths and hyphenation inserted in the case of awkward word or line breaks. By looking at the blocks as shapes, designers should be able to use such tweaks to make blocks accessible and appealing.

The Guts of a New Machine

The iPod became an instant classic by combining high design and powerful technology. But as Apple has learned before, that formula alone doesn't keep you on top.

By Rob Walker

This letter T is a broken part of the clip from a clipboard, found outside a warehouse in Austin, Tex.

Right: Inside the iPod are bits and pieces made by a mix of companies but kept shrouded by Apple beneath a veil of nondisclosure agreements.

wo years ago this month, Apple Computer released a small, sleek-looking device it called the iPod. A digital music player, it weighed just 6.5 ounces and held about 1,000 songs. There were small MP3 players around at the time, and there were players that could hold a lot of music. But if the crucial equation is "largest number of songs" divided by "smallest physical space," the iPod seemed untouchable. And yet the initial reaction was mixed: the thing cost $400, so much more than existing digital players that it prompted one online skeptic to suggest that the name might be an acronym for "Idiots Price Our Devices." This line of complaint called to mind the Newton, Apple's pen-based personal organizer that was ahead of its time but carried a bloated price tag to its doom.

Since then, however, about 1.4 million iPods have been sold. (It has been updated twice and now comes in three versions, all of which improved on the original's songs-per-space ratio, and are priced at $300, $400 and $500, the most expensive holding 10,000 songs.) For the months of July and August, the iPod claimed the No. 1 spot in the MP3 player market both in terms of unit share (31 percent) and revenue share (56 percent), by Apple's reckoning. It is now Apple's highest-volume product. "It's something that's as big a brand to Apple as the Mac," is how Philip Schiller, Apple's senior vice president of worldwide product marketing, puts it. "And that's a pretty big deal."

Of course, as anyone who knows the basic outline of Apple's history is aware, there is no guarantee that today's innovation leader will not be copycatted and undersold into tomorrow's niche player. Apple's recent and highly publicized move to make the iPod and its related software, iTunes, available to users of Windows-based computers is widely seen as a sign that the company is trying to avoid that fate this time around. But it may happen anyway. The history of innovation is

Photograph by Richard Burbridge

Above and left Crossheads, paragraph indents, extra leading before a new paragraph, and paragraph breaks are employed to break up text and create smaller, more visually appealing blocks of text than lengthy columns of gray print. However, Janet Froelich of *The New York Times Magazine* (**3**), (**4**) advises designers not to be afraid of such text use: "*The New York Times Magazine* is a reader's magazine. Its mission is to present both text and images that give our readers a deeper understanding of the cultural and political forces at work in the world. To this end writers' and photographers' voices are critical, and the design serves that mission. Large blocks of text have a beauty that our designers respect. When juxtaposed with powerful photography, judicious use of white space, and strong headline treatments, they give the reader a varied intellectual experience."

It looks neater to have at least two lines of a paragraph at the top and bottom of a column—more details on type sizes, leading, and alignment can be found in Chapter IV.

During the 1980s and 1990s it was fashionable to see pages that were built purely around text and typography, and stories that were interpreted through

3

4

III: Creating layouts **79**

Right Text can be used as well as images to illustrate a concept. A conversation can be laid out to be oppositional, confrontational, light-hearted, or animated. Font use, runarounds, shaping, and spacing can all work toward delivering not just letterforms but the tone, content, and style of an article. David Carson famously used dingbats to illustrate the irrelevance of a Bryan Ferry interview in a month when very similar interviews with the star had already appeared in dozens of magazines (*see* p.168), but Vince Frost on *Zembla* (**1**) and Martin Venezky on *Speak* (**2**) illustrate more subtle ways of suggesting expression through body copy layout. Look at concrete poetry and the work of the Dadaists for inspiration.

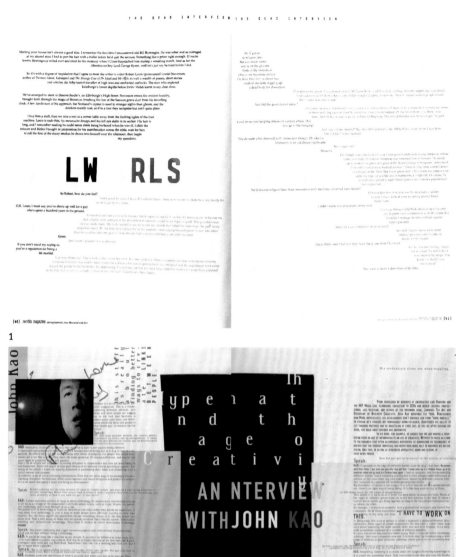

1

2

typography. It takes skill and cooperation between the editorial and design departments to do this well, and a very active engagement with the material on the part of the designer. Vince Frost on *Zembla* went as far as creating shapes to suggest dialogue, and using the language of printing as a visual element— literally, having "fun with words," as the tagline for the magazine states. He says, "There is no point in designing a magazine if you don't like the subject matter."

Drop caps and initial caps
As well as indicating where a story begins, drop caps and initial caps—the former drops below the baseline, the latter sits on it but is bigger than the rest of the body

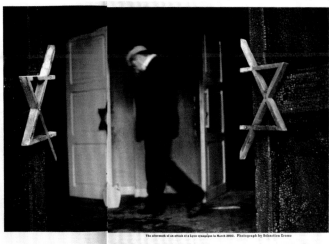

A Frenchman Or a Jew?

Anti-Semitism is again an issue in France, largely as a result of a spate of vandalism and violence by French Muslims. For many French Jews, it has created a climate of fear — and an identity crisis.

By Fernanda Eberstadt

I n a working-class neighborhood of the 20th arrondissement in Paris, on a rainy, leaden-gray morning last month, the housing blocks looked like sodden cardboard. But inside Brigitte Stora's apartment was an explosion of scarlet, ocher and flame gold, of Israeli and North African textiles, of pottery and a brass menorah. Stora, an Algerian-born Sephatic Jew, is a slim, impish-looking woman in her early 40's with a mop of black hair. She was wearing baggy jeans that revealed a strip of designer-style Jockey shorts, and she sewed a ripped camisole as we talked. In the kitchen, her teenage daughter, home sick from school, cooked herself a plate of pasta.

A former Trotskyist who quit a career in journalism to raise her three children, Stora belonged for decades to a political movement devoted to the cause of equal rights for Arab emigrants. French Arabs were her friends and political allies, and the integrated neighborhood in which she chose to live reflected those commitments. In the last three and a half

years, though, Stora's perspective has changed. Since the beginning of the second Palestinian intifada in September 2000 and the subsequent rise of Ariel Sharon to the premiership of Israel, France has suffered what is widely considered the worst epidemic of anti-Jewish violence since the end of the Second World War, much of it at the hands of young Muslims. According to S.O.S. Vérité Sécurité, an anti-Semitism watchdog organization, 147 Jewish institutions — schools, synagogues, community centers, businesses — have been attacked. There have been reported instances of rabbis being smashed. Secondary schoolteachers, under pressure from Muslim students, have canceled classes on the Holocaust. On the last Saturday of January, during a memorial attended by the wife of President Jacques Chirac, a Jewish singer called literal was heckled by a group of French North African youths, who shouted "Filthy Jew! Death to the Jews!"

There are about 600,000 Jews in France — the largest Jewish population after those in Israel and the United States. There is a reason Jews have come to France from places like Eastern Europe or North Africa ever since the French emancipation of the Jews in 1791, the country has — with infamous lapses — provided an enviable model of equality, an enlightenment ideal, enshrined in the French Republic, according to which individual difference is subordinated to common citizenship. But today this ideal is threatened by a tide of ethnic beatenness and challenged by a surge of religious pride and self-identification among France's Jews and Muslims alike.

Although the frequency of anti-Jewish incidents is said to have abated

The aftermath of an attack at a Lyon synagogue in March 2002. Photograph by Sébastien Eromo

3

Left Drop caps can do more than indicate the start of an article, chapter, or paragraph. On this *New York Times Magazine* spread (**3**) about identity crisis among French Jews facing the rise of anti-Semitism, art director Janet Froelich has split the drop cap "I" in two and used it to illustrate that crisis, while echoing the split Star of David in the facing image.

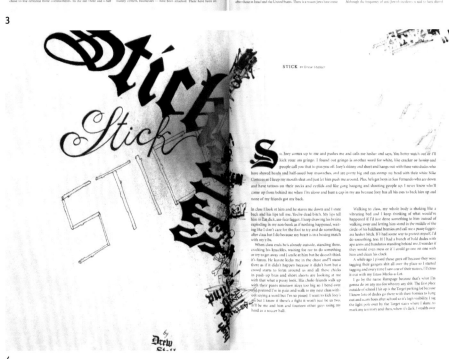

STICK *by Drew Statler*

S o, Joey comes up to me and pushes me and calls me hesher and says, You better watch out or I'll kick your ass gringo. I found out gringo is another word for white, like cracker or honky and people call you that to piss you off. Joey's skinny and short and hangs out with these vato dudes who have shaved heads and half-assed boy mustaches, and are pretty big and can stomp my head with their white Nike Cortezes so I keep my mouth shut and just let him push me around. Plus, he's got boys in San Fernando who are down and have tattoos on their necks and eyelids and like gang banging and shooting people up. I never know who'll come up from behind me when I'm alone and bust a cap in me ass because Joey has all his ces to back him up and none of my friends got my back.

In class I look at him and he stares me down and I stare back and his lips tell me, You're dead bitch. His lips tell him to Eat dick, ass-face faggot. I keep drawing his brains exploding in my notebook as if nothing happened, waiting like I don't care for the food to try and do something after class but I do because my heart is in a boxing match with my ribs.

When class ends he's already outside, standing there, cracking his knuckles, waiting for me to do something or try to get away and I smile at him but he doesn't think it's funny. He karate kicks me in the chest and I stand there as if it didn't happen because it didn't hurt but a crowd starts to form around us and all these chicks in push-up bras and short shorts are looking at me with that what a pussy look. His cholo friends walk up with their pants nineteen sizes too big so I bend over and pretend I'm in pain and walk to my next class without saying a word but I'm so pissed I want to kick Joey's ass but I know if there's a fight it won't just be us two, it'll be me and him and fourteen other guys using my head as a soccer ball.

Walking to class, my whole body is shaking like a vibrating bed and I keep thinking of what would've happened if I'd just done something to him instead of walking away and letting him stand in the middle of the circle of his baldhead homies and call me a pussy faggot-ass hesher bitch. If I had some way to protect myself, I'd do something, too. If I had a bunch of bald dudes with ape arms and bandanas standing behind me, I wonder if they would even mess or if I could go one on one with him and clean his clock.

A while ago I pissed those guys off because they were tagging their gangsta shit all over the place so I started tagging and every time I saw one of their names, I'd cross it out with my fresa Marka-a-Lot.

I go by the name Rampage because that's what I'm gonna do on any mo fos who try any shit. The first place outside of school I hit up is the Target parking lot because I know lots of dudes go there with their homies to hang out and scam hoes after school so it's high visibility. I tag the light pole over by the Target stairs where I skate, to mark my territory and then, when it's dark, I stealth over

by Drew St...

4

Left The initial capital (which is also a partial drop cap) for this spread in *Fishwrap* (**4**) deftly echoes the headline, which, set at a diagonal, directs the reader's eye straight to the first paragraph of text.

copy—can be put into paragraphs to break up copy and avoid a page of monotonous "gray blocks." Drop caps and initial caps can sit within the body copy or outside; they can be enormous, and whole words, or symbols. Thought should be employed when choosing the font for a drop cap or initial cap to complement the rest of the body copy style; it could be a heavy cut of the body typeface or a completely contrasting typestyle, such as an elaborate italic juxtaposed with a clean, modern sans serif.

Crossheads or subheads

These small headings usually sit within the body copy but may be a larger size, bolder, "capped-up" (in uppercase), a color, or set in a different typeface.

Right and below Pull-quotes can be used in a number of ways, from the standard blown-up text, seen in virtually all editorial, to unique ones that visually enhance the content, as shown here in *The New York Times Magazine* (**1**). This issue about Hollywood players featured a cover (by editor Gerry Marzorati) of a ticket line comprised of several high-profile celebrities taking part in that year's Hollywood movies (*see* p.16), backed up by visual devices throughout the magazine such as movie theater tickets used in different ways and pull-quotes. More traditionally, quote marks can be run vertically to create energy or dynamic interest on the page, or run in a blank column to enhance white space as seen here on a spread from *Het Parool* (**2**).

'**I grew up** in the suburbs,' Burton says, 'and somehow if you are deprived of certain feelings, there is a desire to get them out. Otherwise, you feel like you're going to explode.'

1

Quotes, pull-quotes, and sound bites

As with most display copy, pull-quotes are selected by the copy editor, but the design team should have a say in their number, placement, and length. Quote marks form a focal point on a page, and can be used in varying ways to create extra interest. Either single (' ') or double (" ") quote marks can be used, as long as usage is consistent. When the quote is taken from the text but has not been made by an interviewee or subject, quote marks are not usually used. Ways of designing pull-quotes (with or without quotation marks) might include floating text in a box, running them in a separate column, running them as bands across a whole spread, or using them over pictures. In newspapers their use is vital as a device for drawing readers into a news page.

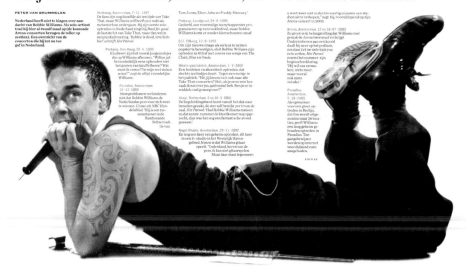

Robbie Williams

Vier avonden de Arena vol met seks, seks, seks en show, show, show

'Hij wil ons vermaken, niet meer, en vooral niets minder'

'Mijn zoontje hoor ik zeggen: Fuck Robbie!'

2

Straplines, section headings, and running headlines

These give structure to the various sections of a publication, identifying or emphasizing what that subject matter, section, or feature is about. Graphics such as lines or rules, blocks, bars, WOBs ("white on blacks"), and shapes can be used to give straplines an identity. A running headline is an abbreviated headline that may appear on further pages of an article, especially if the article continues over several pages, thus reminding readers which story they are reading.

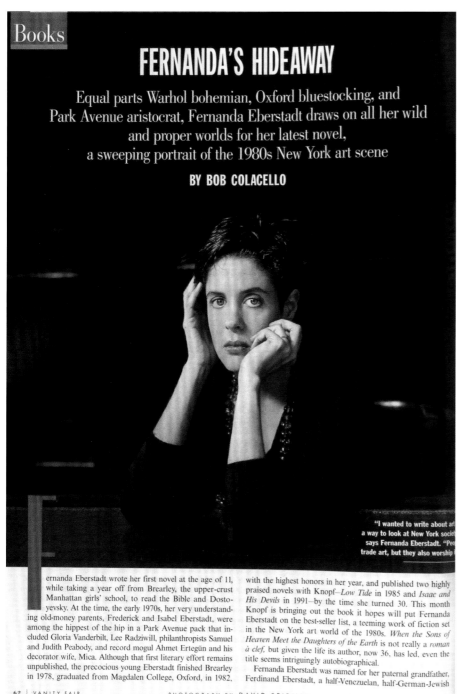

Books

FERNANDA'S HIDEAWAY

Equal parts Warhol bohemian, Oxford bluestocking, and
Park Avenue aristocrat, Fernanda Eberstadt draws on all her wild
and proper worlds for her latest novel,
a sweeping portrait of the 1980s New York art scene

BY BOB COLACELLO

"I wanted to write about ar
a way to look at New York socie
says Fernanda Eberstadt. "Pe
trade art, but they also worship

ernanda Eberstadt wrote her first novel at the age of 11, while taking a year off from Brearley, the upper-crust Manhattan girls' school, to read the Bible and Dostoyevsky. At the time, the early 1970s, her very understanding old-money parents, Frederick and Isabel Eberstadt, were among the hippest of the hip in a Park Avenue pack that included Gloria Vanderbilt, Lee Radziwill, philanthropists Samuel and Judith Peabody, and record mogul Ahmet Ertegün and his decorator wife, Mica. Although that first literary effort remains unpublished, the precocious young Eberstadt finished Brearley in 1978, graduated from Magdalen College, Oxford, in 1982,

with the highest honors in her year, and published two highly praised novels with Knopf—*Low Tide* in 1985 and *Isaac and His Devils* in 1991—by the time she turned 30. This month Knopf is bringing out the book it hopes will put Fernanda Eberstadt on the best-seller list, a teeming work of fiction set in the New York art world of the 1980s. *When the Sons of Heaven Meet the Daughters of the Earth* is not really a *roman à clef,* but given the life its author, now 36, has led, even the title seems intriguingly autobiographical.

Fernanda Eberstadt was named for her paternal grandfather, Ferdinand Eberstadt, a half-Venezuelan, half-German-Jewish

62 | VANITY FAIR PHOTOGRAPH BY DAVID SEIDNER MARCH 1997

Left This "Books" strapline on its red block in *Vanity Fair* (**3**), which bleeds off the top of the page, not only clearly signals which department the reader is in (even when the magazine is shut the red would be visible to the reader), but works harmoniously with the drop cap "F" at the bottom of the page to unify these two graphic elements.

3

vingly real. Genet

: alcohol induced.

y hard way… ❧

1

nphery würde es freuen.
is machen, Clyde — mir ♥

2

ange kann es nicht dauern.
erden wir nach einer Weile
ien Kasten gepackt. ☞

3

Above Jumplines (or turn arrows) and end icons can be emphasized graphically with a box, bullet, or initial from the publication title or other symbol. End icons show the reader the end of the story, and are a good visual guide to the length of an article, as here in *Garageland* (**1**) and *Twen* (**2**), which also used whimsical jumplines (**3**).

 Unsere Stadt ist abgestellt. Alles ist grau und untätig. Ein günstiger Augenblick, um anzu-fangen.
Machen wir uns nichts vor, Clyde — ich weiß, was du über mich denkst. Du hältst mich für eine nette alte Dame, die ihre Tage in der Küche zubringt und an bleichäugige Kinder einge-machte Äpfel verteilt. Aber ich habe in meinem Leben nie eine Küche be-treten, und natürlich gibt es auch kei-

4

Above Along with pull-quotes, there are many other devices for adding visual interest and alerting readers to particularly interesting text. *Twen*, for example, used numerous icons, including a little trumpet that announced a newsworthy item in a column (**4**); and the Internet uses a range of visual indicators that print designers can incorporate into page layouts, including arrows, buttons, and rules.

Icons

If a story is to continue overleaf or elsewhere in an issue, it is helpful to let the reader know by employing either "continued on" and "continued from" lines or some form of directional arrow. This is called a jumpline, turn arrow, or, on a newspaper, a slug. Stories spanning more than one page should break midway through a sentence or paragraph, as a full stop at the end of a page might make readers think they had reached the end of the story. The end of a story should be made clear with an end icon.

Captions

Captions usually appear near or on an image, giving information about either that picture's content, or the reason for the image's presence and its relationship to the story. When there are a large number of images to caption, it can be useful to number each picture and relate it to a list of captions elsewhere on the page. Extended picture captions give additional text information not included in the main body copy. Captions on newspapers are treated as factual matter and rarely stray far from their associated image.

Folios

Folios work as a navigational aid around the issue and so are usually in the same place on each page—either bottom right or middle in order to find and see the number easily. If they are placed near the gutter, flicking through to locate a page can be hard work. Newspapers often put numbers at the top; book folios often incorporate the title and chapter, too. While magazines often drop folios (on full-bleed pictures, full-page ads, etc.), it is vital that a newspaper does not do so (except on ads) in their main news sections. Here, navigation and swift location of stories is key to the reader's experience, so folios must be clear to read and well placed, enabling the reader to flick to a particular story or to one continuing from the front page.

Picture credits

The credits for images normally run on the same page as their image, either running vertically up the side of the image or in the inside gutter of the page. However, if the photographer is well known, his or her name is likely to be treated as a byline or incorporated into the kicker.

Boxes, panels, and sidebars

Rules, color tints, borders, different column widths, and sans serif faces (as opposed to the serif faces often used in feature copy) are traditional ways of handling box or panel copy, either related to a story or being laid out as a stand-alone item.

Images

Images are key visual elements on a page and their relationship to the story is crucial to the design. Either the text is driven by the image or the image illustrates the story; in both cases what is important is to create an interesting dialogue

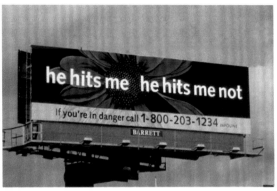

```
1   2   3          3 | Class Action, Yale
    4                  University. 'He Hits Me,
5                      He Hits Me Not'.
                       Billboard project
1 | Lolli Aboutboul: 'A  against domestic
    hungry woman is not  violence
    a free woman', for the  4 | Sheila Levrant de
    UN World conference     Bretteville. 'Pink', 1974
    on Women, Beijing,   5 | Sandra Kelch,
    1995. Photographs by    Cranbrook Academy
    Lana Wong               of Art. 'Bosnian Rape
2 | WD+RU. Team: Siân       Camps', 1993.
    Cook and Teal Triggs.   Postgraduate student
    'Smart Fun', 1996       project
```

6

Left and above There are numerous ways of designing captions, including the caption map seen here in *Graphic International* (**5**) or this discreet list at the bottom of an image page in *WAD* (**6**). Key things to consider are whether a captioning system is going to hamper or constrain your page design unnecessarily, and whether they work. Are they large enough? Will the reader find them easily? Is it clear which item the caption refers to?

5

Left On *Fishwrap* (**7**) all individual page credits are listed on an inventive map at the front of the publication. This approach makes finding credits easy and means they do not have to be incorporated on the highly visual spreads that are a trademark of the magazine. However you handle box text, panels, and sidebars, they must be clearly delineated from running text on the page or other box copy. Here, *Vogue Paris* (**8**) illustrates an excellent way of doing this.

7

8

Below Says Criswell Lappin, creative director of *Metropolis*, "For our first issue after 9/11, Sara Barrett, our photo editor, found this shot from the original construction of the north tower in 1972. I tinted the sky blue to give it a little sense of hope, but other than that the image is unretouched. We knew it was a success because of all the reactions it elicited. People attached different meanings to it, many based on their personal experiences, and it really resonated with what people—both architects and the general population—were thinking. The image references the past and questions the future at the same time. From a distance it looks a bit like wreckage, but once you have it in your hands you realize that it is an image of construction, and with the cover line 'How Do We Begin Again?' it made readers think and reflect. Even David Carson asked me how I photoshopped the image, but we didn't do anything to it except add a little cyan."

between text and visual. Within these two simple functions there are many different ways to approach image use. Martin Venezky on *Speak*, for example, "used design as a device to open up the interpretation of an article … Rather than directly illustrating a story's content, I might develop a visual metaphor as a companion to the text," he explains.

How an image is cropped and scaled, where it is placed in relation to text and other images, and its position on the page or spread all create expression and narrative for the viewer. Faces looking toward the spine create harmony, those looking out draw the eye away from the publication and create tension; if two images face in opposite directions even greater tension is created. A large close-up of a banal image will draw the viewer in, while its contours or shape may create an abstract image that intrigues or surprises.

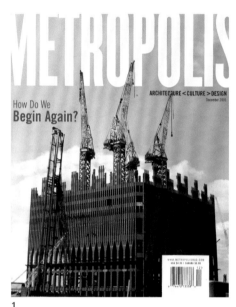

1

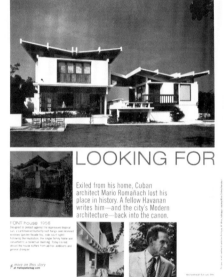

2

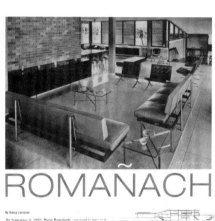

Above right It is important to know when to use images as straightforward illustrations of the text. Criswell Lappin on *Metropolis* (**2**), faced with designing a spread on little-known modernist Cuban architect Mario Romanach, remembers he was "less concerned with the graphic layout reflecting modernism as I was with showing a range of Romanach's work. He was virtually unknown in the U.S., and his architecture says more about modernism than my layouts could. The red tint behind some of the images signifies that a building is in danger or is being destroyed."

Right This layout in *The New York Times "T:Travel" Magazine* (**3**) was constructed around a photo to convey the bleached-out white light of Venice. "I love the Massimo Vitale photograph—inspired by Canaletto, but utterly contemporary. The camp holds true for the typography, with that gorgeous letter 'I' in Fraktur. The formal arrangements just feel very satisfying, and the depth of the image, along with the use of white space and the variations in typography, create a very satisfying page," says Janet Froelich.

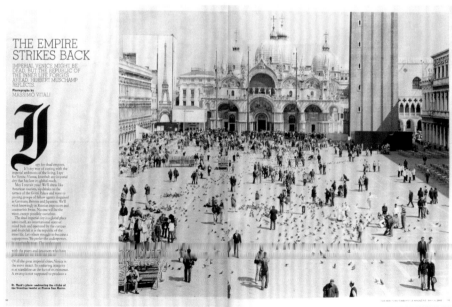

3

WALTER SCHELS

written by Lawrence Schubert

S prechen Sie Deutsch?
You'll have to if you're looking for information about photographer Walter Schels. Even a search of the Internet—the living repository of the ephemeral, arcane, and trivia—yields only German language text. In this fast-moving, short-attention-span world, Schels is a photographer who follows his own path - trends and translations be damned.

Born in 1936 in Landshut, Germany, Schels worked as a shop window decorator for almost a decade before taking up the camera for a career in freelance photography in mid-'60s New York City. Schels was perhaps too formal for the burgeoning school of street shooters dominating the cityscape at the time; he returned to Germany in 1970, set-

tling for two decades in Munich where he honed his skill at portraiture. Newly published with an English text, Schels' latest portfolio, Animal Portraits, elevates the genre to a level previously unattained except in an earlier portrait by fellow German Albert Renger-Patzsch titled "Silver Baboon." Schels' insightful, psychological portraits induce photographer William Wegman, that noted canine portraitist of a Office trainer by comparison. Schels' accomplishment is perhaps demonstrated by its German title, The Soul of Animals. Call him the U. S. king of the animal kingdom—it's only a small exaggeration.

Walter Schels, Animal Portraits (the Same as Time) is published by Edition Stemmle.

Left and below Tension and movement are conveyed in these spreads from *Flaunt* (**4**) and *Harper's Bazaar* (**5**). In the former this is achieved through the donkey facing to the left and using the image as a bleed. This draws the eye out and away from the confines of the page, suggesting movement and space. On the *Harper's Bazaar* spread an interesting discord is created by the positioning of the figures on the stairs. Angles and diagonals create movement, while the positioning of the image on the right, balanced against the full-bleed image on the left, again draws the eye out of the spread.

4

5

Dresses of the night in swaying laces for a newly agile fragility of contrasting skirts, widened tops, bared open footfalls.

Opposite, on the stairs: Red bodice, purple skirt, astonishingly full, driftingly light. *Opposite, kneeling:* Overblouse of turquoise, high in front, cleft deeply in back; skirt of chartreuse. Both by Scaasi, in French lace. At Bergdorf Goodman; Nan Duskin, Philadelphia; Branson's, Chicago; Harzfeld's, Kansas City. Strip sandals by Palizzio. *Above:* Top of royal blue faille, scalloped skirt of flowered black MacCarthy lace. By Talmack. About $225. At Saks Fifth Avenue; Harzfeld's, Kansas City. Sandals by Mademoiselle. Both pages: Bryans stockings; the lipstick is Stendhal's vivid new Seduisant.

Profile: *Flaunt*

Flaunt, a U.S. monthly style title launched in 1998, influenced by 1950s magazine *Flair*, is an excellent example of a magazine that successfully fuses harmony and discord. It is a sophisticated, interactive book, using advanced printing techniques, fold-out articles, beautiful papers, and inserts to create a magazine that surprises but never alienates its readers. Harmony is evident in its handling of body copy and use of imagery, but with each issue its creative team plays with discord through unusual page sizes, unique papers, scale, and use of display texts. *Flaunt* is famous for a daring use of two-part die-cut covers, which changes the normal rectangular format into a playful, interactive experience with windows to open and hearts to peer through, thus echoing the playfulness of the brand.

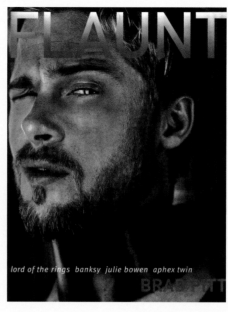

lord of the rings banksy julie bowen aphex twin

Jim Turner, *Flaunt*'s creative director, says: "Our original mission was to create an activity book for adults—something that went beyond the printed page with text and photos, something that would tickle readers, make them look forward to the next issue." Such concepts for the cover and contents would be mere gimmicks were it not for the fact that thoughtful contextualization of imagery and content lies at their heart. "We approach each outside cover every month based on the photograph on the second (inside) cover and what it inspires us to come up with. I simply design to please the eye. It's been called architectural by some people, which is another great interest of mine. I also design interiors, products . . . I feel that a good designer wants to design everything."

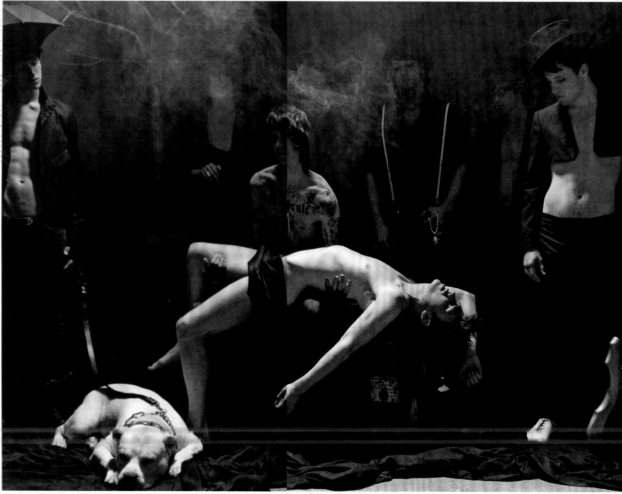

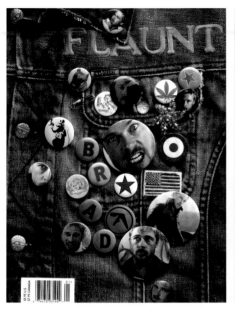

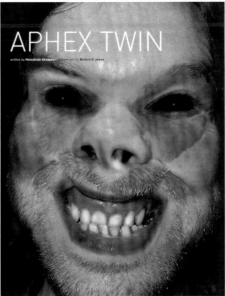

APHEX TWIN

written by *Perachkia Khakpour*, self-portrait by *Richard D. James*

Nobody said Richard D. James, aka Aphex Twin, was easy.

[interview text largely illegible]

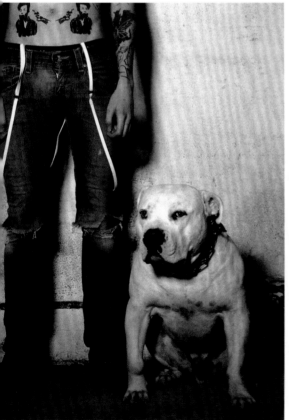

Vintage jeans from Cherry, NY. Pima cotton
Dior Homme by Hedi Slimane. Shoes by Converse

Photographed by Dahlen
Styling: Sam Spector
Hair: Guy Laurent
Makeup: Javier Romero
Prop Styling: Steven Massimo

Flaunt Boy / Age: 23
Birthplace: Portland, Maine
Where you've seen him: He's
half of the duo Dangerous Muse
Current project: The Rejection
EP for Cordless Recordings
www.DangerousMuse.com

Necklace by Goddollars.

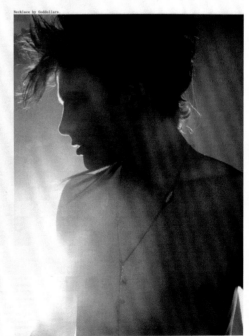

MIKE FUREY

Determining factors in layout construction

The construction of a layout has no magic formula. Essentially, it is about organization, communication, and navigation. It takes in everything from knowing what a planning meeting is for to knowing how much a feature is going to cost, how much time is available for changing layouts, and understanding how the required on-page elements work best together for a particular section's style. Many of these factors will be outside the designer's control, such as budget, space allocation, pagination, and time constraints. This is part of the challenge of any design—finding ways around the boundaries is what makes you creative.

Planning and timeline

All publications have planning meetings or a series of progress meetings. The purpose of these editorial or production meetings is to establish and inform all the editorial departments as to the content and importance of the features for the issue, and sketch out estimates of the amount of space needed for each item or feature. From this information the art department can start to plan how each feature will be illustrated. Visuals might need to be commissioned or sourced and bought. At the same time, the editorial departments will begin researching, writing, and commissioning articles; the technical or beauty departments will start to call in products for testing and photographing; the fashion department will be getting in outfits and organizing shoots. This process is ongoing and fluid— material is constantly assessed, tweaked, or dropped during this period.

The production cycle

For the art department, the production cycle begins when editorial, pictures, and illustrations start to arrive. At this point the process of laying out pages begins. If there is imagery, it is usual to build the layout around this; if not, a focal point can be created by a strong heading. It is important not to detract from or dilute any impact, so avoid elements fighting with each other. Nonprinting areas, or empty space, also create a focus for the eye. Once completed, layouts are passed on to the proofreaders' desks for cutting (if necessary) and proofing. By now, the sections of the magazine will have been defined for the printer's schedule. If the publication is large, these sections may have different deadlines and be sent in a particular order to the printer, with the cover often going last. Sections have to be complete, including advertisements, before they can be printed.

Practical factors

The amount of money the art department has to spend on images, special stocks, inks, and special effects, such as die-cutting, is set well in advance, but exactly how the art budget is spent is up to the art director, who has to make such decisions early on and adhere to them as much as possible, just as the deadlines agreed by the publication and its printer have to be adhered to if the publication is not to miss printing and publication dates. Such time factors may determine the amount of experimentation possible or whether there is time to change a layout if it is not working to a designer's satisfaction. Designers have

Before starting page design

- Gather the copy, illustrative material, and any information from the editorial team, including the most up-to-date flatplan. As the deadlines approach, this will change frequently as more ads are sold or incoming material is found to need more or less space.
- Read the copy so that you understand the article and purpose of the page(s).
- Examine all visuals (illustrations, photos, and any graphics). Are they good enough quality for publication? Remember, digital photographs have to be 300 dpi (dots per inch) to be of satisfactory quality for print; many digital cameras take photos at 72 dpi. Consequently, in converting them, their optimum print size will be reduced to a quarter of the size.
- Make sure you have all the style elements in place, including the template pages of the publication, style sheets, color palettes, and magazine livery.

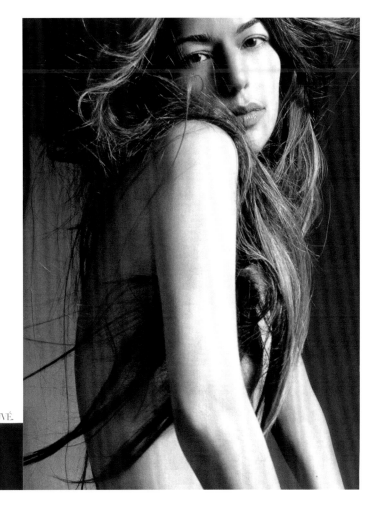

GRANDE
Personne

Fille de Francis *FORD*, monstre sacré, SOFIA COPPOLA s'est taillé un *prénom ET NOURRIT* le *mythe* de la *transmission* du *TALENT* par le sang. CINE-CONTEUSE de vaporeuses *élégies* à la *BEAUTÉ stupéfiante*, la *REALISATRICE* filme comme elle *RESPIRE*. Pas *pour* faire *comme*, mais *PARCE* qu'elle *a* des CHOSES *à dire*.

Par OLIVIER LALANNE. *Photographe* DAVID SIMS. *Réalisation* MARIE-AMÉLIE SAUVÉ.

1

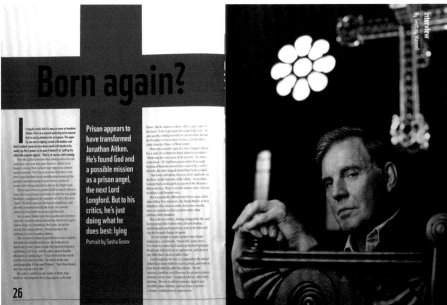

2

Above and left For this *Vogue Paris* (**1**) special issue about the life and work of Sofia Coppola, art director Fabien Baron kept things simple. Sumptuous black-and-white photography by Mario Testino, metallic printing, and a decorative font (Cottonwood) form the bulk of the issue, with space, shape, pagination, and layout construction creating a narrative about the director's life. Gary Cook's layout for a feature on politician Jonathan Aitken in *FT The Business* (**2**) uses the negative space of the underlying grid wittily to convey the religious theme of the article, and to tie the text page to the image to unify the spread.

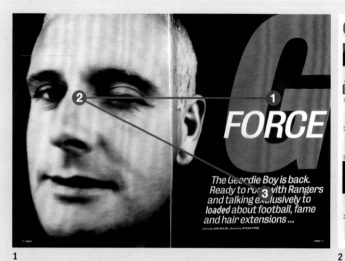

1

2

While there are no definitive rules about how any individual will scan a page or spread, the use of visual hooks, whether in the images or text, will often determine where the eye starts its journey. The eye is drawn to the oversize "G" in this layout from *Loaded* (**1**) because of its dominant size and color, then follows the horizontal serif of the letter to footballer Paul Gascoigne's eye, then finally moves to the smaller kicker text. In this complex spread from Dutch newspaper *Het Parool* (**2**), the eyeline of the subject of the main photograph is linked up to the running head, and the reader's attention then moves through the other elements, often following the vertical and horizontal dominance of the grid—*see* p.66 to view this page without guides.

an entirely personal method of coping with the constraints of tight deadlines. Some get the overall design established on the page, then tweak boxes, type, and color until they are entirely happy. Others will keep starting a fresh layout, saving different versions until they are happy or until time runs out. Similarly, the running order of the pages and number of pages available to editorial are set by the publisher and/or editor, and are usually tied to the advertising sales; pages are sold to advertisers against a particular section or feature, and a publication will have an editorial/advertising ratio, so if ads are added, dropped, or moved, editorial pages are lost, gained, or shifted accordingly. Again, this can have a big impact on design if, for example, a five-page feature has to be shrunk into three pages.

Design factors: spatial issues

The demand from contemporary readers is for a publication to be portable in size and format, and flexible and varied in its content—a publication that can be dipped in and out of randomly. This is reflected in the design by the use of imagery, display copy, colored headings, boxed type, bullet points, and lists. A publication that tends to run text-heavy articles will probably use white space to counterbalance the gray effect. All these devices take up space, but a balance of text, images, and graphic elements must be achieved.

The number of words for an editorial page is usually predetermined. If the story has been massively overwritten and the page becomes impossible to design, the copy editor can usually cut copy to a reasonable length. Occasionally,

1

2

a feature might need to be designed before the words have been written, or be completely design-led. In this case a word count is decided on and the piece written to length. The format of any illustrative material must also be taken into account. If the illustration is a digital image, it may have to be used at a certain size; some photographs are grainy and any enlargement would emphasize this, which may not suit the magazine's style. Sometimes when journalists are writing articles they come across information that should be emphasized to make better sense of the copy, or the picture research team may have negotiated to print a picture at no bigger than a couple of columns. This sort of information may well be supplied at the last minute and it will have some degree of impact on the design.

One spatial issue that is particularly relevant to newspapers is that of horizontal and vertical designing. Until the mid-twentieth century, many newspapers were designed with multiple-deck, one-column headlines that created pages with long, thin, ruled columns, which often made legibility very difficult, and also gave the paper a dense and unappealing appearance. Developments such as the growing use of wider columns and margins, along with the rise of tabloid newspapers and other smaller formats, have pushed newspapers to adopt a more horizontal design, which is more appealing visually and also easier to read. Even in the narrow Berliner format, designers can still create horizontal design through the use of headlines and stories spread across multiple columns that lead the viewer across the page rather than up and down. Where vertical designs are being used, it is important to allow enough margin width to ensure good legibility and to lighten the overall look of the page. White space and blank columns can also be added to further heighten the sense of space and legibility.

Where to place items

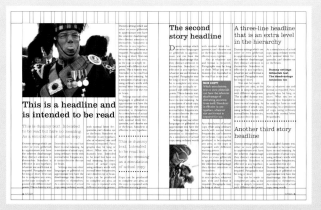

The placement and design of copy can communicate and influence the reader. Deciding whether to give an article an entire spread or place it among two or three others immediately signals its importance to the reader. Here we see one article with a full-bleed image, large headline and kicker, wide column setting, lists, strong color, and lots of white space—all this attempts to stimulate interest and entice the reader.

In contrast, this layout demonstrates how the same article, designed another way, can send out different signals. Here it is laid out not as a feature but more as a news story. With text filling the spread from top to bottom, smaller headlines, a narrower column measure and less white space, the article is reduced in priority and importance. However pull-quotes, boxes, bullet points, and color all help in catching the eye and drawing the reader in.

A newspaper's selling point is often its front page. For this reason it must be prominent on a newsstand. The size and placement of a masthead, images, and headlines are integral to the newspaper's salability. The design of a front page is often created in response to having either a great image or a great headline available, and their respective ability to grab attention.

On a page with multiple stories, the positioning of text and other elements guides the reader's eye around the page. The main story is signaled to the reader by being placed at the top of the page, with the largest headline, image, and kicker, and the widest column measure. In contrast, the other two articles are across a six-column measure, with no kickers, and both utilize a much smaller space on the page. Hierarchy between these two articles is communicated by the headline size, image, and amount of space used.

Design factors: the dominance of shape

A large proportion of editorial design is the organization of shapes to support the written word within the confines or parameters of a publication's style. Mark Porter of *The Guardian* describes it as "being in charge of the distribution of elements in space," these elements being headlines, text, artwork, and white space. The way these shapes are organized creates the difference between a satisfactory and an unsatisfactory layout. Used well, shape distribution can be used to lead the reader's eye through an article as well as navigate around the page, and create a wide range of feelings and meanings.

If you look at a layout and half shut your eyes, you will see all its elements in the form of shapes. Type blends into gray blocks, illustrations and pictures form squares

1

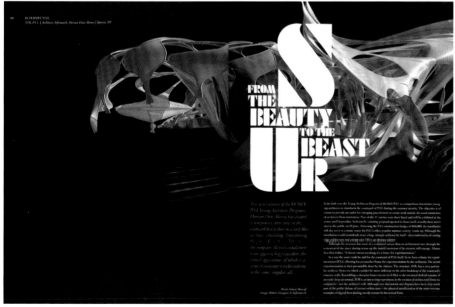

2

Above and left Establishing a visual dialogue between image and text is an excellent way of creating structure and shape in a spread, as seen on these examples from *Inside* magazine. On the Zaha Hadid feature (**1**) Jeffrey Docherty used the shape of the architecture as the layout's determining factor. "I have a true respect for architectural photography. I find myself shying away from the placement of type over an image. I prefer to show images as if they were artworks, framed and unhindered. There are exceptions in which an image or a story can benefit from the combination of the two. In these instances, the type may provide structure or a dynamic twist to the image. However, finding the right spot for text is vital. The obvious spaces can be boring, so finding a dynamic fit of text and image can be challenging. Too often, I observe design blindly giving in to current trends and style. Design is all about finding the proper balance. Learning to exercise restraint is a design quality rarely considered."

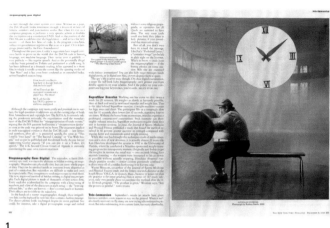

1

2

3

Above and right Three different ways of using shape to create pleasing spreads. For the "Year In Ideas" issue of *The New York Times Magazine* (**1**), which was designed to present the best ideas, inventions and schemes in an encyclopaedic fashion, Janet Froelich was inspired by nineteenth-century illustration conventions, and "chose the photographer Rodney Smith for his ability to build on those visual ideas to create images that felt like explanations without really being explanatory." The combination of imagery, white space and indented text intelligently and wittily plays on the encyclopaedic form, and creates a harmonious and delightful spread. For a piece on the new Boeing offices, Criswell Lappin at *Metropolis* (**2**) simply created archetypal plane shapes from image and text boxes to visualize clearly the content, but also to create interest and reader recognition. In *I.D.* (**3**), a visually intriguing spread is created through the graphic pattern of the images, which are balanced well against the white space and chunky blocks of the text page.

or rectangles with the occasional irregular shapes of cutout pictures or decorative type. If you continue to keep your eyes half shut, you begin to see how these shapes work together and connect to form other shapes or strong diagonal lines. White, or nonprinting, space also produces shapes. These shapes create balance, harmony, or discord. Creating patterns with shapes helps to give the layout flow.

Shapes in a layout have to fulfill two functions: first, all the above shapes have to work together on the page area; second, the contents within the shapes have to work directly with the page layout. Shape organization and coordination are key techniques for creating a satisfactory layout and, through variation in the shapes, an essential factor in making features distinct from each other. By organizing shapes in this way, the designer can draw the viewer's eye to a particular point on a page— it might be the largest image, the loudest color, or the oddest shape, and for this reason designers use many tricks with their palette of shapes to create interest.

Design factors: shape as a classical proportion

Whether through custom or an innate sense of balance, convention tends to favor

Profile: *I.D.*

Since its inception more than half a decade ago, American design magazine *I.D.* ("The International Design Magazine") has benefited from a totally collaborative approach to its production and creative process; the editorial team and art team work closely not only to realize content, story direction, and ideas, but to find these in the first place. Such an approach is not unusual in contemporary magazines, but *I.D.* is unusual in pioneering it and succeeding in keeping it fresh and innovative, so much so that it has won many design awards over a number of years. Its clean, simple, and timelessly classic design ethos bucks trends but always remains contemporary and fresh, managing to convey enthusiasm and professionalism without being slick or shallow. It is particularly strong in its use of imagery that is playful and witty but never undermines the content of the images, and in the bold way its designers scale and crop images. News pages are lively and well paced, and the grid enables versatility in layouts, so that the magazine's different sections are strongly signposted. The great advantage of having a close collaborative approach to the magazine, believes art director Kobi Benezri, is that "It gets the designers involved in the editorial content as much as the design. The design direction has to have a strong relation with the content it is illustrating, and there is constant discussion of materials, story ideas, editorial calendar planning, and every editorial aspect. Many times I select a photographer for a particular feature based on who the writer is because I know that he or she would fit the style of writing. Or in some cases the story would take an angle that could work well with the design direction we've established. The design of the magazine (hopefully) plays an important role in communicating what the magazine is about and what we believe in."

The International Design Magazine

$5.95 US · $8.50 CAN SEPT/OCT 1999

Special Issue
MY HOME TOWN: **Penn Jillette** on the Design Capital of the Universe
WET DREAMS: **Sin City's Greatest Obsession**
FEED ME: **The Science of Slots**

1999 NATIONAL MAGAZINE AWARD
WINNER
GENERAL EXCELLENCE

Loving Las **Vegas**

COMAG £5.00
INTERNATIONAL
DESIGN SEP/OCT 99
9 770894 537036
www.magazinecafe.co.uk

Token Gestures

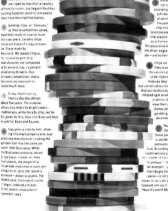

Casinos need chips—and lots of them. A large new casino typically places an initial order of 500,000 chips, and several orders like this will have the entire industry backed up for days or even weeks. As the gambling adage goes, the person who invented poker was smart, but the person who invented the chip was a genius. Linda Rattner examines the $25-million-a-year chip industry. Photography by Davies + Starr.

III: Creating layouts **97**

Golden rectangle

To make a golden section from a square, divide the square in half. The diagonal of this half square is rotated to the horizontal, defining the length of the rectangle. If a square is added to the long side of the resulting rectangle, a new golden section is then formed.

certain classical proportions. The most famous of these in editorial design is the golden section, which is defined by the ratio 1:1.618, or a height of 16.2 and a width of 10. This shape is thought of as pleasing on the eye and can be seen in many layouts.

Design factors: shape through color

Shape is often used to break up the monotony that might be created by a page that is type-heavy. This can be done with photographs, illustrations, decorative type, white space, and blocks of color, tones, or the text itself. Tonal shapes are effective in separating, organizing, or pulling elements together, and psychologically, the text appears easier to read when it is broken into smaller chunks. Color can add meaning to a layout by linking elements together through colored headings, borders, and rules. The eye is very sophisticated in its ability to make connections by the use of these types of signposts.

Designers should not be afraid to experiment with color, both in terms of the palette and its use in a publication. As Mario Garcia says, "Color is such a personal issue. We think that readers today like vibrant colors and don't necessarily equate them to vulgar or downmarket. For example, for years the handbag maker Louis Vuitton made bags in brown, now LV bags come in yellow, lime green, and pink." Garcia's use of bold colors in *The Observer* newspaper, both as navigation tools and layout elements, has made this Sunday title vibrant, broadening its appeal to a younger audience. "In surveys, readers like color and color coding, and I do too. It organizes things at a visual and practical level," says Garcia. He suggests using one palette for coding and another for the rest of the colors in the publication.

Design factors: tension

Tension can be used to great effect in supporting an editorial stance, and is created by the shape of elements and their relationship to each other and to the edges of the page. For example, elements can be positioned to create a

Right Using the diagonal eyeline in the photograph as the basis for the design of the spread, *RayGun* (**1**) creates a pleasingly off-kilter layout. The effect is heightened by repeating and rotating the outline of the photo.

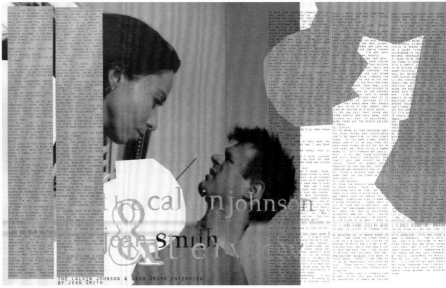

1

diagonal movement, leading the eye to other shapes or to other areas of the page, while bleeding an image or text off the page can create a dynamic effect. Tension can also be created by the use of color. Images used in conjunction with each other can repel or attract other elements and shapes by their color or tone.

Design factors: repetition and flow

On many titles a visual continuity or repetition forms the central essence or identity of the publication. In the case of repeated tones or shape, these are usually built on a grid structure or alignment (for more on grids, *see* Chapter IV) to maintain harmony throughout the publication. Other factors that reinforce repetition and flow are the positioning of typography, visuals and graphic devices

2

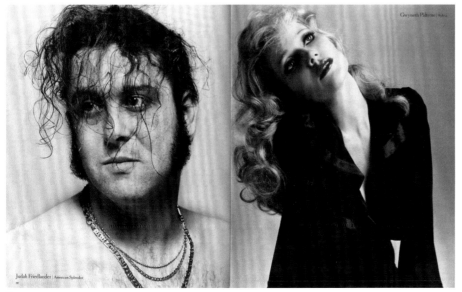

3

Left *Esopus* (**2**) uses a huge, predominantly red image to create an uneasy, unsettling spread that is gripping and filmic. *The New York Times Magazine* image below (**3**) illustrates how two figures looking away from each other and out of the spread, rather than into the spine, create tension.

Right *I.D.* magazine (**1**) uses rules, scale, color, and typography to ensure that each department and the pages within those departments have their own identity and character. On *Metropolis* (**2**), the color barcodes Criswell Lappin employs as an iconic reference to the retail industry also give the theme of shopping a distinct identity. "Since we were covering a variety of shopping environments, we needed a symbol that could represent them all. Each barcode is used to signify the different categories of new retail environments that we covered."

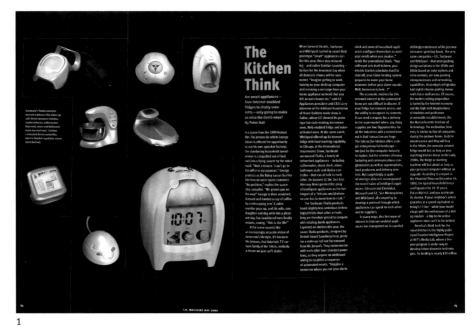

1

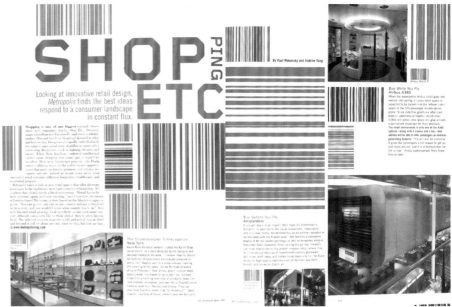

2

such as sidebars and rules, and their respective colors and sizes. All these elements enable the designer to construct a flow of layouts that is consistent but allows for variation and fluidity, as repetition on every page is rarely desirable in any publication (even a phone book is varied with the use and placement of display ads and different weights of fonts).

Design factors: experiments with scale

Scale is used to guide the viewer's eyes through the article, provide visual interest, and dramatize or emphasize the editorial message. One large word in a headline can change or skew the emphasis and meaning of the whole page, an effect that can also be achieved with images. Scale is relative, it creates a

hierarchy, and there are many situations where this would be entirely appropriate—for example, in an article that contained both main and subsidiary elements. But it has a visual purpose, too, making the page lively and creating interesting blocks and shapes. The content of the publication plays an important part in sizing and use of visual material. For example, a travel magazine will often use full-bleed pictures to create a feeling of expansiveness and to help fulfill the dream of being in that location. If the picture were smaller, it wouldn't evoke the same response or desires.

Design factors: contrast

There are occasions when it is appropriate to illustrate an editorial piece with subtle contrasts in size of the design elements, but this must be done with caution, as it might make the design look tentative and weak. It is more usual to illustrate designs with extreme contrast—one large element balanced against several small ones. Imagery and its sizing are always affected by the relationship to other items on the page or its boundaries. Imagine sizing an image of a tomato slice so that it bleeds off all the edges. It would take on a completely different look if the same image were used in a sidebar the size of a thumbnail.

Design factors: balance

In design terms balance is very important. It can be achieved in a number of ways. Symmetry or an equal number of items are literal examples of balance that are not always successful if they create little or no dynamism, tension, or contrast. Experimentation with balance can create a relationship that strengthens the design. For example, balance might be achieved in an asymmetrical way: One large image could be counterbalanced with several smaller ones or a larger, dark picture.

3

Above On this money-themed issue of *WAD* (**3**), the tiny Monopoly car works as an instantly recognizable icon of capitalism, but also creates a bold and distinctive layout.

Below One image, two extreme crops (**4**), (**5**), show how very different responses, balance, and expression can be conveyed through intelligent cropping. Contrasting sizes, colors, and scales can produce a very graphic effect, almost becoming a pattern, as is demonstrated on this page of *I.D.* (**6**), which turns a page on wallpapers into a very graphic form of wallpaper of its own.

4

5

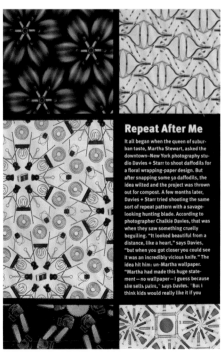

6

Right Two different forms of balance on a spread: *Flaunt* (**1**) simply balances the two pages on the horizontal diagonally; *Dazed and Confused* (**2**) creates a filmic storyboard.

1

2

Balancing the elements of a layout is individual to the designer, but key to doing so successfully is ensuring that one side of a layout is given equal weight with the other.

Design Factors: depth

Spatially, working in print is limited to two dimensions, though the illusion of depth can be created through production techniques such as die-cutting, embossing, and the use of metallics and fifth colors. But it can also be achieved through the arrangement of the elements on the page. For example, skillful overlapping of the design elements—shape, type, and color, in particular— can make pages stand out or even "jump" out at the reader.

3

If any father has been forsaken by his children, it is Thomas Paine. Statues of the man should greet incoming journalism students; his words should be chiselled above newsroom doors and taped to laptops, guiding the communications media through their many travails, controversies and challenges. Not so. A fuzzy historical figure of the 1700s, Paine is remembered mostly for one or two sparkling patriotic quotes – "These are the times that try men's souls" – but little else.

Yet Thomas Paine, Professional Revolutionary, was one of the first to use media as a powerful weapon against an entrenched array of monarchies, feudal lords, dictators, and repressive social structures. He invented political journalism, creating almost by himself a mass reading public aware for the first time of its right to read controversial opinions and to participate in politics.

Between his birth in 1757 and his death in 1809, enormous political upheavals turned the Western World upside down – and Paine was in the middle of the biggest. His writings put his own life at risk in every country he ever lived – in America for rebellion, in England for sedition, and in France for his insistence on a merciful and democratic revolution. At the end of his life, he was shunned by the country he helped create, reviled as an infidel, forced to beg friends for money,

His **Rights of Man** was a clarion call for universal democracy.

His **Common Sense** inspired Americans to independence.

The Age of Paine

He died 186 years ago. So why should **Thomas Paine** be adopted as the patron saint of the age of information?

Jon Katz on an old hero for a new era..........

denied the right to vote, refused burial in a Quaker cemetery. His grave was desecrated. His remains were stolen.

A popular old nursery rhyme about Paine could as easily be sung today:

Poor Tom Paine! there he lies:
Nobody laughs and nobody cries.
Where he has gone or how he fares,
Nobody knows and nobody cares.

Certainly that's true of today's media. The modern-day press has become thoroughly disconnected from this brilliant, lonely, socially-awkward ancestor who pioneered the concept of the uncensored flow of ideas and developed a new kind of communications – journalism – in the service of the then-radical proposition that people should control their own lives.

In the US, his memory has been tended in the main by a few determined academics and historians, and a stubborn little historical society in New Rochelle, NY, where he spent most of his final, impoverished days. In Britain, the Thomas Paine Society (president, Michael Foot MP) is widely regarded as no more than a harmless hobby for old lefties.

But if journalism and the rest of the country has forgotten Paine, why should we remember another of history's lost souls?

Because Paine is for the taking and he is worth having. If the old media – newspapers, magazines, radio, and television – have abandoned their father, the new media – computers, cable and the Internet – can and should adopt him. If the press has lost contact with its spiritual and ideological roots, the new media culture can claim them as its own.

For Paine does have a descendent, a place where his values prosper and are validated millions of times a day: the Internet. There, his ideas about communications, media ethics, the universal connections between people, the free flow of honest opinion are all relevant again, visible every time one modem shakes hands with another.

The Net offers what Paine and his revolutionary colleagues hoped for in their own new media – a vast, diverse, passionate, global means of transmitting ideas and opening minds. That was part of the political transformation he envisioned when he wrote: "We have it in our power to begin the world over again." Through media, he believed, "we see with other eyes; we hear with other ears; and think with other thoughts, than those we formerly used."

Tom Paine's ideas, the example he set of free expression, the sacrifices he made to preserve the integrity of his work, are being resuscitated by means that hadn't existed or been imagined in his day – via the blinking cursors, clacking keyboards, hissing modems, bits and databytes of another revolution, the digital one. If Paine's vision was aborted by the new technologies of the last century, newer technology has brought his vision full circle. If his values no longer have much relevance for conventional journalism, they fit the Net like a glove.

Paine's life and the birth of American media prove that information media were never meant to be just another industry. The press had a familiar and profoundly inspiring moral mission when it was conceived: information wants to be free. Media existed to spread ideas, to allow fearless argument, to challenge and question authority, to set a common social agenda.

Asked about the reasons for new media, Paine would have answered in a flash: to advance human rights, spread democracy, ease suffering, pester government. Modern journalists would have a much rougher time with the question. There is no longer much widespread consensus, among practitioners or consumers, about journalism's practices and goals.

Jon Katz can be e-mailed at JDKatz@aol.com

Illustration by Mark Sommers

WIRED APRIL 1995

4

Above and left Skillful conveyance of depth can be created through background and foreground color use, as seen here in *Wired* (**3**). On *Metropolis* (**4**), Criswell Lappin demonstrates a great way of enlivening a feature on door handles by making their appearance three-dimensional.

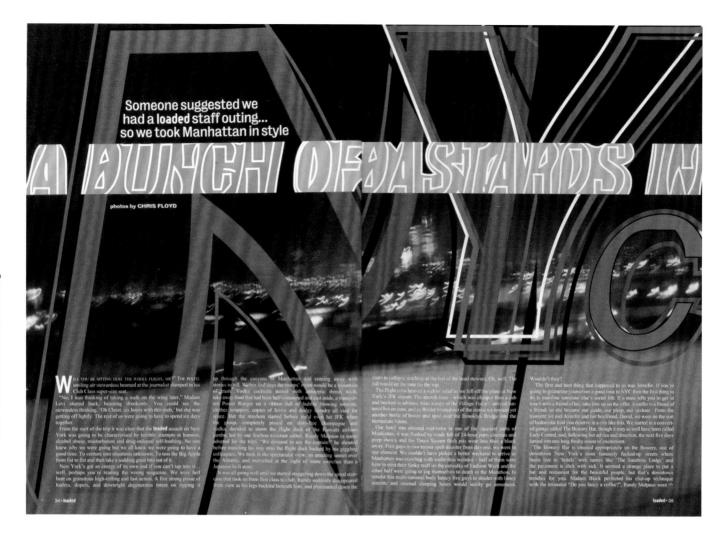

Someone suggested we had a **loaded** staff outing... so we took Manhattan in style

photos by CHRIS FLOYD

Above In the 1990s, *Loaded* magazine was particularly skillful at implying motion through a combination of headline manipulation, full-bleed images—using a long exposure to heighten the sense of speed—and scale.

Implied motion

The projection and interpretation of movement onto a two-dimensional page is a substantial challenge. The effect is often created using the photographic techniques of double exposure, multiple printing, blurred motion, or the use of multiple sequences of stills in a line.

Harmony and discord

Depending upon a publication, design can be conservative or cutting-edge. Creating a visual balance or disturbance on a page is often left to the individual instinct, training, and experience of the designer, who will make the elements of a layout either complement or compete with each other in order to create harmony or discord. In philosophical terms, the clash between harmony and discord goes beyond mere style and echoes the great divide between the two streams of human history, thought, and development—the division between the classical, ordered organizer and the rootless, restless romantic. The competition and compromises between these extremes makes for a creative tension that may never be resolved.

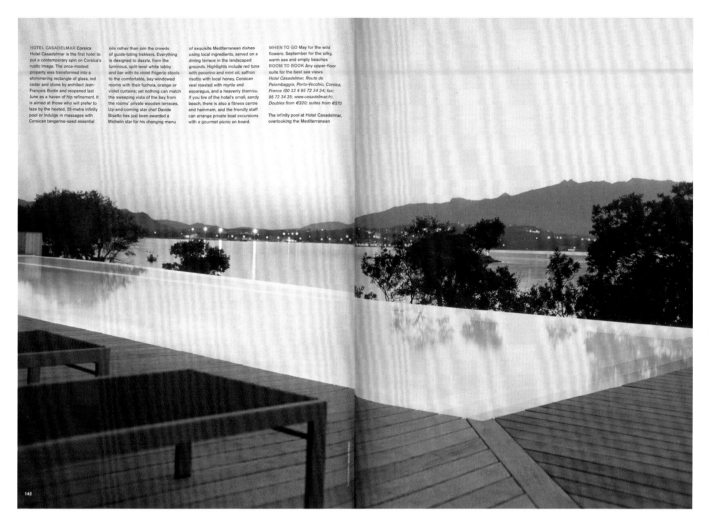

HOTEL CASADELMAR Corsica Hotel Casadelmar is the first hotel to put a contemporary spin on Corsica's rustic image. The once-modest property was transformed into a shimmering rectangle of glass, red cedar and stone by architect Jean-François Bodin and reopened last June as a haven of hip refinement. It is aimed at those who will prefer to laze by the heated, 25-metre infinity pool or indulge in massages with Corsican tangerine-seed essential oils rather than join the crowds of guide-toting trekkers. Everything is designed to dazzle, from the luminous, split-level white lobby and bar with its violet Frigerio stools to the comfortable, bay-windowed rooms with their fuchsia, orange or violet curtains; yet nothing can match the sweeping vista of the bay from the rooms' private wooden terraces. Up-and-coming star chef Davide Bisetto has just been awarded a Michelin star for his changing menu of exquisite Mediterranean dishes using local ingredients, served on a dining terrace in the landscaped grounds. Highlights include red tuna with pecorino and mint oil, saffron risotto with local honey, Corsican veal roasted with myrtle and asparagus, and a heavenly tiramisu. If you tire of the hotel's small, sandy beach, there is also a fitness centre and hammam, and the friendly staff can arrange private boat excursions with a gourmet picnic on board.

WHEN TO GO May for the wild flowers; September for the silky, warm sea and empty beaches ROOM TO BOOK Any upper-floor suite for the best sea views *Hotel Casadelmar, Route de Palombaggia, Porto-Vecchio, Corsica, France (00 33 4 95 72 34 34; fax: 95 72 34 35; www.casadelmar.fr). Doubles from €320; suites from €570*

The infinity pool at Hotel Casadelmar, overlooking the Mediterranean

Achieving harmony

Harmony in editorial design can be achieved in several ways. Design purists in the Bauhaus and Swiss movements believed that a harmonious design should feature:

- an even gray, with no superfluous "tricksy" elements such as oversized drop caps to detract from the classical feel of the layout;
- a calm, rigid typographical grid;
- an unfussy sans serif typeface throughout;
- small body copy;
- leading that strengthens overall visual quality and does not draw attention to itself, but is never so wide that the white space conflicts with the copy;
- headlines set in the same typeface as or in a bolder version of the body copy, at just a few point sizes larger;
- margins wide enough to differentiate text boxes clearly, but not so wide as to appear ostentatious or wasteful;
- any extra material such as running heads or folios following the overriding principles already described;

Above Images can be the anchor for a harmonious design, as seen in this *Condé Nast Traveller* spread, in which the long line of perspex in the foreground is mirrored by the body of water in the background. The full-bleed off the spread creates a sense of space which the placement of the text does not hamper.

- photographs anchored by placing them across the column grid at one-, two-, three-, or four-column widths exactly, horizontally aligned with other elements;
- white space used carefully to create breathing space and balance.

On such a layout, the overall feel is one of regularity and evenness with no jarring elements. This is often seen at its best in book and catalog design. But as anyone who reads editorial knows, magazines and newspapers rarely follow such a style because they need to highlight content in different ways and to create hierarchies and visual excitement. They do this by marrying harmony with some discord, creating a unity of opposites.

Fusing harmony and discord

Contemporary readers schooled in a visual style derived from television and the Internet as well as from printed matter respond well to elements of discord in layouts, and many contemporary publications now fuse aspects of both in the same package. Harmony can be achieved by using common elements—a running headline, a distinctive folio, the application of Bauhaus principles to text—and mixing them with the discord created by typefaces that change and clash frequently, or by a conflict of shapes and balance, or by the way text is handled. Text can be hand-produced, scribbled over, cut up, and generally distressed and damaged. Text boxes can be angled, oddly shaped, or overlaid. Drop caps can be half a page high. Beautifully considered type may be deliberately rendered almost illegible by being printed in yellow over the yellow dress of a model in a photo feature. Whatever mixes are applied, the effect should not be one of anarchy but of excitement, interest, and freedom in order to communicate meaning in some way. Such an approach can help give a publication an identity that makes it stand out from the crowd.

Overthrowing harmony

Why do some designers choose to emphasize the discord in their layouts? The best reason is because the content and brand are trying to do something different, perhaps propound an alternative lifestyle, offer a radical political agenda, pick up on the disaffection of a cultural zeitgeist . . . Generally, great designers on such publications will use design intelligently and inventively to illustrate a new or alternative approach. Neville Brody's *The Face*, David Carson's *RayGun*, and Martin Venezky's *Speak* are extreme examples of such ventures that fuse style and content in a nontraditional or unexpected kind of harmony—one that unites the discord of their design with the dissent of their message. Producing such fresh, radical design month after month, however, can quickly drain the resources of even the most committed and inventive designer. Equally, the popular acclaim and commercial success that accrues to a radically designed magazine will blunt its cutting edge, so designers must always remain aware of cultural shifts and their title's role within them if using discord in this way. It is worth noting that, historically, many experimental and avant-garde titles—including the hugely

THE STYLE COUNSEL

● **The State of the Nation's dress by Paul Weller**

● Text by Lesley White: Photography Jill Furmanovsky

THE STYLE COUNSEL

"I SUPPOSE PEOPLE find it difficult to penetrate me," offers the pale young man in the white mac, "they're not sure whether I'm really deep or there's nothing there. I dunno . . . I don't sit around trying to analyse myself!" Most people his age wouldn't share this reluctance to describe Paul Weller, whether or not they'd met him or even listened to his songs. His reputation goes before, or rather *instead* of him, making him someone you just know about, have an opinion on.

Reluctant hero to a generation of sensitive suburban youth, Weller never demonstrated the obvious charisma of other teen idols. Articulate but never eloquent, he could almost have been any working class Woking boy – a quality that made him seem totally authentic, easy to both idealise and identify with. There is something very convincing about the man, an intensity that demands

24 THE FACE

respect. To his small circle of friends he is, simply, "the main man"; to the fanatically loyal Jam fans Weller walks on water. Quite a few people, however, wish he'd drown.

Always depicted as unsmiling, often accused of rigid dogmatism, the prospect of meeting this "spokesman for a generation" and "angry young man" (clichés breed clichés) was daunting. Moreover the challenge of not simply augmenting the dusty pile of "exclusive" interviews that all end up saying the same thing (being Paul Weller is a worthy but serious business) made wild invention an attractive proposition. Happily, it didn't come to that.

With one mythically successful chapter of his story completed and a fresh one begun with The Style Council, there was plenty of brand new ground and Weller covered it optimistically and light hearted. Even when I interrupted his work at Polydor studios two

days later to nervously report a faulty tape recorder and ask him to repeat the ordeal, he acquiesced, laughing. Perhaps I caught him on a good day (but twice?), perhaps the easy self-irony is newly learnt . . . either way, to set the record straight, his humour was never in doubt.

The video for "Speak Like A Child", the Style Council's debut single, proves the point. It has Weller and a group of friends attired in ludicrous Sixties gear romping through the Malvern Hills in an open-top bus: very Cliff circa '65 and *very* silly. At one point Weller recomposes that well known earnest expression . . . and the real Paul, watching beside me, laughs out loud at his own pathos.

That well documented concern with words like *honesty* and *dignity* still informs much of what he says but the austere puritanism I'd anticipated turned up as a relaxed confidence, the pragmatism of one who knows what he's

1

2

Above and left Neville Brody's designs for *The Face* (**1**) look tame by comparison with *Speak*'s crash-and-burn design approach (**2**), but both exhibit an anti-authoritarian design style that was directly connected to the morally and politically stagnant milieu in which the designers were working. In different ways each design replaces harmony with a vital edginess, but remains legible and accessible.

III: Creating layouts **107**

lauded *RayGun*, *Speak*, and *The Face*—were short-lived or lost their edge in a market that often diluted their style, but their impact and role as catalysts in print design are undeniable.

In summary

Harmonious designs are likely to continue to be the norm, being commercially safe and appealing to a corporate mindset. Such design sits comfortably with advertising material and ensures a working environment in which standard templates can be handed off safely to junior designers and where instructions are clear and readily understood. With these considerations and more, designs of a harmonious type are pleasant, acceptable, and easy on the eye, and are unlikely to be challenged seriously. Although kudos and prizes do tend to accrue to innovative layout design, the role of the avant-garde remains as it always has been—the testing ground for new ideas, which may or may not be picked up and incorporated in diluted form by larger circulation or mainstream publications.

Style—what is it, how do you get it, how do you deliver it?

Style is difficult to verbalize for many designers, most of whom will say it's instinctive, a gut feeling, something that feels right. But although no rules as such exist for acquiring style, styles and style techniques can be taught and learned

Below A large part of style consideration in editorial design is cultural. For the redesign of Brazilian newspaper *Folha de S.Paulo* (**1**), (**2**), (**3**), Mario Garcia (with Paula Ripoll art directing for Garcia Media and Massimo Gentile for the paper) looked at everything, from bylines and jumplines to inside pages with numerous ads and supplements, in order to arrive at a paper that would appeal to the typical *Folha* reader, who considered it "user-friendly." "The philosophy of the redesign intensifies that relationship with the readers, respecting their different ways of reading a newspaper," says Garcia. At the forefront was a lively color palette and navigation system, which, in Garcia's opinion, has resulted in "a very vibrant, newsy, and visually appealing, but not overwhelming, newspaper . . . even though this is Brazil."

1 2 3

from recognition, appreciation, training, and exposure to visual media. Knowledge of these things will help the designer create the right style for any particular publication, be it formal or informal, traditional or modern, symmetrical or asymmetrical.

When you are attracted to a publication, what catches your eye first? Is it the colors, the image, or the cover lines? When you pick it up, are you conscious of its weight, how the paper feels? Do you notice anything else—its binding, for example? Does it stand out in some way? Can you say what makes it stand out? If it features a complex die-cut cover or an embossed fifth color, what does that suggest to you? Style will set the mood for a readership; from the style the reader can make assumptions about content and tone. Once familiar with the clues, a publication becomes like an old friend—the reader knows what to expect, looks forward to the next encounter, enjoys spending time with that "friend." The various style components that make up a brand can be categorized into three main areas: editorial style, design style, and advertising style.

Editorial style

The editorial style is the organization or flow of the pages, the expression and tone of the writing and visuals, and the amount and variation of the types of articles. Most publications have a framework. For example, both features and interview spreads are longer than other editorial pages and are designed to be read from the beginning of the story to its end. Other pages, such as reviews, news, and listings pages, can be scanned or read in short bursts in random order. Approaching the overall organization of the content in such a manner helps to fulfill the reader's expectations of editorial consistency. This style is generally set by the editor, and the editorial designer must ensure that it is communicated clearly to the reader through the design style.

Design style

The design style of a magazine is how all of the visual elements are presented— a creative counterbalance of typography and image. The design style of a magazine is inextricably linked to its brand and can be subdivided into the following areas: format (size and shape), stock, structure, and design elements.

Format: The format or size of the publication generally has to take several factors into consideration. When designing, the size, shape, and number of pages are dictated by the printing presses and the paper sizes that go on them. The format may need to take into consideration envelope sizes when mailing to subscribers. By conforming to a conventional range of sizes, magazines can be stacked and displayed on regular newsagents' shelves. There are, of course, magazines that choose not to follow these dictates: U.K. design magazines *Creative Review* and *M-real* make a statement by publishing on a square. *Statements*, *soDA*, and *Visionaire* change formats with each issue. These sorts of format decisions are taken on aesthetic grounds but have to be balanced with practical cost considerations. Format decisions should also take functionality and content

Profile: *soDA*

Independent Swiss magazine so*DA*, launched in 1997, started life as a 64-page publication with a print run of 500. It combines startling and provocative imagery with emerging print technology to deliver what it calls "a magazine for a mental lifestyle." Coeditor Iris Ruprecht says its content and design ethos is rooted in "a strongly held belief that we have to dig deeper and put the 'shiny surfaces' in second place. Lifestyle today has become a very complicated attitude, where most people are no longer able to follow or create their own paths and dreams but simply follow the order to consume. For this reason, we tried to set up some key phrases such as 'mental lifestyle' and 'intelligent entertainment,' which we try to connect to the existing world, but in a conflicting and ironic correlation." Each issue takes about five months to produce, and is a collaborative creative process between editors, contributing editors, and artists and

designers from a number of disciplines, and involves close relationships with printers and paper suppliers.

The design of so*DA* (the name is a German expression, *so da*, similar to the French word *voilà*, meaning "there it is," but, says Ruprecht, "It is also, importantly, a reference to Dadaism and its way of seeing things") comes very much from this collaborative approach, as *soDA* does not have one overarching design vision, instead dealing with each issue independently of its predecessors. "We begin by trying to find ideas and authors with a straight focus. Then we add our point of view to these to create interesting and sometimes controversial connections. To do so, we have to constantly change our look to find the best-fitting surroundings for the contents. This design approach keeps us open-minded, fresh, and always under construction—in flux," she concludes.

into account. Printing a glossy, oversize publication to create a feeling of luxury is fine (if predictable!) for a first-class hotel chain, whereas something that needs to be portable—such as a listings magazine—serves its reader better when in a smaller format.

Stock: This, too, plays a part in style and functionality, and the tactile appeal of printed publications should not be underestimated. A publication printed on newsprint will have a more environmentally friendly feel than a fashion magazine printed on glossy paper, and is therefore better suited to a particular brand message and readership. On magazines and books, the feeling of quality is often transmitted through the paper, weight, binding, and finish. The tactile

1

Left and below Jeremy Leslie uses stock to confound expectations on the Virgin Atlantic first-class fanzine *Carlos*, which manages to feel like a high-quality, luxury product in part "due to a matter of context . . . Twenty years ago, in a world of magazines that were not *all* full-color, *Carlos* (**1**) would have looked cheap because it didn't make use of what was then an expensive commodity: full-color. It would have looked like many magazines—one- or two-color. Today, full-color is the norm, and anything that's different to that stands out and looks rare and 'expensive,'" explains Leslie. Swiss magazine *soDA* (**2**) changes format and stocks with each issue, a luxury afforded by its once-a-year publication, which renders familiarity with its format irrelevant. *Pariscope* (**3**), a weekly listings title for Paris, is small enough to fit into a bag or pocket and has remained consistently profitable, with sales in the region of 103,000 each week. A square magazine such as *Imprint* (**4**) is rare though not unique. In a specific market against its competitors, an unusual choice of format can stand out, but issues such as paper wastage and the impact on the newsstand should be considered, too.

2

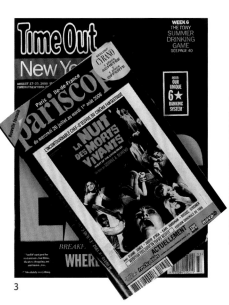

3

4

quality of a beautifully produced publication such as *soDA* (which has used metallics and colored plastic on its covers), *Matador*, or *Statements* will deliver a very different feel and message to that of a gossip weekly such as *Hello*, or a news weekly such as *The Economist*.

Structure: Readers rarely read a periodical from cover to cover, and the traditional pace and structure is built on the assumption that the reader starts at the front before dipping in and out of features and articles that are of interest. However, there is no reason not to experiment with this pace. Regular readers will quickly become familiar with any structure; more important is consistency and a good navigation system to aid new or occasional readers. Criswell Lappin of *Metropolis* says that the key is "varying the design and length of stories in the feature well to alter the pacing and keep people interested. Readers want to turn the page to find out what is next."

Design elements: Many elements make up a design, including visuals, typefaces, colors, panels, and graphic elements. Individual use of these and their combinations establishes a style and helps to create a mood. The typefaces you choose and how you use them will ensure a feel that is timeless or trendy, and there are thousands to choose from. For example, Lee Corbin at *Flaunt* uses type in a number of ways, as he explains:

> *There is a lot of information to organize every month for each issue. We use typography to organize this information so that it is easily navigable by the reader. We also use typography to create visually stimulating compositions, which help to give our magazine its identity. In each issue of* Flaunt *we use type that is chosen because of its legibility and type that is chosen because of its character. We look for something that fits the project. Sometimes that's determined by the content of a single story, or an entire issue. If we feel it's appropriate to depart from what we are doing typographically in the rest of the issue for one story, then we do. In this case we usually let the title of the story or the images steer us in the right direction.*

Equally, the type of illustration or photograph selected will immediately communicate something to the reader, but by scaling, cropping, and positioning, it can say something completely different. There are no rules as to how you should use these design elements, provided that, together, they express the identity of the publication in general and the specific content in particular. This is true for both newspapers and magazines—as Mario Garcia says, "Both magazine and newspaper designers have to work hard to make sure that design is there to enhance content and to make it accessible. There are different techniques in terms of the look and feel, but the effort and logistics are the same."

Left A good editor and art editor will ensure that advertisements harmonize with the editorial, whether this involves placing ads opposite one-page features where they will complement each other or ape the design style and tone of the editorial, as shown here on *Loaded*. This latter, known as advertorial, will demonstrate similar stylistic attributes as editorial. A strapline reading "Advertorial" or "Advertising feature" may be the only thing that clearly distinguishes the page, spread, or even feature from the editorial, so the placement of this line is very important.

Advertising style: A publication often has to accept advertising and advertorials to cover the cost of publishing. Advertisers wield a lot of power and can be instrumental in determining pagination and the number of spreads available to editorial. As a condition of purchase they may request particular spreads or slots facing editorial pages and, because the first third of a publication is so desirable, this results in fewer spreads in this section being available to the designers. Moreover, right-hand pages are more expensive than left-hand ones because they are more visible, so a title may be forced to sell more of these, resulting in whole sections consisting predominantly of left-hand pages. In such a case, designers have to make these layouts work hard. If they know what the advertisement is, they can design the editorial page to stand out against it, but they can also create an aesthetically pleasing spread that works in harmony with the ad as well as with the magazine as a whole. Either way, through its shapes, contrast, and tones, designers will need to design the page as an element in its own right, as well as a strong aspect of a feature that may span a wide range of pages.

How to convert inspiration into a layout

The search for inspiration when trying to arrive at an interesting, dynamic, and relevant layout concept can be difficult for any designer at any point. Sitting and staring at a computer screen is quite possibly the least creative action that a designer can perform, but what can you do about it? Move away from your work environment. Going to art galleries, street markets, the movies, shops, funfairs, or just sitting in a park and looking at the skyline can often spark an inspirational idea by allowing the designer to look at things from a totally unexpected perspective. On the following page are a number of creative exercises that can help, too.

"Don't follow what other graphic designers are doing. Find your inspiration in other places, such as art, film, fashion, or history."

ERIC ROINESTAD, ART DIRECTOR, *FLAUNT*

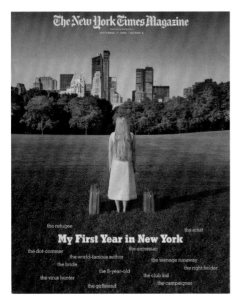

Above Janet Froelich, art director of *The New York Times Magazine*, explains, "The theme of this issue was the classic 'coming to New York' story. We spent a year with each of the subjects, from the moment of their arrival through their first year in the city. The cover had to convey that sense of wonder, anticipation, and fear. We were inspired by one of Cindy Sherman's untitled film stills, the one with the hitchhiker on the road, suitcase by her side. We scouted locations and came up with the great lawn in Central Park, where the buildings in the skyline feel timeless, and the stretch of lawn unfolds with both possibility and anxiety. We shot it in black-and-white because it felt like the spirit of the city, and used yellow as a spot because it's so very New York. Black-and-white and yellow for taxis—very simple."

Where else can a designer turn for inspiration?

All creatives struggle at some point with the search for inspiration, and all find ways out of the impasse. These can include:

Architecture: Referencing architectural structures is a rich source of visual inspiration. Many buildings are based on a grid structure, which, when translated to a layout, can give exciting and useful divisions of space. The great American designer Saul Bass realized this and incorporated the grid structures of buildings into some of his most successful screen credit sequences, in which his elegant typography slid effortlessly across the perspective lines of office-block windows.

Nature: The hugely magnified images of butterfly wings, insect eyes, and fish scales and the exoskeletons of arthropods can offer excellent ideas for scale, shape, contrast, and structure. The Crystal Palace in London, for example, was based on the ribs of a lily leaf.

Industrial design: Images gleaned from industrial design can be a source of inspiring imagery. Being man-made and designed, industrial objects can often be easily translated into text and picture boxes. Sleek ocean liners, streamlined trains, the understated, elegant lines of Ken Grange's Parker Pens, and the work of Jonathan Ive at Apple Computer are the result of a skillfully crafted application of solid design principles—the very same principles that you can apply to your layouts.

Look around you: Look at your virtual and physical desktops. However they appear to those unfamiliar with them, you will probably know where and what everything is, and this is central to design thinking; all you have to do is make the underlying structure apparent to others. The things you collect, the way in which these things are displayed—all of this is design. On *Speak*, designer Martin Venezky would begin by reading the manuscript:

> *After that, I'd enumerate the relationships and imagery that stuck with me. With that fresh in my mind, I would begin sifting through piles of pictures, books, type, and so on, pulling out things that struck me either directly or indirectly. I make a point of not organizing my files, which keeps the element of surprise always in play. While looking for one kind of image, another one might slide into view that is more exciting and unexpected.*
> *I often refer to the "poetic gap" as the space between a direct illustration of the text and its more eccentric interpretation.*

Get away from your desk: Ideas arrive most easily to a mind that is allowed to wander. Your subconscious carries a myriad of images and concepts—the trick is to unlock and make use of these. Play games, stare out the window, go for a walk, and *always* carry a small design notebook with you. Sometimes a quick sketch rushed off in a local park can be translated into a dynamic, powerful, and unique layout, headline treatment, logotype, or page design.

Essential design skills IV

It should be becoming clear by now that, in order to create effective and successful layouts, designers need a broad range of practical, technical, and mental design skills and knowledge. The preceding chapters have dealt with many of these skills, such as understanding a publication and everyone's roles in it, being able to create particular styles, constructing successful layouts, and remaining innovative and inspired in layout creation. In this chapter we continue our focus on the design skills and knowledge needed to be an editorial designer, specifically:

- the ability to master objective visualization;
- skillful page preparation;
- an understanding of and skill in working with typography;
- strong artwork skills and production knowledge;
- the ability to create consistency without monotony;
- project managing time and cost.

Mastering objective visualization

This is a complex skill that involves the ability to select, reject, emphasize, arrange, and combine essential elements in order to design a layout that is completely attuned to its subject matter or *raison d'être*, the publication's style, and the readership. The designer must be able to:

- understand and make a good and accurate interpretation of editorial material—do this by reading the copy and, where appropriate, talking to the features editor, writer, and/or photographer;
- synchronize thinking with an editor to produce the layouts he or she has in mind—meetings and mock-ups are the keys to achieving clear communication here;
- have a clear idea of the requirements and purpose of a particular publication, or know the brand, the reader, and the relationship between the two;
- produce more than one version of a layout (if, for example, the pagination alters). Always develop more than one idea—this has the dual purpose of testing the strength of your original idea against other solutions, and offering backups for discussion and development if the first idea is unacceptable;
- stay inspired and, as far as possible, free from constraints—once they have been learned, all the elements and structures of editorial design can be examined, questioned, played with, revisited, and broken. Don't get so stuck in one route and direction that you can't approach a graphic solution laterally;
- visualize and produce layouts from material that may have been created or selected before the start of a layout. Always have a sketchbook on you. Work out ideas and rough layouts on paper, create sketches, diagrams, and other material before going near the computer.

Jeremy Leslie's guide to the editorial designer's must-have attributes

- ◼ An interest in the content he or she is working with and the ability to make it look interesting.
- ◼ Good typographic skills.
- ◼ A strong sense of what's what in illustration and photography.
- ◼ An understanding of market context, competitors, etc.
- ◼ Being able to spot a good idea regardless of whose it is (and give credit for it).
- ◼ The ability to choose the right battle.
- ◼ Bloody-minded self-belief!

Page preparation and grids

Building successful foundations for layout construction consists of choosing the format and stock, creating appropriate grids, knowing how to use design to signal priorities, and working with a flatplan to ensure that sections and pagination keep the flow and pace of the publication while working through constant changes.

Grids

Rather like blueprints in architecture, grids are invisible sets of guidelines, or systems of order, which help the designer determine the placement and use of text, images, and other design elements, such as white space, margins, and folios,

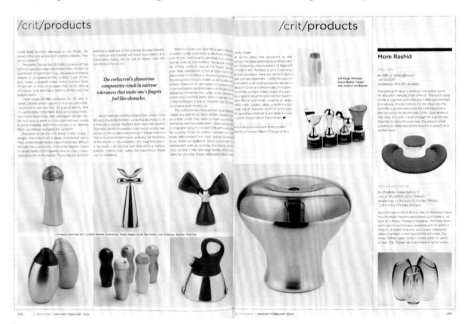

1

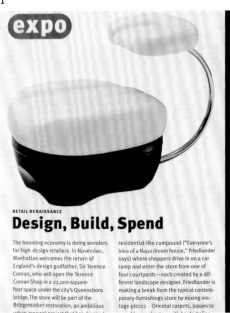

2

Left There are many sophisticated grid formations. The basic grid formation is three or four columns wide for magazines, and six to twelve for broadsheet newspapers. This may be consistent throughout or used to indicate different editorial pages. A features page might be laid out on a two- or three-column grid, while news and review items might be produced on narrower column grids or, more commonly, mixed widths—perhaps two wide and one narrow, where pictures and captions can be placed. "On *I.D.* (**1**), (**2**), a regular issue has multiple grid systems. For department pages, we use a three-column grid; on a feature story we use one of three grid systems: two two-column pages and one three-column. This gives us the flexibility to change the structure according to the quality and format of the artwork or the length and style of the writing. Default for features is two-column, but when a story is written in more of a news style (short sentences, factual), I prefer to use the three-column grid to avoid short paragraphs on a wide column and a bad-looking rag," says art director Kobi Benezri. But, like all good designers, he does not restrict himself completely to his grids.

Grids and how they shape design

This grid is based on two columns with wide gutters, ample margins, a hanging folio line, and a 12-point baseline grid. It echoes an editorial-heavy magazine, where words are more important than pictures. To create variety and avoid a text-heavy spread, the folio line, margins, generous baseline grid, and wide gutter all provide white space, balancing out the dominance of the text. This grid gives the design an intellectual feel.

A headline intended to be read but have no meaning

The dummy settings which use other or even gibberish to approximate text have the inherent advantage that they distract attention to themselves. Simultext is effective in any typeface, at whatever size and format required. Paragraphs may be long or short. Text can be to complete any area, as the copy is simply repeated with different starting points. Intended to be read but have no meaning. A simulation of actual copy, using ordinary words with normal letter frequencies, cannot deceive eye or brain.

Simultext is effective in any typeface, whatever size and format required. Paragraphs may be long or short. Text can be produced to complete any area, as the basic copy is simply repeated with different starting points. This is a dummy text. It is intended to be read but have no meaning. As a simulation of actual copy, using ordinary words with normal letter frequencies, it cannot deceive eye or brain.

What you see here is dummy text. It is intended to be read but have no real meaning. A simulation of actual copy with normal letters

Settings which use other languages or even gibberish to approximate text have the inherent disadvantage of distracting attention to themselves. As a simulation of copy, using words with letter frequencies, it can't deceive the brain. Simultext is

Dummy settings which use other languages or even gibberish to approximate text have the disadvantage of attracting attention to themselves. Simultext is effective in any typeface, at whatever size and format is required. Paragraphs may be long or short. Text can be produced to complete any area, as the copy is simply repeated with different starting points. This is dummy text. It is intended to be read but have no meaning.

In comparison, this three-column grid with smaller gutters and smaller baseline grid is a more standard magazine format. There is more variation possible with this grid and here it echoes a glossy magazine with its large picture, big headline, and ample white space. The spread here is engaging and entertaining.

This is the title of this article

Paragraphs may be long or short. What you see is dummy text. It is intended to be read but have no real meaning.

Trial settings test

Gibberish heading

- Approximate text goes here please
- Shows the upper advantage
- Distract attention away from others
- Simultext is effective
- Whatever the size and format required can be provided
- Intended to be read
- Presentation copy uses languages or even gibberish to approximate text
- As a simulation of actual copy
- Using words with normal letters
- Frequencies cannot deceive the eye or brain in whatever attention

Section Heading

Dummy settings which use languages or even gibberish to approximate text have the inherent disadvantage of distracting attention to themselves.

A two-deck lead story headline

A third-level heading

Text can alter to complete any area, as copy is simply repeated with different starting points.

Header that is four lines

This is dummy text. It is meant to be read but have no real meaning. What you see here is dummy text.

Second title

Paragraphs may be long or short in order to fill any area.

This five-column grid, with its smaller margins and baseline grid, is more reflective of a trade or listings magazine. The narrower column width helps organize the large number of stories on one spread, while the smaller margins, gutters, and baseline grid help fit as much onto one page as possible. The grid gives this layout a practical feel.

1

2

Left Many periodicals or serial publications, which are published just once or twice a year, don't bother with a grid system, relying instead on their conceptual approach to content and treatment to create continuity from issue to issue. Annual publication *soDA* (**1**) takes this approach. The theme dictates the format, design, and underlying grid (if any) of each issue. *Metropolis* (**2**) uses a two-, three-, and four-column grid throughout the magazine. Says Criswell Lappin, creative director, "On editorial pages the text never comes above a certain point on the page, leaving plenty of white space at the top. The *Metropolis* logo moves cinematically back and forth across the top of the page as you progress through the magazine. This is a convention that still exists from Paula Scher's redesign in 1999. Features are printed on an uncoated sheet, which lets readers know—visually and tactilely—that they are in a specific section of the magazine. This allows us to be more experimental in the layout and structure of this section, because it only contains editorial content. Each feature is designed individually, based on the content of the story and the quality and quantity of art that supports it. Most stories are loosely based on the same two- and three-column grids that appear in the rest of the magazine, but we are not afraid of dropping the grid altogether if another approach works better for a particular piece."

helping to maintain continuity while still allowing for variety in the layout. Good grid systems anchor but do not necessarily constrain items on a page. Where a publication has a particularly fluid design, the grid acts as an anchor or point of reference, a departure point that roots the whole structure. Sizes and shapes of type, images, and areas of white space can be preplanned, greatly facilitating the process of creating a layout. They can vary from rigid three-column grids to more complex ones of nine or twelve units that enable greater flexibility and almost endless permutations. In either case, the grid remains defined, but having the confidence and knowledge to manipulate and personalize the layout around it is what will make it into something special.

It is useful to be aware of grid conventions that underpin different forms of publishing, if only in order to deviate from them if desired. A weekly or daily, for example, usually has a formal grid structure because its production process has

IL PADRINO

Interview by Simon Hanauf
Images courtesy of Cappellini

Giulio Cappellini is one of the world's most influential furniture manufacturers. The list of designers that have been commissioned by Cappellini reads like the who's who of design of the past few decades. Simon Horauf managed to steal an hour of Cappellini's time during his first visit to Australia.

Giulio, how is the sky in Melbourne different to the sky in Milan?
(Laughs) The colour of the light is totally different. The sky in Milan is warmer and a paler blue. This is my first time in Australia and I am very impressed with the light here and the colour of the sky. The colour of the light is very important for us. Depending on the colour outside, you have a totally different perception of colours and textures inside. So, the same red will look different in Australia to what it looks like in Milan.

I personally like the really white, cold light of Australia. In Milan, the light is warmer, but I like the cold, clear light.

This might have nothing to do with the colour of the light, but tell me, why has Milan managed for so long to be the centre of design and manufacturing?
There were a lot of very good designers with big ideas in Italy, like Sottsass or Castiglioni, and on the other side you had the businesses that saw the potential of good design in the marketplace. There are a few companies that are truly interested in design and that invest in innovations and take risks. But this is really what you need to do and it doesn't matter if you are from Italy, Brazil or Australia. We had a lot of problems when we started working with foreign designers. Many people accused us of

1

Above and right On *Inside* magazine (**1**) the underlying grid is restrained, but its simplicity doesn't hamper design and layouts of other department pages. "A simple grid can still carry many possible combinations. You have to look at the bigger picture. Readers like to feel as if they have an understanding, almost a relationship, with the magazine. The consistency of the grid nurtures this need. If it's kept consistent, the avid reader of a magazine can pick up any issue and feel comfortable navigating through 'new' material," says art director Jeffrey Docherty. *The Observer* newspaper (**2**) underwent a redesign in 2006, in which design consultant Mario Garcia led a move from a six-column broadsheet format to a five-column Berliner format. He says, "The smaller canvas allows for better movement of elements, makes the designer more focused and decisive in terms of what images to bring into play in a protagonistic role, while allowing space for type to tell the story in a narrative format."

2

3

4

Left and above In a magazine feature, for reasons of legibility, the grid traditionally has three columns, but literary magazines often use two wide columns instead to form a classical symmetry and deliver big dense blocks of text. *The New York Times Magazine* (**3**), (**4**) pages shown here take this farther, boldly using one wide column that defies Fassett's theory of legibility (*see* p.122), while remaining accessible and with a formal beauty provided by its classical structure.

Above Chunky blocks of text in formal grid structures can look very effective "floated" in space, as seen here in the redesigned *The Guardian* newspaper (**1**).

to be simple and fast. Quarterlies, by contrast, have the luxury of time, enabling experimentation and fluidity in the grid and columns system. In Fernando Gutiérrez's annual *Matador*, each issue is designed using a strict but different grid and one typeface. Some publications don't bother with a grid at all, choosing to use just the limits of the page as a grid. In this way they can build up the structure of a layout around an image or headline. Handled well, the result could be a fluid, flexible page and publication, but caution should be used in such an approach— it must be right for the publication, its brand attributes, and its readership.

Legibility issues play a part in the construction of a grid, so Fassett's theorem of legible line length should always be considered. This states that line lengths containing 45 to 65 characters are legible (characters include letters, numerals, punctuation, and spaces). Line lengths exceeding these limits challenge legibility. This does not mean that 40 characters or 75 characters should never be used, but anything that challenges established legibility theory should be examined closely —including a designer's reasons for doing so. If clear, easy reading is important, grids must take this into account. In newspapers, five columns are viewed as the optimum number for tabloid or Berliner formats, and a story deeper than 3 inches (7.5 centimeters) under a multicolumn headline is traditionally broken up with subheads and/or images. There are stylistic conventions, too, that might be considered: In a magazine feature, for reasons of legibility, the grid traditionally has three columns, but literary magazines often use two wide columns instead to form a classical symmetry and deliver long lengths or squares of text that shout "we're intellectual"; many supplements take this as their basic structure but lighten the page through white space and other design elements.

Templates

Once a grid has been established, templates should be made up for the different sections—news pages, feature pages, back sections, and so on. These templates should be flexible enough to allow for maximum versatility and individuality in pages and spreads, but also comprehensively designed so that all the major elements of the design—boxes for display fonts in alternative sizes, columns, picture boxes, caption boxes, and so on—are available (for more on templates, including an example, *see* p.75).

Pagination

Pagination, or page planning, is the order in which editorial appears. Such planning is important in design terms because the flow created by a publication's pagination will determine the pace and balance, and ensure that spreads of similar contents are spaced apart. Determining pagination is usually a collaboration between the editor, art editor, production editor, and advertising sales head. The only real restrictions are those of the print process—the way sections need to be made up for the presses—and the needs of advertising. Special attention should be paid to the details: A feature ending on a left-hand page with a new feature facing it is rarely desirable, and neither is a feature that is interrupted by four consecutive pages of advertising, or by an unexpected

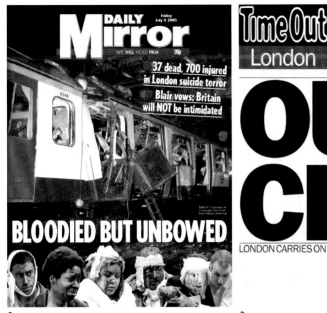

2 3

Left The day after London was bombed, national tabloid the *Daily Mirror* (**2**) portrayed the capital as bloody but unbowed. Newspapers will usually treat such huge events pictorially. London listings magazine *Time Out* (**3**), by contrast, opted to make a bold design statement with its simple text cover that had an expressively visual impact, something that would have been difficult to achieve pictorially after a week of exhaustive visual coverage.

advertising insert. The best way to test the pacing and flow of your publication is to produce miniature spreads that are then pinned to a large board in the art room. These can easily be shifted around as the flatplan changes, enabling you to monitor constantly the effects such changes are having.

Signaling

In periodicals an integral part of pagination and page preparation is the ability to signal the importance, priority, and style of articles to the reader. All the design elements act as signals, from an article's position in the publication and on the page to the width of columns (wider columns usually indicate features or the opinion and editorial—op-ed—section of a newspaper), type size, length and position of a headline, length of text, style of text setting, use and size of images, and use of color. A newspaper illustrates this very clearly. On the front page the lead story will be near the top of the page (so that it's visible to the reader at the newsstand) and have the biggest headline and most space allocated to it, with less important stories radiating from it. The op-ed pages distinguish themselves from news pages by using a lot more negative space, picture bylines, pull-quotes, wider columns, and different type weights and sizes. But this signaling is also visible in magazines. In the news and reviews pages, signaling is similar to that of a newspaper, but in the feature well it may be more subtly employed. If the headline is very prominent and the article spans eight pages in wide columns with full-bleed commissioned photographs, it's clear that the publication wants you to read it. A designer should adopt a coherent and consistent use of such signals appropriate to his or her publication.

Sections

Most editorial is printed in sections, or signatures, because of the volume of pages and the size of the print presses. Sections are made up as multiples of four and are

	1	2	3	4	5	6	7	8	9	10	11	12	13	14	15	16
A	1	2	3	4	5	6	7	8	9	10	11	12	13	14	15	16
B	17	18	19	20	21	22	23	24	25	26	27	28	29	30	31	32
A	33	34	35	36	37	38	39	40	41	42	43	44	45	46	47	48
C	49	50	51	52	53	54	55	56	57	58	59	60	61	62	63	64
C	65	66	67	68	69	70	71	72	73	74	75	76	77	78	79	80
B	81	82	83	84	85	86	87	88	89	90	91	92	93	94	95	96

Above A flatplan showing pagination for a 96-page publication using three sheets of paper (A, B, and C) to be printed on both sides. Each sheet prints 32 pages, 16 on each side. If your publication is not full-color throughout, the flatplan should clearly distinguish between the color and black-and-white sections by using a tint on the color pages or by creating a bold keyline around them. The yellow tinted pages indicate full-color, the red pages indicate two-color, and the gray tint indicates a one-color print such as black. The color sections can be placed anywhere in an edition, as long as the color distribution matches up on each sheet. Most printers print and bind in multiples of 16 pages, although 20 or 24 are also widely used. Usually the printer will require all the pages within one sheet section first— i.e., all the pages falling on sheet A need to be sent to print a day or two before those on section B, and so on.

usually printed as booklets of 8, 16, or 32 pages, which, when laid flat on top of one another, make up the publication. This enables the whole issue to be printed over a period of time, section by section, but it also means that costs can be controlled and kept down; for example, effects such as a fifth color or particular type of paper can be applied to one section to give a publication a desired feel or appeal for a reasonable cost, because all the special effects only need to be applied to that plate.

The flatplan

The single most important tool in producing any publication is the flatplan. This ingenious exploded diagram of a publication, similar to a film storyboard, enables everyone involved in its production to see pages, content, print sections or signatures, editorial-to-advertising ratio, and pagination at a single glance. Usually the responsibility of the production editor or studio manager, flatplans are updated constantly to reflect inevitable changes that will occur, from a feature that needs to be extended, shrunk, or dropped to a specific ad that needs to go opposite a particular editorial page. Such changes will necessitate a rearrangement of a section so that balance and pacing are still maintained throughout the publication. Each time such an alteration or amendment occurs, a new flatplan will be printed out and distributed to keep everyone up-to-date on developments.

Stock selection

The selection of paper is vital to the feel, tone, style, and look of a publication, because it affects both expression of the publication and reproduction of its contents. There are two traditional routes for stock selection—via the printer

Contents

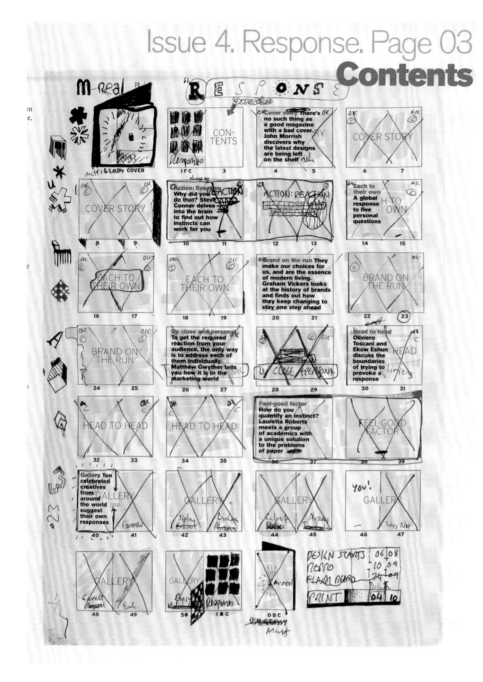

Left A working flatplan shows where the various elements of a publication's content are to appear. Page one is conventionally the front cover. A diagonal strike through a page indicates that it is reserved for advertising, but "AD" written clearly on the page works just as well, particularly if you want to use strikes as a production schedule device—one strike to show that the page has been designed, another to show it's been proofed, and so on. A good naming or numerical convention for new versions of the flatplan is important: Mark the date, time, and version number clearly on a prominent part of the sheet. This witty contents page for *M-real* gives a good idea of how a flatplan might look once the publication has gone to press.

or a paper merchant—but the best is a combination of the two. A printer will be able to give you good initial guidance and work closely with you to find the best stock for your specific production needs. For example, if you know you want a thin, coated gloss stock with no show-through and high brightness, the printer will usually be able to suggest good examples. Paper merchants are happy to send printed and blank sample books and sheets to designers and will also make up a sample in your chosen format (usually via the printer), giving you a good idea of the weight and feel of the publication. But if you require unusual print or production techniques, such as an embossed fifth metallic color or die-cuts, speak to your printer—this is where his or her knowledge and expertise come

1

2

Above As an independent publication or microzine, *soDA* (**1**) survives by selling ads, through subscriptions and, as in this case, with the support of printers or paper companies, who are often keen to promote particular techniques and stocks. For this issue about surface, the cover is made of holographic card, while inside pages use metallic inks and numerous coated and uncoated stocks in different colors. *Flaunt* covers (**2**) are often die-cut and embossed—this May 2001 cover mimics a schoolbook and has raised strips of Scotch tape and R.E.M. and Missy Elliott logos to create a real three-dimensional depth. Such covers are produced because, "When you're called *Flaunt*, you sort of have to flaunt yourself and be a little showy. We have to flaunt the special inks, tricks, and embossing. It's important to sell the word and the image of flaunting by going the extra distance. The embossing also throws in another sensitivity that most magazines don't use—the tactile element to touching the front cover. People love to touch the cover," says Jim Turner, creative director.

into play. And look at existing print material that may match your needs; you will often find that publications list the stock or printer's name, making your search that much easier.

Paper considerations

Stock selection is usually a question of balancing your needs. For example, if your main criterion is faithful color reproduction, then the best sheet to use is a bright, blue-white, thick-coated sheet with an ultrasmooth finish. This reflects the most light at the best angle without adding a tone or hue of its own. But other issues may need to be considered: What if there is a lot of text? Or weight is an issue? This guide should help.

Coated or uncoated? Coated papers reflect light better and absorb less ink, giving images more detail; the higher the number of coats, the sharper the images. Uncoated papers offer a softness in print contrast that can work well with fine art or illustration and make text easier to read.

Gloss or matte? A high-gloss stock is usually used on a high-quality publication with a large number of images, but many matte stocks offer excellent reproduction and can make a publication stand out from its competitors.

Thick or thin? We all associate thick papers with art and "highbrow" books, but

3

thin papers can give the same sense of opulence and richness, depending on other qualities such as density, brightness, and coating.

Dense or opaque? The opacity of stock will affect its show-through, so bear this in mind when specifying your stock, and test it by laying it over a black-and-white striped design. If using an opaque stock, you will need to consider the page carefully to minimize print show-through. An asymmetric grid, for example, will show through more than a symmetrical one.

Heavy or light? We associate weight in paper with luxury, but luxury costs— not just the paper itself, but in postage and portability. Do you want to discourage potential purchasers from carrying your publication around with them because it's the weight of a telephone book? If the image you are trying to project is that of a faithful companion, should the publication be portable?

High or low brightness? The brighter the paper, the more blue light it reflects, which works well for reproducing images. But such brightness can create glare that might interfere with readability, and because of the amount of bleaching needed to achieve high brightness, qualities such as durability and printability may be affected.

Recycled or virgin stock? Readers of a magazine about environmental issues would expect it to be printed on stock that was environmentally friendly, which

Above Paper manufacturers and suppliers go to great lengths to persuade designers to use their paper, producing numerous swatch books and luxurious samples containing different weights and colors of a particular stock (**3**). Remember that these can look very different with print on them, so ask to see a job that's been printed on the stock you are interested in, and ask for a dummy to be made to the size and number of pages in your publication.

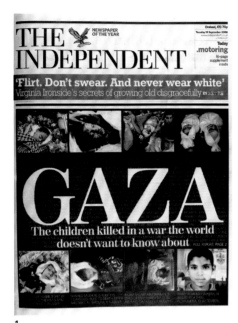

1

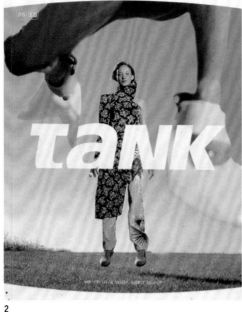

2

3

Above As newspapers continue to lose sales, they are fighting hard to find more readers, many changing format from unwieldy broadsheets to the popular Berliner, compact (**1**), and tabloid formats, and moving toward even smaller formats such as A4. The best examples do not simply try to "shrink" content to fit the smaller page, but consider the new format as a new design, looking at columns (their numbers, widths, and lengths), negative space, typography, and other design elements such as rules and folios. Mario Garcia uses the analogy of moving from a large house to a small flat: "You have to reassess what you need and want to keep, and what you are happy to leave behind."

Above right A publication's format should be dictated by its readership and its purpose, such parameters allowing for a wide variety of approaches. Microzines such as *Tank* (**2**) have the freedom to be as big or small as they want (or indeed to change with every issue). *Glamour* magazine has found massive success with its "handbag" format, which has been copied worldwide, while *Emigre* (**3**) has experimented with different formats. This one enabled an expansive, large-scale design approach suited to its subject matter, the design work of David Carson.

could be anything from wholly recycled unbleached stocks to partially recycled stocks. Most paper merchants now offer these, but you can also find out what the different terms mean by getting advice from environmental agencies.

Format

Format is defined as the shape and size of a page. The most common format —A4—is dictated by the width of paper rolls and the size of the drum on the offset web presses commonly used to produce mass-circulation magazines and books. Because American and European drum circumferences differ, there are slight variations, notably a shorter standard format in the U.S. Consumer magazines also have to conform to requirements such as shelf size in shops and the ability to fit through a standard mailbox. While short-run publications have the luxury of printing on a bespoke format, it is still worth bearing in mind the reader's needs— a large-format magazine or odd shape can be a nuisance if filing for future reference is important.

Choosing and using type

Any publication should create an enjoyable, accessible, and appropriate experience for its reader, and a large part of this is determined by the use of typography. Readers who are accustomed to unvarying pages of dense text in a novel would not read the same page in a magazine, where decoration, variation, space, and cohesive use of design elements are expected. Type that is too small, too dense, and too uniform will put off the reader, as will columns of "gray" text; an editorial designer has to employ a range of tricks to keep the reader interested.

Practical issues may need to be considered, too. On some publications, particularly dailies and weeklies, designers need to accommodate exact lengths of copy and headlines. And lastly, but most importantly for a publication's

4 **5**

identity and appeal, aesthetic, emotional, and contextual considerations apply. Type, more than any other design element, signals certain associations to the reader. To address all these issues satisfactorily, each different form of type should be selected for its specific function, but also to form a whole that is appropriate to the publication. At *Flaunt*, Lee Corbin's selection of fonts is determined by what is happening typographically throughout the entire issue. "I try to take account of what's going on in the photographs, the clothes, the content, illustrations, and so on, in all the stories running in the issue. I decide what faces will be used in which sections, and the varying degrees of abstraction," he explains.

There are no hard-and-fast rules for how big or small text and headings should be. Logically, the display text—information intended to catch the eye

Above Two very different but equally effective approaches to font use for headlines. In *Vogue Paris* (**4**), the choice of a vibrant red serif face for the words "L'amour absolu" results in a spread that is bold and passionate without being brash or masculine. *About Town* (**5**), by contrast, is the opposite—confident, manly, and swaggering, it visually reflects the topic.

Below How to break up columns of text: On this page from *Die Zeit* (**6**), long, narrow columns are given more interest by running them around the page's heading and exploded graphic. In the heavily covered pages of *The New York Times* (**7**), the delicate section title, "Essay," set in a box of white, and a picture centered across two columns, help break up the copy. Many magazines use color for display text, but it can be effectively employed for breaking up body copy, too, as seen here in *WAD* magazine (**8**).

6 **7** **8**

and be read first, such as headings and introductions—will dominate the page by being larger than body text and captions, while body copy should always be large enough to be readable by its intended audience. It's a good idea to experiment with these by printing them out at different sizes with different leadings. There are no formulaic type sizes that always work for all situations—it's more about using judgment to determine what looks and works best for the publication's readership. It is also worth considering that most typefaces were designed for a particular purpose, and for that reason may work better at certain sizes than others. But by using such faces in offbeat or unexpected ways, a designer can deliver an inventive, original, or starkly awkward layout that may

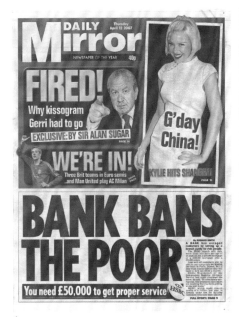

1

2

Right British tabloid newspapers (also known as "redtops") rarely use serif faces, and often use all capitals in their headlines, as seen here in the *Daily Mirror* (**1**). While the use of an uppercase sans serif fails to distinguish the newspaper from its rivals, it very clearly signals the type of newspaper it is. *Die Zeit* (**2**), by contrast, uses serif faces in upper- and lowercase, their delicacy emphasized by italics and by wide gutters and margins. These combine to convey the sense that the content is analytical and thoughtful; there is nothing rushed about the page—it demands a much deeper level of engagement and commitment from the reader than a tabloid would. *Corriere della Sera* (**3**) uses serif and sans serif, in bold and roman, and also uses italics for its kickers. Typographically it feels ambivalent, but the whole spread, bringing in layout elements such as wide margins and white space in columns, still manages to convey a certain rigor and intelligent tone.

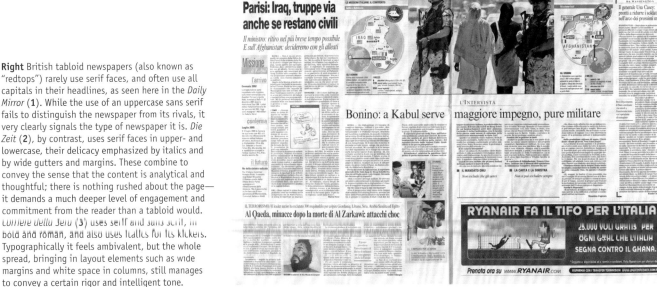

3

Changing the impact of images and copy with layouts

In this layout the headline is hero—it dominates the page and draws the eye's attention. Echoing a tabloid newspaper, the headline is hard-hitting while the body text is lowest in priority. There are only small variations in typography, little white space, and short articles. This gives the newspaper an immediate and throwaway quality.

Using the same image and copy, this spread gives an entirely different feel. With a softer headline, greater white space, and the introduction of pull-quotes and subheads, the body text now carries the highest priority. This layout tries to create easy access to the article but still uses a large headline and image to draw attention to the spread. With the feel of an upmarket magazine, it uses the same components to create an intellectual look for the article.

The image is the dominant feature of this layout. Aided by dotted rules, a single short story, and a dominant kicker, it achieves a glossy-magazine feel. These publications are quick to navigate and easy to flick through. The images tend to play hero in order to grab the attention of a skimming reader.

Right While *Fishwrap*'s format and stock change from issue to issue (**1**), what unites them, says graphic designer Lisa Wagner Holley, is "typography—a sensitivity to working with it, and carefulness about the read and the reader's experience." Editorial elements are shared also, using pull-quote texts to unify images (footnoting conversational ideas to address the reader more intimately). Fonts—in this issue, Minion, Trade Gothic, Knockout, and Young Baroque—are carefully considered to work with each other because, adds Wagner Holley, "The text is very important to us as we try to keep the read friendly, legible, smart."

1

Right *Flaunt*'s (**2**) use of Hoefler and Gotham as body copy contrasts well with elaborate and decorative headline fonts, many hand-lettered by the magazine's art directors. "At *Flaunt* there is a lot of information to organize, both image and copy, every month for each issue. We use typography to organize this information so that it is easily navigable by the reader. We also use typography to create visually stimulating compositions, which help to give our magazine its identity. In each issue of *Flaunt* we use type that is chosen because of its legibility, and type that is chosen because of its character. We also frequently create and sometimes draw typefaces for specific layouts or issues. We use type that expresses the feel of the content and that also expresses our own interests," explains art director Lee Corbin.

2

be perfect for its readership. Newspaper headlines, by contrast, should have nothing "tricksy" about them; they need to be clear, clean, and unambiguous in their design. This is not to say that serifs can't be used for newspaper headlines; many quality papers use italics and serifs in headlines to impart a gravitas and quality that sans serif heads sometimes lack.

Readability and usability are the main considerations when choosing a body typeface because of its vital role in communicating the editorial message. Broadly speaking, we are more accustomed to reading serif faces, and traditionally, these are used in long columns of text, such as feature pages, with sans serif faces offering visual variation through their use in shorter texts (news pages, reviews,

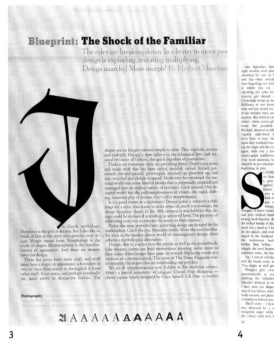

box text, and so forth). The use of a serif typeface gives a formal feel, while a sans serif face has a more relaxed, contemporary look. If a letterform is curvaceous and flowing like a script face, this delivers a softer feeling, whereas a hard-edged, Germanic gothic typeface makes a very different statement (but as both of these are very hard to read, neither should be considered for large amounts of body copy). Type is meant to be read as a shape, and sometimes as a visual element in its own right. It is one of the most flexible elements of editorial design—the stylistic muscle of a publication.

Above left A great combination of fonts underpins *The New York Times Magazine* (**3**): Cheltenham (redesigned by Jonathan Hoefler), Stymie (redesigned by Cyrus Highsmith and Matthew Carter), Garamond, and Helvetica. The designer's care and love of typography are particularly in evidence in this issue about design. As art director Janet Froelich explains, "This page serves as an introduction to the entire issue, it telegraphs to the reader that they will be reading and discovering ideas about design and culture. That mission drives the design, the idea of which was to present the history of typography in a concise, telegraphic fashion. We asked the typographer Tobias Frere-Jones to choose twelve fonts that presented the history of type, from Old English through to grunge style. We began the story in the magazine with an initial cap from one of those fonts, and all of those fonts are represented at the bottom of this title page with the letter 'A.' The design is satisfying because the hierarchy of information is clear, the proportions are classic, and the letterforms are both beautiful and informational."

Above and left Too many publishers, editors, and designers fear that large blocks of text will deter a reader. But used as shapes and tones, blocks of text can offer an elegant, simple beauty. David Hillman on *Nova* (**4**) happily filled spreads with nothing but dense columns of text together with pull-quotes or drop caps, while this issue of *Emigre* (**5**) on David Carson uses just text and folios to express an intensely intellectual dialogue.

Right At design magazine *Metropolis* (**1**), creative director Criswell Lappin is not afraid to experiment with guest headline fonts if such an approach works for a particular piece. While fonts for body text and caption information stay consistent (Bodoni Book and Trade Gothic), the typography used in headlines is often dictated by the story, especially if a specific font or stylistic treatment relates to the content. This is a significant part of the *Metropolis* brand and is the opposite of the standard "house fonts" system used in most publications. This opener for a 20-page feature on the new Seattle Public Library, designed by Rem Koolhaas, is a good example. Driven by the concept of the building, "The main idea was to identify the building as a collaborative project rather than attribute the building to one iconic architect, which is so often the norm with a well-publicized building like this," explains Lappin. "The names on the first page function as an extensive byline for the project, and the list is cropped to indicate that there are more participants. We have the liberty to do this because of the subject we cover—design. There are not many magazines where I think this system would work. Sometimes we have a feature well where each headline is set in a different typeface, but it still works because it is done smartly with consideration to the content of each piece."

1

Type use in newspapers

While typography underpins the design of all editorial matter, its use in newspapers differs from that in magazines. As Mark Porter explains, "In newspapers the first priority is always legibility of typefaces and readability of pages. Only after that do you think about using type to establish a distinctive voice for the paper, and try and create beautiful and dramatic typographic design." In terms of key font considerations for handling typeface in newspapers, Porter adds, "Text legibility is by far the most crucial. In display type, color and range of weights also become more important." Porter's introduction of the custom-designed Egyptian for *The Guardian* as both headline and body font is unusual, but, with more than two hundred weights, the font shows a versatility and ability to perform in its different roles that is rare for a single typeface.

In introducing new fonts to a publication, whether commissioned or existing, the creative director must ensure that the relationship of the type to the brand,

2

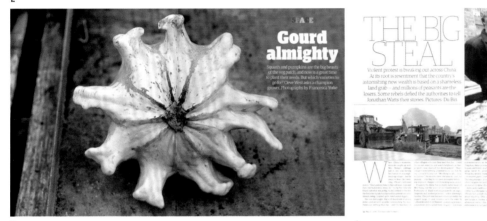

3

4

content, and other design elements works as well as it can. They do this by trusting their instinct and by their understanding of the publication, says Mark Porter:

> *Egyptian was commissioned for* The Guardian *because we wanted something that had some of the properties of a classic serif typeface, while remaining modern and distinctive. It had to be legible and flexible and have a strong personality, and it succeeds in this. The range of weights also enables us to avoid the system, which most other newspapers adopt, of mixing a serif and a sans—in most sections we only use Egyptian, which gives the paper a unique typographic character.*

Type as expression

In layouts where it isn't possible to use images, or where images are dull, typography has to be handled particularly creatively, a role that evokes medieval illuminated manuscripts and continues with imageless advertising posters. The confident editorial designer can have a huge amount of fun with type. In fact, the duller the material, image, or copy, the greater the challenge for the designer to employ imaginative and creative skills, using techniques such as typeface

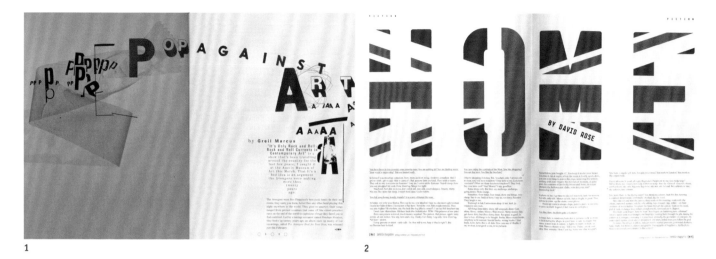

1

2

Above These two spreads show very different but equally strong and innovative use of type as illustration. For *Speak* magazine (**1**), Martin Venezky draws on his collection of typographic ephemera to construct an innovative illustration for the subject—an exploration of the relationship between rock and contemporary art. Equally appropriate and reflective of its subject is Vince Frost's typographic illustration for a *Zembla* feature about nationalism (**2**).

juxtaposition, changing the shape and arrangement of elements or letterforms, and creating scale contrast. Look at concrete poetry, such as the work of Carlos Drummond de Andrade, Stéphane Mallarmé, George Herbert, and Ian Hamilton Finlay; look at Russian constructivism, the Bauhaus, and the Dadaists, and, later, the work of Otto Storch on *McCall's* magazine, Alexey Brodovitch on *Harper's Bazaar*, Tom Wolsey on *Queen* and *Town*, Harri Peccinotti on *Nova*, Neville Brody on *The Face*, Fabien Baron on *Vogue*, David Carson on *Beach Culture* and *RayGun*, Martin Venezky on *Speak,* and Vince Frost on *Zembla* to see some great examples of type used in this way.

Type as illustration

While type is, at its most basic, a method of conveying words, it can, of course, do much more. An editorial designer will use type to interpret and express the editorial, communicate meaning, offer variation, work with the image and other

Right On *Inside* magazine (**3**), Jeffrey Docherty uses type craft to distinguish individual departments in the magazine "so that they are sufficiently distinct from each other, but still recognizably part of a brand." He keeps font use to a minimum: separate faces for body and heads, and a third face, which may be in complete contrast to the others. "This third typeface can change the mood of the magazine. On this spread about a library in Cottbus, Germany, the architects used a letter motif to surround the entire exterior paneling of the building, which I decided to replicate in the titling. Interlinking the individual letters and stacking them one above the other gave an automatic visual reference to the project," says Docherty.

3

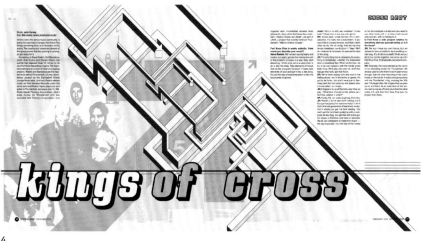

kings of cross

4

primal

scream

5

6

Left Three spreads that use type as illustration in very different ways. The scale and manipulation of headlines in the magazine *Inner Loop* (**4**) were entirely in keeping with the frenetic, anarchic tone of this indie dance magazine. "Because the two headline faces were quite different in style (military-style template and a kind of script), they helped to lend each feature its own identity within the mag, but also combined to give the whole a distinct *Inner Loop* feel. I think they expressed the different voices of those being interviewed. They were also very robust faces, which could stand out from strong graphic elements such as running across a bitmapped photo," says art director Ivan Cottrell. On *RayGun* (**5**) David Carson consistently used type to form illustrations, hand-lettering or combining it with imagery to create the kind of work seen more frequently in the art world than the print world. Fernando Gutiérrez's use of type in *Vanidad* (**6**) is not just a wonderfully decorative juxtaposition and skillful arrangement of type and image; it breaks down the words of the subject, "Belle de Jour," into letters—a fitting illustration for a call girl who became famous for the entries in her online diaries. The crop and scale of "Belle de Jour" on the right-hand page is elegantly balanced by the headline on the far left, creating an arrangement over the spread that is harmonious and tender but has massive impact.

1

Above and below Letterpress is a highly illustrative form of typography that can be used to build a layout, as in this cover from *FT The Business* (**1**) by British letterpress lecturer and illustrator Alan Kitching, and also in this issue of *Zembla* (**2**).

design elements to convey emotions or make symbolic or lateral links. These can be achieved in a number of ways: Manipulation can offer opportunities for creating links between, or playing off, the type, image, and meaning; combining different weights, leadings, sizes, and ranging can offer expressive abstract or literal interpretations of the content; the use of a particular clichéd typeface, such as a gothic or typewriter face, can create a symbolic or cultural link that immediately conveys something about the content.

Finding type

Whether it is in the form of cookie cutters, fridge magnets, pasta shapes, or hair accessories, type can be found in many ways. Martin Venezky scours flea markets and antique stores for it; Vince Frost has probably visited every letterpress foundry in England in search of it; Alan Kitching has made a career from illustrating with it; and most designers will probably have some quirky examples of it knocking around. Letterpress and wood type now have a limited use, and most unusual forms of type are used for display rather than for body copy, but finding such three-dimensional, physical examples of type can prove inspirational to designers who now rarely handle physical examples of type, instead obtaining fonts through print and online font catalogs and foundries, most of which can supply fonts immediately via the Internet.

2

Profile: *Zembla*

Literary culture magazine *Zembla* (named after a fictional northern land in Vladimir Nabokov's *Pale Fire*), whose byline is "fun with words," was launched in 2004 by Simon Finch, edited in London, U.K., by Dan Crowe and designed in Melbourne, Australia, by Vince Frost at EmeryFrost and in London by Matt Willey at Frost Design. Its union of substance and style set it apart from many special interest magazines, and it playfully subverted the often dour and incestuous world of book reviewing, which sees authors from the same publishing houses reviewing each other's books in broadsheet supplements, by asking authors to review their own books. In designing the publication with a frenetic, in-your-face typographic approach and bold structural format, Vince Frost has been charged with

treating the content with disdain by making text illegible. The example below, taken from the launch issue, shows the entire text of one story knocked out of a black panel, which is cropped tight around the text area, forming a ragged right edge against the white of the page, what some might view as deliberately obstructive design. But Frost says, "I did not mean to upset the writer or reader. I normally stand back and let the writer be the hero. However, I simply wanted to try something different for a change rather than just do the same thing all the time. It feels good to get that kind of reaction as opposed to being 'nice.' Graphic designers are normally invisible and not normally the heroes. I find this frustrating as it is a barrier between the 'design world' and the public domain."

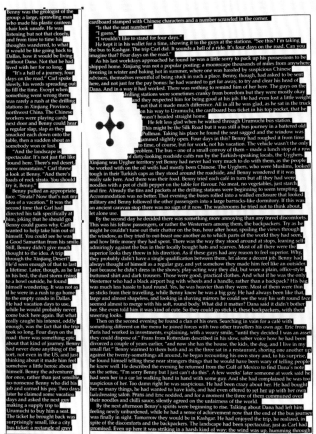

Custom-designed type

As in any creative industry, type design and use tend to follow trends, which can result in publications looking very similar. An obvious way to distinguish yourself from the crowd is to commission your own font family. As well as creating a unique identity, such a move also affords you a font that truly expresses and conveys your brand attributes. *Flaunt, Another Magazine,* and *The Guardian* newspaper are all titles that have taken this route recently. Lee Corbin at *Flaunt* felt it was time for change, so decided to introduce a custom font to the new body fonts, Berthold Akzidenz Grotesk and Century Schoolbook, both of which he believes fit very well with the new custom faces.

In the previous year of issues we used Gotham and Hoefler Text for our standard faces. Both faces were designed by Hoefler & Frere-Jones, so they worked well together. Gotham has a strong character that does not call too much attention to itself, but in its heavier weights it really dominates the area around it. We matched Gotham up with Hoefler because Hoefler has such a classic look. It's also an enormous family, which gave us plenty of options.

With a new logo came the need for a new font, which Corbin designed in two weights—a bold and a light face—with more variations to come.

The logo came first, but I was already interested in creating an extrabold face based on geometric figures. I exploited the use of symbols, like crosses, x's, triangles, and circles, as letterforms. Because that's what I did in the logo, this gave the face more character and reinforced the new logo. It was also used very sparingly so that both the logo and typeface don't become tired.

A final few words of warning on using type: The development of prepress technology meant the sudden demise of professionals such as the typesetter and compositor, roles that became the responsibility of the designer and the computer. The latter's default settings in programs such as QuarkXPress and Adobe InDesign should not always be assumed to be right for your publication, so an understanding of, and care with, kerning, hyphenation, leading, letter

Below In 2006 *Flaunt* magazine created its own typeface (**1**), (**2**), "because there wasn't anything preexisting that possessed the feel I wanted for the new issues, but also because a new typeface would be exclusive to our magazine," says art director Lee Corbin. He has built many alternate characters into the new *Flaunt* face so that "it will allow for more unique combinations in titles. It was based on the logotype that I created for the redesign, so that it would reinforce the new identity beyond the cover of each issue." Of the two initial weights shown here, the bold face is used more sparingly and with ample space around the individual characters. "The letters that make up the new *Flaunt* logo come from this alphabet, so the use of the face in the magazine is meant to reinforce the new identity. The thin face is used more frequently and more experimentally. It is also displayed larger as it is not so dense," explains Corbin.

1

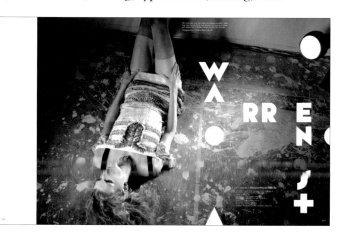

2

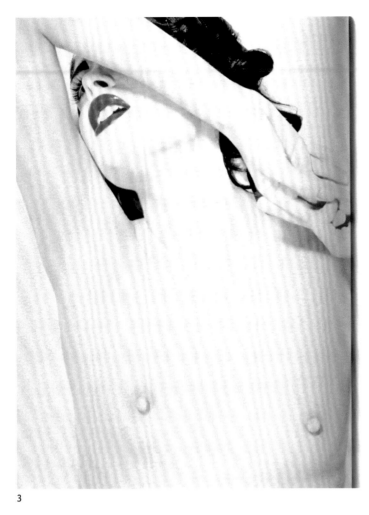

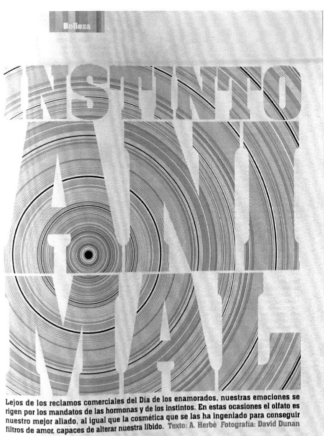

INSTINTO ANIMAL

Lejos de los reclamos comerciales del Día de los enamorados, nuestras emociones se rigen por los mandatos de las hormonas y de los instintos. En estas ocasiones el olfato es nuestro mejor aliado, al igual que la cosmética que se las ha ingeniado para conseguir filtros de amor, capaces de alterar nuestra libido. Texto: A. Herbé Fotografía: David Dunan

3

spacing, trapping, and tracking is necessary. Similarly, page composition and make-up, which used to involve physically moving elements such as display text, galleys, and images around three-dimensional space, is now all done on screen. Arguments rage as to whether this is a good or bad thing, but when construction of a three-dimensional delivery medium is undertaken in a two-dimensional environment, there is unquestionably a physical and emotional diminishment. Try to compensate for this by handling and playing with paper, color, inks, photographs, and mark-making implements as much as possible. Print out layouts as often as you can—they are very different from screen layouts. Always proof on page rather than on screen and never rely solely on a program's spell-check function. Read all headlines, display text, and captions carefully; these are often spelled incorrectly because the copy editor's focus is on body copy and no one thinks to check the display text. Also make sure that ligatures, hyphenation, and kerning are corrected.

Above A brilliantly expressive use of type by Fernando Gutiérrez on *Vanidad* (**3**). Think about how the design elements make it work. Consider, in particular, scale, cropping, balance, and arrangement.

Artwork skills and production issues

Some designers manage to design perfectly well with minimal software skills, but in magazine or newspaper design, where the need to react quickly and effectively to layout and flatplan changes is essential, a competent designer will need a strong

Above Color swatch books are a vital tool for designers, who should never rely solely on the colors on their screen, no matter how well calibrated it is. They need to be updated regularly as colors fade—when not in use, make sure swatch books are kept in their case. The most widely used color system is the Pantone Matching System, which will also indicate, where relevant, the CMYK equivalent.

Opposite The seventh issue of *Oz* magazine is one of the publication's most famous, thanks to its iconic Bob Dylan cover by Martin Sharp. Sharp exploited new printing techniques to create an image that expressed the experimental druggy mood, music, and culture of the time.

working knowledge of design, layout, and image manipulation software programs (QuarkXPress, InDesign, Photoshop, Illustrator, and Freehand) and good technical skills and knowledge. Screen calibration, printing and its processes, reproduction, color management, color separation, photography, and illustration and how best to acquire them, and when and how to use information graphics are all artwork skills—the nuts and bolts of successful design.

Software

With the arrival of the Apple computer in the 1980s came the desktop publishing revolution, and software developers were quick to publish programs that enabled anyone with a rudimentary understanding of page makeup and a technological bent to produce their own magazine or book. Such programs have developed to the point where they have made once-integral aspects of printing—repro, typesetting, and compositing—redundant, making the designer and production editor responsible for all these skills. The complexity and ability of these programs is vast, and being able to experiment and get the most out of them depends on your knowledge and understanding, as is the case with any tool or material.

Screen calibration

Professional screen calibration software (a device that sits on the screen and measures its appearance) is the only absolute method of ensuring that what you see on-screen is an accurate representation of what you get on the page, which is of vital importance in designing. But it is possible to get good screen calibration cheaply—Apple users, for example, might find that Berg Design's shareware application, SuperCal, makes a very noticeable difference—or even free, by using your computer's own color balance features in the gamma control panel. Photoshop has an excellent step-by-step guide to using this control panel in its help menu.

Printing

The best printer is, to begin with, one who prints a lot of similar work to yours, so look through such publications and find the name of the printer, or contact the publication's production editor and ask for it. But other factors should be considered, too: Can the printer and press handle the print run? Can they deal with your stock and chosen format? Can you get an ICC Profile (*see* p.145) off the press that you can apply to your desktop system? Will the printer be able to meet the turnaround time you require? Is their color repro quality adequate for your needs? Is their fee acceptable? It is always a good idea to get quotes from three or four printers before making your decision, but communication is the most important factor—a good, long-term relationship with your printer will reap massive rewards. Printers have knowledge, experience, and skills that you will never have, so nurture your relationship with them to get the best from them. In the 1960s, antiestablishment magazine *Oz* and its printer exploited the printing process and emerging technologies within it to deliver techniques that had never been seen before, including color washes, split-fountain inking (where

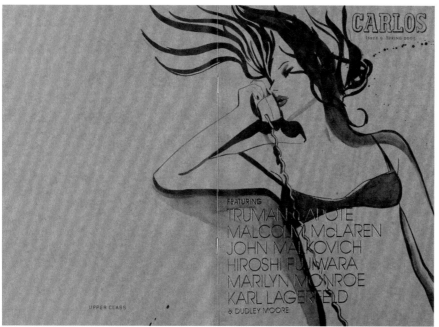

1

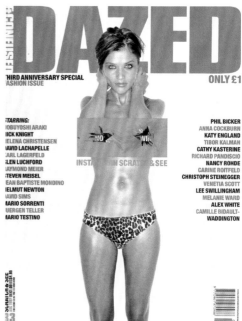

2

This page Different uses of special techniques: on first-class Virgin Atlantic magazine *Carlos* (**1**) and *Dazed & Confused* magazine (**2**), metallic embossing adds an unusual dimension. On *Carlos*, it is particularly effective used on simple card, offering an unexpected take on luxury publishing. For indie title *Amelia's Magazine* (**3**), the cover was wrapped in a cutout by artist and illustrator Rob Ryan, giving readers a limited edition piece of art, but also turning a two-dimensional cover into a three-dimensional one. *Twen* (**4**) often used foldouts to enable the use of great visual elements (including games, art reproductions, and topical photo stories), and *Esopus* (**5**) takes the concept of foldout farther with its 3-D art pop-ups.

3

4

5

two colors are printed simultaneously through one divided ink supply) and fifth colors, including metallics. Such experimentation was not simply stylistic posing; it visually echoed and reinforced the publication's editorial stance of experimentation and in-your-face, maverick antiauthoritarianism.

Peculiarities in newspaper printing

How many times have you seen newspapers in which the text is completely illegible? Or in which the pictures make your eyes go funny? Usually, this is due to misregistration, where the four color plates have not been laid down exactly on top of each other. When this happens the page is said to be "out of register," and it will affect all the pages in that section. Given the speed of newspaper production and the huge lengths of runs, there is little the designer can do about this, but the other common problem with newspapers—ink bleed and consequent fills—can be controlled. Because of newsprint's lack of coating and absorbency, it is important that designers choose the right fonts where fill will not be a problem (such as Bell Centennial, designed by Matthew Carter for telephone directories, which deals specifically with the problem of fill). Equally, WOBs and color use on fonts and boxes should be carefully considered when laying out on newspaper stock.

Repro houses

Prepress systems and digital photography are making the traditional functions of the repro houses (scanning and proofing transparencies and working with digital images) redundant, but they are still very useful to the picture editor and designer. Their understanding of color, out-of-camera manipulation, and achieving the optimum results for your images will nearly always be greater than yours, as will their scanning equipment, so if you can afford to, use a repro house.

Color management

Reproducing color is complicated, as there are three different aspects that need to be addressed: what the eye sees, what the monitor shows, and what a print nozzle produces. Fortunately, the print industry has developed a color management system that gives an image a profile (called an International Color Consortium, or ICC Profile) so that as it moves through the printing process— from original to monitor viewing, separation, prepress, proofing, plating, and printing—all the tools involved are calibrated and adjusted to ensure color accuracy and consistency. If your publication is being produced without ICC Profiling, stick to "safe" colors when making up color palettes or using spot colors (check the gamut warnings for these, which indicate when a selected color will alter appearance when converted from RGB to CMYK), and don't rely on what's on screen. In such cases it is best to make up colors using a Pantone swatch book, which should be updated annually to allow for color fade. Be aware, however, that not all Pantone colors are reproducible in CMYK; if you want to use a Pantone color that brings up a gamut warning in your layout program, you may need to make the color up as a fifth one, in which case consult your printer about the best way forward.

1

Above Color and monochrome bars run along the side or bottom of the printed proof and enable both printer and designer to review all the color elements of the page (**1**). Proofs should also be checked for spelling and to ensure that all the content is there, that caption information and folios are correct, and that all bleeds and image alignments across the spreads are adequate.

Proofs and how to use them

There are a number of different quality proofs, and increasingly, printers are only offering PDF screen proofs free; all others have to be paid for. But it is worth budgeting for proofs, and, ideally, for the best available.

The best proofs are wet proofs, which are run from the plates that will produce your publication and are the closest approximation available. Next best are Cromalins and Matchprints, which are run from thin sheets of film and give a very good idea of everything except what will happen when the ink hits the paper. The most popular (and affordable) are digital prints such as inkjets, and of these, Irises, generated by a PostScript inkjet printer, give a good approximation of the final files. It is worth noting that all the above tend to show colors brighter than they will actually be printed.

Laserjet proofs are so poor that they can be badly misleading if you are looking at colors, but they can be useful for checking type, positions, and so on, particularly if you like to proof on page rather than on screen. Finally, there is the PDF proof, which, again, gives little indication of color output, but is useful for checking everything else.

Acquiring, evaluating, and using images

When working with a photograph, choose one aspect of it that is the heart of the image—it may be the framing, the density of color (a perfect blue sky or a rich red dress, the composition, the light, the subtlety of tones …). Whatever it is, a good image will have something that makes it stand out, and it's this that you want to maximize. Keep whatever it is in mind while you're working with the image—it may determine the shape, scale, or structure of a layout and will often be the most important element of it. If necessary, work with the printers at the soft-proof stage (on screen) to optimize this element. Their knowledge of color levels and how these will affect the image's reproduction will be greater than that of even the very best designer. But initially, consider the following.

How good is your original? Highlights and shadows should span the gamut from as light as possible to as dark as possible, with well-defined midtones. It is a good idea to ensure that tones, highlights, and shadows are brought to their optimum output in the prepress stage.

In CMYK, highlights should be set as: **C: 5% M: 4% Y: 4% K: 0%**

Midtones or gamma should be adjusted to improve overall brightness or darkness of the image without affecting the highlights adversely. To do this, use Photoshop's imageadjusting curves and raise or lower the curve at the 50-percent point until the brightness is accurate.

How does it look on the monitor? Assuming your monitor is calibrated correctly, what you see on it should be the very best approximation of what you will get

in print. So, if you're not happy with it on screen, fix it before it goes to press. Photoshop has a number of features that will improve images, but a very basic one is Unsharp Masking, which most professional bureaus use to improve the quality of an image. An average unsharp mask setting is amount: 160 percent; radius: 2 pixels; thresholds: 9 levels. Adjusting these settings will improve nearly all photographs.

Finding images

A good editorial designer will be constantly on the lookout for new photographers and illustrators, and will locate them through these routes:

BAD BIRDS
LYNNE ROBERTS-GOODWIN

Lynne Roberts-Goodwin's "Bad Birds" are portraits of long-dead birds from the collection of the Department of Ornithology at the Australian Museum in Sydney. They were photographed in the artist's studio with the assistance of Dr. Walter Bowles, the Department's Head Veterinarian, and his assistants. The initial twenty portraits were made from the Australian Avian collection, including native Australian bird species such as the Budgerigar and the Ring-Necked Parrot. The birds were placed as if they were in a museum diorama but without the painted backdrop. They all face away from the camera, but are nevertheless easily identifiable as species by plumage, markings, and relative differences in upper body proportions. The absence of the face confounds our anthropomorphic projections, frustrating our tendency to want to read certain kinds of temperament or character onto the faces of animals. Of course, even though the frontal view isn't really necessary for species classification, it helps immeasurably in the identification of individuals, as official identity documents such as passports have long demonstrated. Indeed, a different strand of Roberts-Goodwin's own work acknowledges the utility of the conventional portrait view. In another of her animal projects, she worked with scientists on location at isolated royal falcon preserves in the Persian Gulf, in Oman, and the United Arab Emirates, recording royal hunting birds who were deliberately posed facing the camera in order to satisfy her royal clients. Roberts-Goodwin is now helping ornithologists in the region to develop animal passports that will at some point assist in the regulation of the international rare species trade and the eradication of the illicit hunting-bird market.

The reason why Roberts-Goodwin's bird photographs can simultaneously function in both artistic and ornithological spheres is that her images are highly exact, which is to say that the metonymy of plumage enables a surprising degree of information. For the "Bad Birds," she knew that rear-facing and less conventionally informative views would show the color shifts and marks in plumage that differentiate males from females and juveniles from adults, and even breeding from non-breeding birds. But at the same time she understood that turning the birds away, despite the ornithologically functional result, would inevitably suggest that she—or the birds—refused to disclose something essential of their character. Her series' title, "Bad Birds," amplifies this uncertainty. For much as we might like to project human emotions onto birds (and imagine that these once talkative animals are like bad children, told to stand in a corner, face to the wall, or else suppose instead that the birds are shy, refusing to meet the camera's gaze), it is more the case that her "Bad Birds" are, first, the museum's imperfect, bad specimens and, second, that the categorization implied by "Bad Birds" invites precisely the kinds of psychological projection described above, even if to confound it by a studied, documentary neutrality.
– Charles Green

Photos courtesy of the artist and Brenman Galleries, Sydney, Australia.

2

LUST

AN EXTRACT FROM THE NOVEL SEX, SUGAR & SHOPPIN' BY STEVE LOMAX

3

Left Choosing an appropriate image that "fits" both the text and the tone of the magazine can result in a spread that is compelling in itself, but also reinforces the brand and its attributes. *Cabinet*'s (**2**) use of photography in this spread emphasizes the title's studied, thoughtful approach to art; *Garageland*'s (**3**) more grungy, in-your-face image reflects the DIY art aesthetic the publication promotes. Both have an impact on the spread, but both also say something about their differing attitudes to art.

IV: Essential design skills **147**

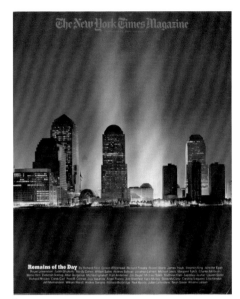

1

Above Good use of imagery is more than expressive; it can define an era or event in a way that words simply cannot. The ability to find or create such imagery is a crucial part of a designer's skill, as Janet Froelich recalls while discussing the aftermath of 9/11. "9/11 happened on a Tuesday morning. *The New York Times Magazine* (**1**), which is on a weekly schedule, completes each issue on a Friday, nine days before the publication date. So we had three days to tear apart the September 23 issue and remake it in response to 9/11. During those terrible days, we had to try to imagine what our readers would want to know about two weeks later. We had to think forward, while almost everyone was simply reacting to the nightmare of what had just happened. One of the ideas was to ask artists and architects for their thoughts on a memorial. Two artists, Paul Myoda and Julian LaVerdiere, had been part of a group working in studios in one of the Twin Towers. They came up with a plan, which they called 'Towers of Light,' in which they imagined two powerful beams of light, positioned in the center of the footprint and pointed towards the sky. I worked with a photograph by Fred Conrad, which showed lower Manhattan the night of the disaster with that awful arc of dust and debris, and with a Photoshop artist to create the vision of those twin beams of light. That became our cover and, one year later, it became one of the most moving memorials to the events of 9/11, as the Lower Manhattan Development Corporation made it a reality. It is hard to describe the combined feeling of pride and awe, to see the cover of our magazine become a living memorial, viewable for 50 miles [80 kilometers] in all directions, to such a terrible event."

Agencies: These will have Web sites and portfolios showing their clients' work, and are a good route for the designer looking for ideas of style, tone, and so on. Do online searches and contact professional bodies (such as the Association of Illustrators in the U.K. and the American Society of Media Photographers in the U.S.) to find these.

Degree shows: Students' work will reflect cultural trends and offer exciting new directions and visual styles, so go to as many students' exhibitions as possible and collect names and examples of work from those you like. Pick up cards giving contact details to keep on file in your office.

Other publications: Publications targeting the creative industries will often showcase and use the work of the best new and emerging image-makers. Trend-setting style bibles and alternative magazines offer good sources of new work, too.

Other media: Areas such as motion graphics, animation, television "stings," and title design give you insight into visual trends and new image-makers to approach.

Awards books and CDs: Most of the creative professional bodies (American Institute of Graphic Arts, D&AD [Design & Art Direction], Association of Photographers, Association of Illustrators, etc.) have annual awards ceremonies for professionals and students, both of which offer good sources of practitioners.

DIY: You are a visual creative, so why not build up your own stock library comprised of your friends' and your own work? Encourage your designers (and give them the time, if possible) to take photos, draw, and continue the mark-making they learned at college. This will help all of you to develop ideas and directions for layouts and keep up your creative energy, and it may also result in affordable visuals that can be used in those layouts.

Portfolios and commissioning

When you find image-makers you like, invite them to bring in their portfolio. Set aside enough time to go through it properly with them, ask them questions about the pieces and the way they work. They may not be very confident or articulate, particularly if they are young or students, so be patient, encourage them, and let their work speak for them.

When it comes to commissioning, the kind of brief you give will determine to a large degree what is produced, so be clear about what you want and communicate this. Do you want an alternative view to the text, or something that visualizes it literally, or a series that provides visual reportage of a specific nature? Do you want the photographer or illustrator to read all the text (if there is any), a précis of it, or none of it? However clear the brief is, talk to the people you have commissioned to make sure they understand what's required. Make sure deadline, fee, and administrative requirements (invoicing, expenses, payment, tax matters) are clear. And finally, make sure that the shoot, if there is one, is organized.

Information graphics

Along with photography and illustration, information graphics offer the designer a great visual tool, and, with the advent of the internet, they have seen a massive resurgence. Their ability to act as decorative images and simplify complex information is perfect for the visual information culture of the twenty-first century, but they were actually popularized some seventy-five years ago, when designer and typographer Thomas Maitland Cleland devised a format for business magazine *Fortune* that unified editorial and visual concepts in a completely new way. Since then, magazines such as the *Radio Times*, *Wired*, *FT The Business,* and news magazines worldwide, particularly graphics-heavy newspapers such as *USA Today*, have refined and made ever-greater use of information graphics. When commissioning people to produce information graphics, designers should take as much care as they would with any other image-maker.

2

3

4

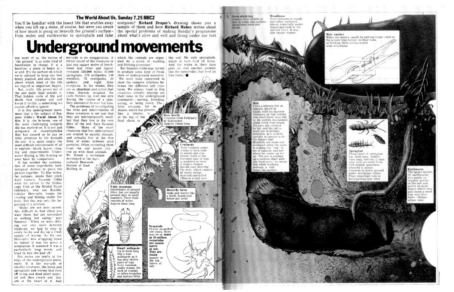

5

Above and left On the television listings magazine *Radio Times*, David Driver used a number of techniques and styles to deliver information on subjects as diverse as how the Apollo and Soyuz spacecraft docked (2), how an orchestra works (3), and how the police districts in Kojak's New York were laid out (4). A firm favorite were the graphics of Richard Draper, who devised pictorial approaches to information graphics, as seen here in the "Underground movements" panel (5). Driver also used montage, incorporating graphic panels that crossed and unified spreads, and illustrated covers to enhance visually and consistently engage the readership of a publication that, by necessity, was text-heavy and densely packed.

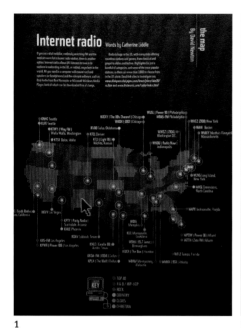

1

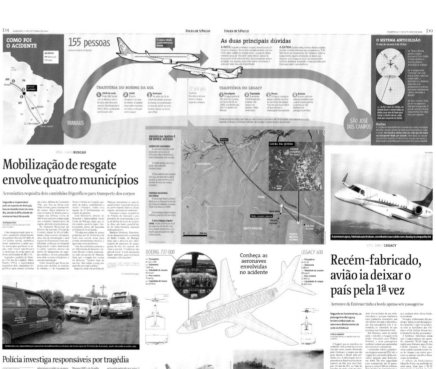

2

Above The use of information graphics on *FT The Business* was inspired by the Internet (**1**), but made great by art director Gary Cook's love of graphic artists, according to its editor, Michael Watts. Cook's remit on the magazine "was to try and display information in an unexpected way. Graphics had only really been used to illustrate complex stories in the newspaper, but we felt that bright visual elements like this could be used in different ways in a new culture that relied heavily on imagery from television and the Web. Michael had an idea that every week we would do a map on the inside back cover: a random display of information by David Newton. This was one of the most popular pages in the magazine. Sometimes it showed a visual breakdown of the average age of death across China, other times the amount of beehives kept in London, and so on—random every week." This use of information graphics was not confined to the back page, and often featured as the sole illustrative device in a spread (**2**).

Right For this spread about a midair plane collision (**3**), Brazilian newspaper *Folha de S.Paulo* uses information graphics to illustrate aspects of the tragedy, such as the airplanes' routes, locations, and designs that photography could not illustrate. They act as additional information rather than graphic replacements for photography, and, through the use of such devices, readers can be given a more thorough understanding of an event.

3

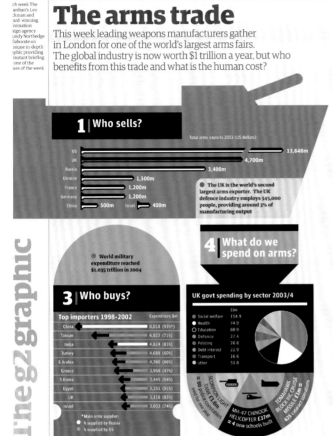

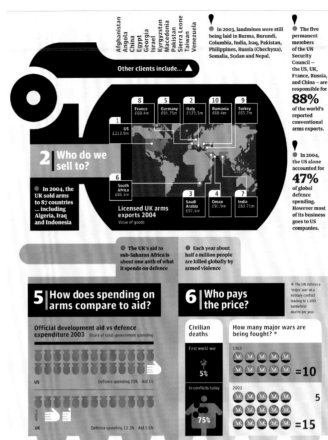

The arms trade

This week leading weapons manufacturers gather in London for one of the world's largest arms fairs. The global industry is now worth $1 trillion a year, but who benefits from this trade and what is the human cost?

"The g2 graphic"

1 | Who sells?

Total arms exports 2003 (US dollars)

- US 13,648m
- UK 4,700m
- Russia 3,400m
- Ukraine 1,500m
- France 1,200m
- Germany 1,200m
- China 500m
- Israel 400m

● The UK is the world's second largest arms exporter. The UK defence industry employs 345,000 people, providing around 3% of manufacturing output

3 | Who buys?

● World military expenditure reached $1.035 trillion in 2004

Top importers 1998-2002 — Expenditure $m

- China 8,818 (93%*)
- Taiwan 6,822 (71%)
- India 4,824 (81%)
- Turkey 4,688 (60%)
- S.Arabia 4,360 (64%)
- Greece 3,958 (47%)
- S.Korea 3,445 (64%)
- Egypt 3,251 (74%)
- UK 3,116 (82%)
- Israel 3,033 (74%)

* Main arms supplier:
■ % supplied by Russia
□ % supplied by US

4 | What do we spend on arms?

UK govt spending by sector 2003/4

	£bn
● Social welfare	154.9
● Health	74.9
○ Education	60.9
● Defence	27.4
● Policing	26.8
● Debt interest	22.9
● Transport	16.6
■ other	51.8

SCORPION LIGHT TANK £1.6m = 80 police constables paid for one year

MH-47 CHINOOK HELICOPTER £37m = 4 new schools built

TOMAHAWK BLOCK IIIC CRUISE MISSILE £1m = 625 cataract operations

2 | Who do we sell to?

Other clients include... ▲

Afghanistan, Angola, China, Egypt, Israel, Kyrgyzstan, Macedonia, Pakistan, Sierra Leone, Taiwan, Venezuela

● In 2004, the UK sold arms to 87 countries ... including Algeria, Iraq and Indonesia

Licensed UK arms exports 2004
Value of goods

- 8 France £69.4m
- 5 Germany £91.75m
- 2 Italy £123.5m
- 10 Romania £60.4m
- 9 Turkey £65.7m
- 1 US £213.9m
- 6 South Africa £85.5m
- 3 Saudi Arabia £97.5m
- 4 Oman £91.9m
- 7 India £83.71m

● In 2003, landmines were still being laid in Burma, Burundi, Columbia, India, Iraq, Pakistan, Philippines, Russia (Chechnya), Somalia, Sudan and Nepal.

● The five permanent members of the UN Security Council – the US, UK, France, Russia, and China – are responsible for **88%** of the world's reported conventional arms exports.

● In 2004, the US alone accounted for **47%** of global defence spending. However most of its business goes to US companies.

● The UK's aid to sub-Saharan Africa is about one 40th of what it spends on defence

● Each year about half a million people are killed globally by armed violence

5 | How does spending on arms compare to aid?

Official development aid vs defence expenditure 2003 — Share of total government spending

US — Defence spending 25% — Aid 1%

UK — Defence spending 13.3% — Aid 1.6%

6 | Who pays the price?

Civilian deaths

First world war — 5%

In conflicts today — 75%

How many major wars are being fought? *

1965 — =10

2003 — 5 — =15

* The UN defines a 'major war' as a military conflict leading to 1,000 battlefield deaths per year.

4

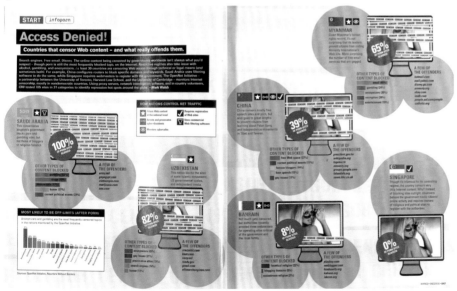

START [Infoporn]

Access Denied!

Countries that censor Web content – and what really offends them.

MYANMAR — 65%
CHINA — 39%
SAUDI ARABIA — 100%
UZBEKISTAN — 82%
BAHRAIN — 8%
SINGAPORE — 0%

HOW NATIONS CONTROL NET TRAFFIC

MOST LIKELY TO BE OFF-LIMITS (AFTER PORN)

5

Above and left Information graphics can offer attributes that other visuals can't. In this spread from *The Guardian* (4) illustrating the arms trade, the shapes of the various weapons immediately impart knowledge and communicate figures associated with specific arms. This *Wired* (5) spread on Internet access worldwide is less successful, but still offers an arresting and accessible wealth of information.

IV: Essential design skills **151**

Tips and techniques for avoiding monotonous layouts:

- Try to vary your approach to constructing layouts.
- Experiment with building up a page from color blocks or cutouts, which bring white space and geometric considerations into play alongside text, images, and other design elements.
- Visualize each layout as a separate entity with the use of the style book.

Right and below German weekly news magazine *Stern*'s cover, feature pages, and photographic spreads all display a lively, populist approach to the news. Bold crops such as the face halved by the edge of the cover (**2**), along with a straightforward three-column grid on feature pages (**3**) and ever-popular aerial photography (**1**), all appeal to a broad audience.

Consistency without monotony

One of the editorial designer's most challenging—and enjoyable—tasks is creating a distinct, individual product or issue that is obviously part of a strong brand, but does not look or feel the same with every issue. How do they do it? With a good grid that is flexible, pagination that ensures similar spreads are interspersed with other pages, and inventive use of the design elements at their disposal.

A daily newspaper or weekly news-based magazine will have tight deadlines and short lead times, and the design has to be led by functionality and legibility.

1

2

3

As a result, the designer has to develop and adopt a problem-solving approach, setting in place a grid and production system that enables fast layouts, fast repro and printing, and a design approach that is ordered and organized. But one need only compare a few of these titles to see that, within such order, there are still many opportunities for inventive structure, different directions, and wholly distinct results, as seen here in these weekly news titles from Europe and America.

An annual, monthly, or quarterly publication has the luxuries of more loosely structured frameworks, a bigger visuals budget, greater flexibility in such elements as grid, fonts, and image treatment, and the ability to experiment almost

Below Where American news magazines once exhibited a conservative style of design to convey seriousness and depth, they are now more relaxed in their designs. *Time* magazine's cover logo and trademark red borders (**4**) are skillfully carried inside the magazine and onto headlines and straplines on the news pages (**5**), (**6**), where layouts are lively and original. The cover on U.K. financial magazine *The Economist* (**7**) is witty and eye-catching—in contrast to the calm orderliness of its feature pages. Again, this illustrates how magazines can remain original and engaging from issue to issue and page to page.

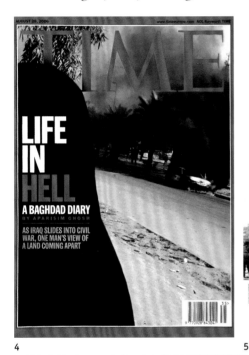

4

North Korea's Rising Waters

The Summer Just Got Hotter

STAR RECRUITS

Much Ado About Abe

OPERATION: KILL KERMIT

5

6

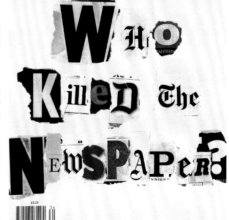

7

Profile: *Speak*

Dan Rolleri, editor and publisher of *Speak* magazine, rode the crest of the independent magazine wave when he came out of college in the mid-1990s. The desktop publishing revolution ushered in by microcomputers and publishing programs had spawned thousands of magazines dealing with hundreds of specialities, and Rolleri decided to follow suit.

Rolleri's first title—a music video trade magazine—was, in his own words, "a horrible failure." His second attempt was the popular culture magazine *Speak*, which is widely regarded as an excellent example of the genre. This success was due in no small part to the combative but collaborative relationship that existed between Rolleri and the publication's art director, Martin Venezky. And, from the outset, Rolleri had strong ideas about his magazine's designer:

> At the time, there was a glut of magazines on the newsstand, and I wanted Speak to stand out visually. It was important that the art director be willing to push the form. It was also important that the art director have an organic quality about his or her work. But more than anything, it was important that I liked the art director's work (not a small challenge because I didn't like much).

Rolleri's ensuing stormy relationship with Venezky, which included the two suing each other, is well documented, but what is less well-known are Rolleri's very strong feelings and understanding of the designer's impact on the magazine:

> It was important for me that the art director be intellectually driven and curious about the magazine's content, as opposed to only looking to follow a template or showcase his or her abilities separate from the magazine.

Rolleri knew that Venezky had all that, and more:

> He reads, he thinks, he's extremely diligent. I wanted to match his effort, to get the editorial to live up to the design. I probably failed more times than I succeeded, but after my time with Martin I can't imagine ever working with another designer again.

> "Editors and art directors need to have a dynamic rapport. And healthy respect. And an ability to argue and to sometimes lose."

MARTIN VENEZKY, ART DIRECTOR, *SPEAK*

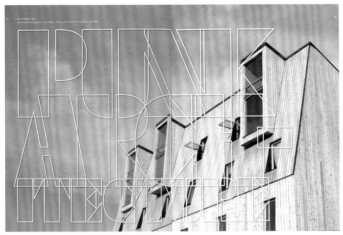

1

2

3

4

endlessly with layouts. But this can present its own problems; it can be difficult to adhere to the brand message when presented with greater freedom, so it is important to find a balance between those elements that need to be constant (brand and identity) and those that will change with every issue.

The house style and style books

Determining the role of design in delivering a brand's attributes to its users results in a house style. This is a "look" created by the selection and juxtaposition of the various elements—fonts, grids, format, stock, use of space, and so on—as described in Chapter III. For example, the house style might dictate that four sizes of headlines are used throughout the publication, or that a headline of a particular size is always used over two lines, or that images are never used below a certain size. In order for this prescription to be maintained, adhered to, and updated or revised properly, a style sheet or style book should be created in the appropriate desktop publishing program to cover all visual and textual aspects of the publication. The latter aspect is usually produced by the chief editor, but the former is the remit of the art department, which will produce a style book detailing all the design elements: fonts (including display ones such as headlines, folios, bylines, pull-quotes, and captions, plus all the body copy fonts) with weights, sizes, and stylings (such as italics or bolds), and other graphic elements

Above Two spreads from the same department of *Inside* magazine (**1**), (**2**)—"In Profile"—offer very different solutions to layouts, while sharing a bold use of type and design elements. "The layout process has many potentially determining factors, such as the number of pages per article, word count, image crops, and even the advertising within the publication. Color and flow also need to be considered as the magazine is being constructed. On completion, the magazine has to work as one canvas. I often find myself revisiting stories to create rhythm throughout the entire publication—much like the composition of a song structured by its verses and choruses," says Jeffrey Docherty, art director. *soDA*'s emphasis is on visual culture (**3**), (**4**), so many of its spreads are full-bleed color images. Consistency lies in the inventive and original photography and reproduction, and monotony is avoided by careful pagination of the publication. Particular attention is paid to placement of spreads. Finally, different formats and stocks keep the publication consistently original and exciting.

such as rules and drop caps, folios, grids, colors, and spacing. Example sheets of these (hence the name "style sheets"), with the elements marked on them, should be produced and distributed to every member of editorial.

Redesigning—when and why?

Designers may tweak elements of a layout to update a publication and keep it feeling contemporary and relevant (for example, a heavy font may be replaced with a medium or light version from the same family to accommodate changing tastes), but, eventually, even the best-designed long-running publication may become outdated and stale. In this case, a major overhaul or redesign should be

Right and below In 2003 art director Kobi Benezri, working with his predecessor Nico Schweizer, undertook a redesign of *I.D.* magazine. "When we started working on the design we knew that the look of *I.D.* had to be updated (the last redesign by Bruce Mau took place in 1992) (**1**). The new design came in correlation to a new editorial approach—coverage of a broader range of design fields, different takes on particular previously discussed subject matters, new departments, and a more critical approach; we wanted to make sure the design took the same attitude and was very informative and objective. At the same time we had no intention of impressing anyone with overpowering design elements or eye candy. There was a clear purpose for the layouts and we tried to keep it subtle and elegant, and put our mark where it was necessary." New features included new fonts—Scala was replaced with the very modern Gerard Unger font Coranto for body text; Meta was replaced with a variety of fonts that would change over time to keep the design up-to-date—and new sections, including a photospread called "Scape" (**2**) and a new back section called "Crit" (**3**).

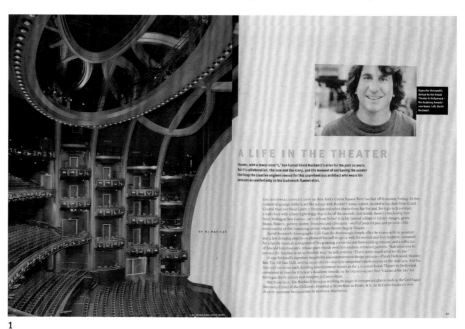

1

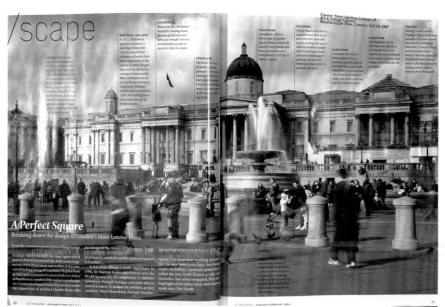

2

3

considered. Many publications also redesign when sales are falling, or in times of economic recession when advertising revenue drops and they need to boost sales, but doing so is a risky strategy, as any redesign can—and almost certainly will—alienate some existing readers while enticing new ones.

The best reason for a redesign is to stay in tune with and reflect the needs of a readership; over a period of five years, fashion, taste, and styles will alter sufficiently that a magazine aimed at 16-year-olds will have to redesign to keep in step. But it is important not to let readers dictate the redesign; contextualizing the publication through cultural trends and shifts is the best approach. It is also important that a redesign is not conducted in a vacuum. If visual trends shift over time, so, too, do the other elements that go to make up a publication: The content and tone should also be carefully examined and addressed to ensure that no one element is isolated and that the whole publication is moving forward cohesively and intelligently. Lee Corbin at *Flaunt* magazine took this approach in 2006 when he completely overhauled the look of the magazine, even creating a new logo and custom-designed fonts:

> *The entire magazine has been rebuilt, graphically at least, to accommodate more variation and a new identity. We simply had to do away with most of our preceding visual identity to make room for new ideas. Our magazine is constantly changing; as we are a monthly publication we need to embrace spontaneity—we had to give the magazine a new voice.*

While redesigns happen fairly frequently on magazines, newspapers rarely overhaul their publications—such a step is a logistical nightmare from a production perspective for a daily title. As Mark Porter explains:

> Editorial design is the framework through which a given story is read and interpreted. It consists of both the overall architecture of the publication (and the logical structure that it implies) and the specific treatment of the story (as it bends or even defies that very logic).

MARTIN VENEZKY, ART DIRECTOR, *SPEAK*

4 5

Left To stave off homogeneity in his many redesigns of newspapers, Mario Garcia offers this suggestion: "I run through the city, look at houses, curtains on windows, stuff in the trash bags, visit the local museums. How do the local artists paint? I use my senses, and I bring no preconceived ideas to a project. Start with a fresh empty canvas each time. Let your imagination go." Both British Sunday newspaper *The Observer* (**4**) and Dutch daily *Het Parool* (**5**) were redesigned by Garcia in 2006. With few ads on the cover, *The Observer* offers a lively yet dignified layout, the mix of one lead story with both above-logo and bottom-of-page teasers giving readers the suggestion of serious, in-depth journalism with value for money. *Het Parool* by contrast puts teasers between the logo and the lead story; text is minimal, the feel is of picture-led stories.

Above Mario Garcia has redesigned newspapers worldwide, frequently working with new formats. In 2005 he redesigned *The Observer* newspaper, taking it from a broadsheet to a Berliner format. He thinks size is not an issue, and certainly not a negative one. "The canvas is smaller, therefore one must be more focused and direct in creating hierarchy. So, what the publication must do in creating criteria for inclusion and exclusion is simply draw up a list. Study your readers of today. Do your visual and editorial archaeology and evaluate what needs to stay and what must go. Differentiate between real antiques and Aunt Clara's old teacup, so to speak. Newspapers have a tendency to drag old visual things as 'antiques.' But they are nothing more than old things, not worthy of preservation." On *The Observer* redesign, he retained the elegance of the broadsheet through use of typography, but gave the paper a more vibrant, youthful feel through color coding, which readers in surveys have been shown to like. He used one palette for coding and another one for other colors throughout the paper to ensure that such color coding would work with other elements on the page. He approaches all of his redesigns from the standpoint of journalism, because, he insists, "People come to a newspaper for its content, *not* its look. Design is part of the enhancement of that content."

Mario Garcia's top ten dos and don'ts of redesign

1 Not all redesigns are alike, so customize your work to make it appropriate for the specific product undergoing a "rethink."
2 Get a full briefing of expectations, target audience, and extent of change. I always say that some redesigns are nothing more than a face wash, while others are the full bath, complete with bubbles and candles!
3 Plan the rethink of the publication around the four major story structures: typography, page, architecture, and color.
4 Story structuring should be the first step: How do editors tell stories in this publication? How many styles of storytelling techniques should be created? How can hierarchy be emphasized?
5 Typographically, test at least three font combinations of serifs and sans serifs to choose the most convenient and appropriate.
6 For page architecture, develop at least two grid patterns with various column measurements, and perhaps include both in the final design.
7 Play with a color palette that starts with two dozen combinations of colors, from dark to light and in-between, then create a simple palette of no more than ten shades for continuous use.
8 Emphasize navigation—readers who surf the Internet become impatient and bring that impatience to print. Work hard to make sure that navigational strategies are a top consideration of the redesign process.
9 Review the "break of the book"—the order in which content will appear. Time to move elements in or out? Or to change the order of events?
10 Work closely with editors and reporters, as they will bring that necessary journalistic ingredient to the process of visually changing a publication.

Newspaper redesign is usually market-driven. There is a tendency for editors to assume that what they are doing is totally successful. It's only when sales start to fall that they realize they might need to change. But this is a particularly interesting moment, because newspaper readerships are in decline all over the world, and pressure from television and the Internet is forcing journalists and designers to question their assumptions about what modern readers need. There has never been so much redesigning and format-changing going on.

Media such as the Internet and changes in distribution and demographics are having a design impact on both newspapers and magazines: Formats are shrinking, pages are becoming more uniform, and navigation is becoming simpler, because, says Mario Garcia, "The Internet has created a savvy, impatient reader who expects hierarchy, good navigation, and fast motion on the printed page."

Looking back, looking forward V

All designers benefit from an awareness of trends, cultural shifts, and the contemporary zeitgeist, and this is doubly so for editorial designers, many of whom have to ensure that they are in the vanguard of visual fashion and culture. For this reason, we look at broad cultural and design trends and delivery media. But editorial designers can also gain huge insight into their craft—not to mention ideas and inspirations—by looking at work from the past, especially those designers and publications that were particularly influential, innovative, or groundbreaking. Whether through an understanding of print techniques, a style of cropping, a certain grid or structure, a use of typography and symbols as a means of expression, or the ability to exploit the latest print technologies, designers over the last eighty years have created graphic ephemera that stand shoulder to shoulder with fine art in their ability to inspire visual delight and express cultural concerns in conceptual form. The designers who have done so are numerous, but in this chapter are gathered a handful of the best. In studying the work of these past masters, contemporary designers should focus on the following:

- motivating and underlying principles;
- reasons why a particular design works in a specific context (in any given period);
- how the past plays a part in mapping out future trends and directions.

Looking back—motivating and underlying principles

All designers look at other design work, but many focus exclusively on contemporary work. This is important in terms of being aware of cultural shifts and changing and emerging trends in typography, illustration, photography, stock, and so on; but it is equally important to look at work that has gone before. What should you look for? Ideas and directions certainly, but you won't understand them unless you understand the principles underpinning them, which in the past were often closely aligned to movements in art and culture, which, in turn, were contextualized both politically and socially. So, for example, the ideas around mechanization and functionality, which formed part of the Bauhaus principles of the 1930s, reflected the industrialization of Western society and the rise of socialism in eastern Europe. When Neville Brody appropriated the typographical and geometrical styles of Russian constructivism in the mid-1970s, it was a cultural gesture that drew on the spirit of overthrowing oppression. An understanding and exploration of such principles, and how they relate to and reflect their cultural and political milieu, will give contemporary editorial designers a set of tools with which to develop their own cultural responses and connections, which are needed to acquire a true understanding of their publication's readership. So, study from the past often—not to copy great designers, but to understand their work.

Understanding why a particular design works in a specific context

Understanding how designers work involves an understanding of why a design works in its particular context. This means examining the broad picture—the underlying and motivating principles of a publication as outlined above—then focusing on individual layouts and understanding why they work for the publication in question and its readership. How do the layouts work to communicate the principles? Find out by deconstructing the layout, then looking at how the individual elements work alone and together. *The Face* is an example: Neville Brody understood that, in principle, a magazine about alternative culture could draw on influences and styles outside its own cultural milieu, and give them a contemporary forward-looking twist to communicate its cool outsider status. But which styles to choose? He intelligently opted for an appropriate visual style with roots and connections that were abundantly clear to a youthful readership, whose political integrity was untainted and whose cultural cachet was assured. He conveyed these principles through layouts composed predominantly of type, shapes, and geometrical elements—rules, blocks, and scale. The effect was startling: new, bold, irreverent, and absolutely right for the readership.

Exploring the past to map future trends and directions

It is clear from the case studies and influential publications listed here that the intellectual, moral, and cultural climates of an era play a part in creating key design movements, which in turn influence the styles of editorial design. Such movements and styles do not exist in a vacuum, and do not become meaningless or irrelevant as the zeitgeist shifts. They may go out of fashion, but through an understanding of their principles they always have something to offer, as Neville Brody illustrated with *The Face* (below). By updating the principles and styles of constructivism, Brody ushered in a whole new style of editorial design that would exert huge influence over other designers.

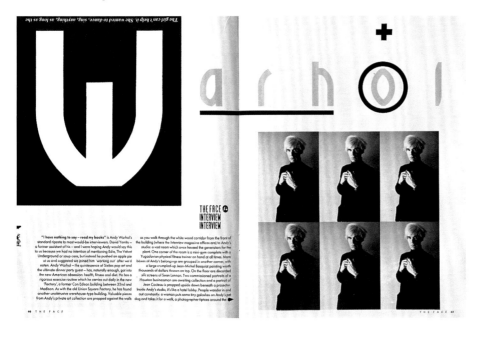

Case studies—designers and publications

M.F. Agha

Dr. Mehemed Fehmy Agha (known as M.F. Agha) was one of the first "art directors." A Russian–Turkish constructivist working on German *Vogue*, he was discovered by Condé Nast, who was trawling Europe looking for designers to introduce the modern (European) style to his publications. In 1929 Agha took over the flagship Condé Nast title, American *Vogue*, and lived up to expectations; control of *Vanity Fair* (below) and *House & Garden* followed. What Agha brought to these titles was fresh, new, and vital art direction. He was a pioneer in the use of sans serif typefaces and emerging print and photographic techniques such as montage, duotones, and full-color photographs, favoring photography over illustrations wherever possible. He experimented with photographic layouts, exploiting double-page spreads to take images across the gutter and using full-bleeds to create a sense of space and scale. His use of leading photographers, including Cecil Beaton and Edward Weston, was matched by his employment of artists such as Matisse and Picasso years before any other American magazine.

On *Vanity Fair* M.F. Agha adapted the stylistic tenets of European modernism to a U.S. title and its market. He achieved this by simplifying and systemizing type use, recognizing the spread as a palette on which the various design elements—gutters, margins, headlines, and white space—could be endlessly expanded and manipulated to create vibrant and varied spreads. He understood that by playing with the position and size of his design tools, such as floating small headlines on white space at the bottom of the page, he could create impact and energy—something hitherto unseen in editorial design. Hence, traditional decorative elements were pushed off the page in favor of sparse layouts in which scale and shape became the primary means of decoration.

Towie, the new form of Contract Bridge

BY WILLIAM J. HUSKE

1934—a picnic for the British

Alexey Brodovitch

Russian émigré Alexey Brodovitch was art director at *Harper's Bazaar* from 1934 to 1958, and in that period initiated techniques that have set standards of art direction ever since. Indeed, he pioneered the notion of art direction as conceiving and commissioning visual material rather than simply laying out pages. In terms of style, Brodovitch introduced asymmetrical layouts, movement, stripped-down simplicity, and dynamic imagery to magazines (and U.S. editorial design in general), which had previously been dominated by static pages filled with decorative but irrelevant clutter. These innovations were based on the simple "modern" graphic style he had helped develop in Europe in the 1920s, which, in turn, was based on an amalgam of modernist movements and styles in art and design—notably Dada and constructivism. Obsessed with change and new ideas, including early abstract expressionism, Brodovitch developed a style that by the 1950s was a byword for elegance, largely achieved through white space and understated color, along with contrasts of scale, precise, restrained typography (often Bodoni), and photo shoots and spreads invested with lively drama.

Part of Brodovitch's skill lay in his ability to discover and nurture new photographic talent, including Irving Penn and Richard Avedon. He introduced the work of avant-garde European photographers and artists such as A.M. Cassandre, Salvador Dalí, Henri Cartier-Bresson, and Man Ray to the American public. He used this photography as the backbone of spreads that were light, spacious, full of movement, and, above all, expressionistic—something we take for granted today. To achieve this, he took shoots outside the studio, and made the models—what they were doing, where, and why—as important as the clothes they wore.

A desire to innovate and experiment lay at the heart of Brodovitch's work: a very instinctive approach based on eschewing the rational and the dogmatic for the constant pursuit of change and modernity.

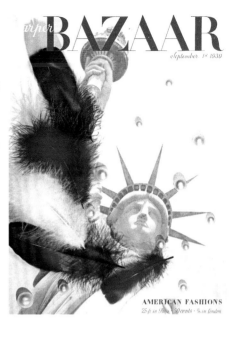

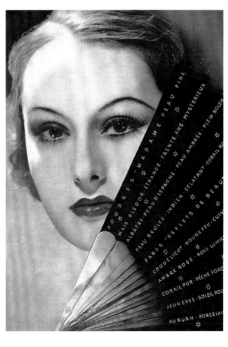

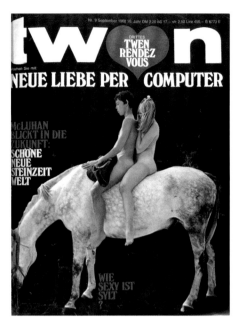

Willy Fleckhaus

German designer Willy Fleckhaus is noted for his work on just two publications, but *Twen* (illustrated here) and *Frankfurter Allgemeine Magazin* (*FAZ*) are widely regarded as among the most influential titles in postwar editorial design. Fleckhaus's genius was to take the International Style, which dominated postwar graphic design, and give it an explosive 1960s energy created by the use of huge, tightly cropped pictures anchored to a rigid, grid-ruled approach to design. The resulting spreads offered a formal simplicity that he carried through to *Frankfurter Allgemeine Magazin*, ten years after leaving *Twen*. This news magazine experimented and played with illustration in much the same way that *Twen* had done with photography, and retained the simple formalism of the earlier title, which was copied throughout Europe. In his book designs for publishing houses such as Suhrkamp, Fleckhaus's work shows as much aplomb and understated panache as that used in his magazines.

Twen

Twen launched in 1959 as a provocative youth title that combined erotic photography with thoughtful, intelligent articles. Its aim was to attract a new readership that demanded to be seen as distinct from its parents, an audience that was finding a language and style of its own: the emerging youth culture that was sweeping the West. This culture demanded a new graphic style, and designer Willy Fleckhaus provided it by combining elements of Swiss formalism—the rationalism of the grid and simple typography—with the witty and bold visual aesthetic of American publishing. To achieve this, he devised a 12-unit modular grid for the publication's large-scale format, 10.4 x 13.2 in (26.5 x 33.5 cm). The importance of this grid lay in its ability to combine units in a seemingly endless number of ways, enabling the use of two, three, four, or six columns, while horizontal units could be used to break down the columns into chunky blocks. What Fleckhaus put in place was a series of versatile coordinates on which to anchor his layouts—a brilliant solution that stood out from every other publication. Into this grid Fleckhaus then dropped some of the most striking imagery of the time, cropping and manipulating compositions to produce strange shapes and massive close-ups that looked like weird landscapes, surreal portraits ...anything went as long as it was dramatic, visually subversive, and different. Combining the large format with distinctive black pages, minimal type (though a trained journalist, Fleckhaus didn't like writing and believed that visual storytelling had more impact), and some of the most eye-popping visual reportage of the day, *Twen* offered a dramatic shock-of-the-new publication that perfectly reflected its social and cultural milieu.

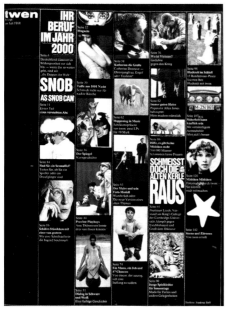

HAPPENING IN MUSIC

Julie
der
Zeitzünder

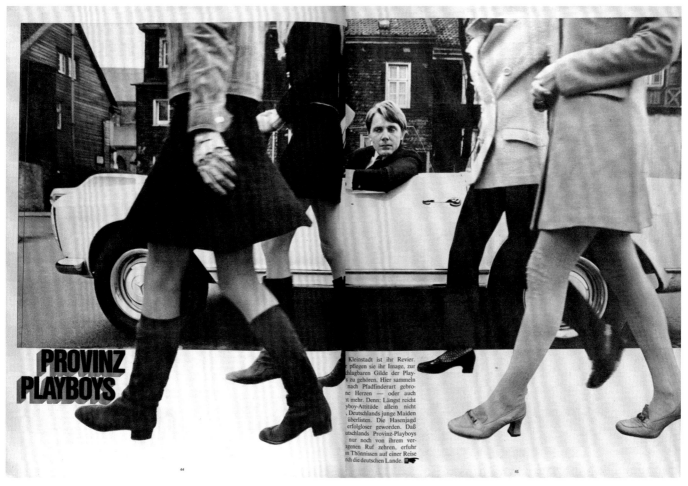

PROVINZ
PLAYBOYS

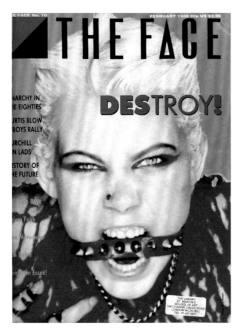

Neville Brody

Neville Brody joined *The Face* in 1981, and immediately established a design aesthetic rooted in, but not aping, the work of the twentieth-century art movements constructivism, Dada, and expressionism. Here, once again, was typographic symbolism: playful experimentation that looked back to the mechanization of print and the opportunities it afforded the visual communicator, and utilized the expressionism inherent in stark, bold, geometric shapes and symbols. This was visual culture affiliated to political rebellion, which had a particular appeal for the overtly political designer. *The Face*'s antiauthoritarian, postpunk political and visual identity was a perfect match for Brody's experimental, individualistic approach to design because they shared the same rebellious spirit and helped define the look and feel of their time. Brody's main contribution to this youth culture magazine was to break with traditional methods of type construction and establish it as a versatile, malleable design element that was barely distinguishable from imagery and could act as a vehicle for meaning.

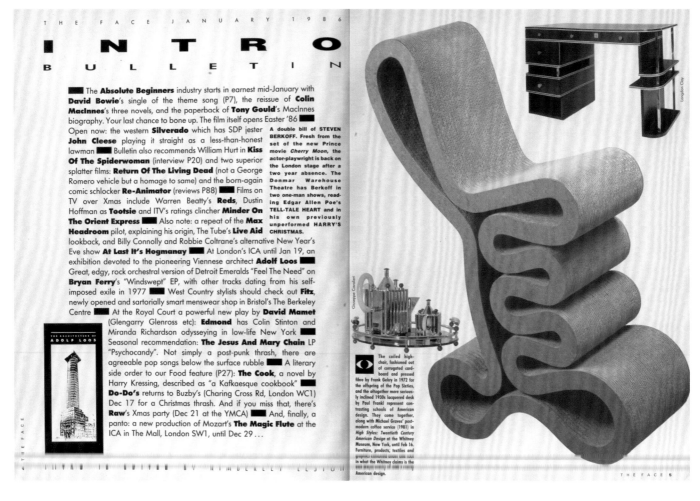

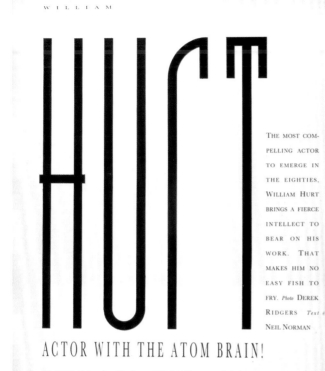

WILLIAM

HURT

ACTOR WITH THE ATOM BRAIN!

THE MOST COMPELLING ACTOR TO EMERGE IN THE EIGHTIES, WILLIAM HURT BRINGS A FIERCE INTELLECT TO BEAR ON HIS WORK. THAT MAKES HIM NO EASY FISH TO FRY. *Photo* DEREK RIDGERS *Text* NEIL NORMAN

"That stuff about God, you know, it's really tricky."
"I know."
"It can easily be manipulated."
"I know."
"It's difficult to articulate."
"Yes, I know."
"I wouldn't want to be, uh, misconstrued."
"No."
"You want to know if I hurt myself?"
"Uhuh."
"Every day . . ."

TO PENETRATE THE MASK, that is always the intention. The unnatural process of instant and enforced familiarity is an elaborate charade of question and answer and observation which can promote, destroy or reveal. An hour or so in the company of a stranger yields little that is concrete. The only tangible things I had to show when I walked away from this particular interview were a used 90-minute cassette tape and two empty packets of Silk Cut. The only deductions to be made from that were that William Hurt talks a lot and smokes a lot.

20 THE FACE

THE FACE 21

The Face

Neville Brody's design of 1980s counterculture magazine *The Face* revolutionized the editorial role of type and would have a lasting impact on graphic design. Brody's strength lay in using type to express meaning: by employing different faces within words to suggest nonconformity, positioning and angling type to echo the radical edginess introduced by Russian constructivism, and using graphic devices and symbols as page furniture to unify spreads and create visual cohesion. He also took a bold approach to images, cropping, and framing to emphasize content visually. Full bleeds with just a portion of an image visible underlined the title's identity as anachronistic, anarchistic, and thoroughly individual. As the magazine matured, so, too, did Brody's use of type and image, remaining in step with the readers, but always offering innovative and skillful design solutions. He was less successful in applying these same styles to other publications such as *City Limits* and *Per Lui*, but his work on *The Face* continues to stand out as a defining piece of editorial design.

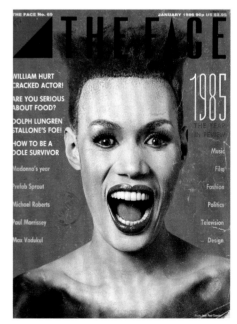

THE FACE No. 69 JANUARY 1986 90p US $2.95

THE FACE

WILLIAM HURT CRACKED ACTOR!
ARE YOU SERIOUS ABOUT FOOD?
DOLPH LUNGREN STALLONE'S FOE!
HOW TO BE A DOLE SURVIVOR

Madonna's year
Prefab Sprout
Michael Roberts
Paul Morrissey
Max Vadukul

1985
THE YEAR IN REVIEW

Music
Film
Fashion
Politics
Television
Design

David Carson

All art directors hope to visualize the content of their publication, but few have succeeded as well as David Carson. A sociology graduate, who famously lacked a design education and worked as a teacher until his early thirties, Carson came to art direction through a love of surfing (qualifying in 1989 as the fourth-best surfer in the world) and skateboarding. Following a three-week workshop in graphic design in Switzerland (taught by Hans-Rudolf Lutz), which he took in 1983 as part of his degree course, he became art director for *Transworld Skateboarding*, where he quickly established his trademark style of illegible layouts that broke every known rule in design and art direction. From here he launched *Beach Culture*, on which he worked for three years before the magazine folded because of a lack of advertising—but not before winning 150 awards. In his subsequent role at *RayGun*, a magazine about alternative rock music (illustrated here), Carson made design history, becoming arguably the most famous art director ever, and with good reason.

Through his intuitive ability to combine type and photography as expression, Carson created a new school of art direction and photography-based editorial design. His work on the magazine reflected a consistent commitment to experimentation and abstract visualization that—and this is key to his style—had content at its center. Though this new visual aesthetic appeared to have come from nowhere, it was, in fact, rooted in the visual expressionism of the Dadaists, and is strongly reminiscent of concrete poetry, in which the typographical arrangement of words, and the shapes formed by them, were fundamental to their effect and meaning.

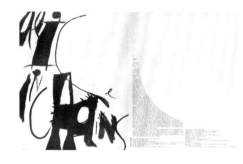

photos: Peter Morello stylist: Jill Spector

Terry Jones

The name of Terry Jones may not have the cachet of Willy Fleckhaus, Alexey Brodovitch, or Fabien Baron, but this English designer is undoubtedly one of the most influential and intelligent editorial designers working today.

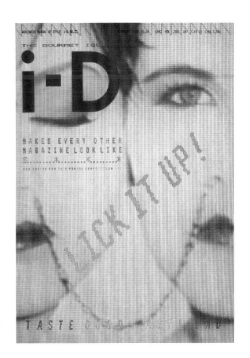

Experience in art direction at British *Vogue*, German *Vogue,* and *Donna* had schooled Jones in the principles of mainstream titles, but it was on alternative youth style magazine *i-D* (illustrated here) that he shone. Born out of the punk movement, this independent title began life in 1980 in a portrait format, and was famed for its frenzied cut-and-paste montage pages featuring readers: people who were clubbing, going to punk gigs, or hanging out on the King's Road, checking out fashion at Malcolm McClaren and Vivienne Westwood's shop, Seditionaries, before going home to concoct their own subversive take on the garments. Its anticelebrity street fashion stance, both in image and content (much of it written by readers), was welcomed by a politically nihilistic audience alienated from the mainstream by a right-wing government and a stilted music scene.

The punk aesthetic underpinning the design of *i-D* is evident, as is the influence of Dada techniques such as montage and photomontage, but it always manages to look fresh and relevant. Jones's instant, apparently makeshift design, which borrowed much from DIY fanzines, was belied by his attention to detail and a rigorous understanding of print that enabled him to use design elements to create a sense of immediacy and spontaneity in every spread and issue. Jones achieved this primarily through print techniques applied before and at the print stage: Photocopying, image manipulation, montage, layering, moiré, and screenprinting were all vital parts of his toolkit, as were the manipulation and layering of type to make text less readable and slow the reader down. By these means, Jones managed to craft a real sense of DIY editorial that has retained its relevance, readership, and, to a refreshing degree, antifashion stance for more than twenty-five years.

V: Looking back, looking forward **169**

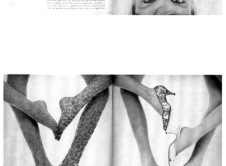

Henry Wolf

Austrian émigré Henry Wolf, who was art director of *Esquire* from 1952 to 1958, completely overhauled the design of this up-and-coming literary magazine, giving it a sophisticated and innovative style. In 1958 he became art director at *Harper's Bazaar*, succeeding Alexey Brodovitch. He remained there for three years, leaving in 1961 to start his own magazine, *Show*.

Wolf saw his task on all these titles as being to express their contents visually by integrating rigorous typography with expressive, eye-catching layouts. On *Harper's Bazaar*, where he inherited Alexey Brodovitch's stable of outstanding visual talent, Wolf built on this legacy, introducing simple, streamlined fonts and calm, spare compositions, which invested the layouts (illustrated left), and the magazine as a whole, with a measured pacing and flow. This was unusual for a designer who was more comfortable with opening spreads and covers than with the hard graft of lengthy features and their attendant problems of continuity and sustaining interest.

Not surprisingly, given his success in advertising, Wolf reigned supreme in creating the concept cover, often best seen in his work on *Show*, where he designed surrealist covers that were clever, witty, and always original. Famous for the belief that "a magazine should not only reflect a trend, it should help start it," Wolf was an intuitive designer who was instrumental in introducing Americans of the 1950s to European modernism.

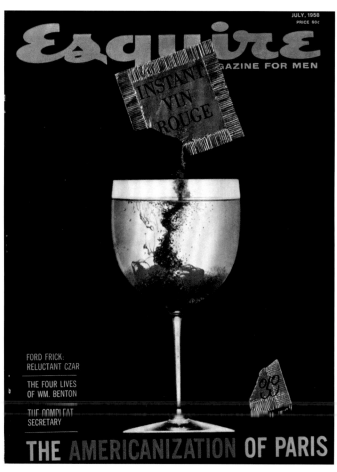

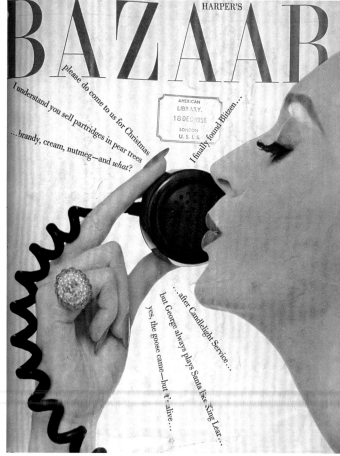

Vince Frost

No designer since David Carson has used type in editorial as expressively as Vince Frost. The results could hardly be more different, but what unites the two is an inherent understanding of the need for editorial design—and particularly typography—to express the content and identity of a publication visually. For both designers, this has resulted in accusations of pointless obstruction in their visual solutions, but set against this is Frost's constant desire to intrigue and engage the reader through vibrant, exciting design.

Along with art directing *The Independent on Saturday* newspaper's magazine in the U.K. during the mid-1990s, Frost devised the design for the *Financial Times*'s weekend magazine *FT The Business*. Both reveal a delight in intelligent conceptual design. Frost favors simplification and "tidy" designs, which may explain his extraordinary ability to work with letterpress and woodblock typography as decorative elements that are always wholly related to content—though perhaps not always appropriate to its tone and style. By reducing the number of design tools in his palette, Frost is able to focus on making each element work extra hard to arrive at clean, bold solutions. On *Big* magazine (below), an alternative style title printed in Spanish and English, he worked with letterpress guru Alan Kitching to produce type that he employed playfully as skyscrapers, speech bubbles, a mask, and various other objects, all responding to the stunning accompanying photography, which in turn echoed the work of seminal New York photographer William Klein. And on the U.K. magazine *Zembla*, a literary magazine that wanted us to "have fun with words," Frost literally interpreted that fun on every page, with bright, energetic, irreverent, and playfully unpredictable designs centered in most cases on type as decoration.

Frost's skill goes beyond individual page solutions, however, to incorporate another, equally important aspect of editorial design: the ability to handle the flow of a publication so that the whole product is an exciting, constantly unexpected experience for the user. Nowhere is this more evident than on *Zembla*, where stunning photography, much of it black-and-white, was combined with letterpress to surprising and delightful effect, and where the regular editorial department—letters, reviews, news, and so on—received as much attention as feature pages.

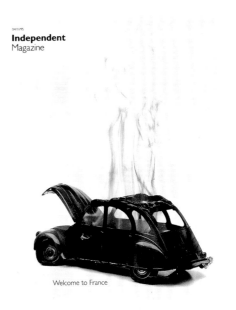

04/11/95
Independent
Magazine

Welcome to France

Photographs by Alan Beukers

CLOSE UP

Portraits by Gino Sprio

Fernando Gutiérrez

Everyone associates Benetton's *Colors* magazine with its original creators Oliviero Toscani and Tibor Kalman, but it is also very much the product of Fernando Gutiérrez, who became its creative director in 2000, adopting Kalman's original concept of visual reportage as honest, stark storytelling. A versatile designer, Gutiérrez has worked on everything, including book publishing, communications campaigns, and editorial design, all produced by his own company within just seven years of graduating from the London College of Printing. Since then he has been quietly reshaping the landscape of editorial design in Spain and beyond, first on a government department youth magazine, for which he created a format based on a double grid, but most notably on the Spanish fashion magazines *Vanidad* and *Matador*—a literary and a photography journal respectively—and on the newspaper *El País*. He has designed and art directed a full range of daily sections and supplements for *El País*, including the youth-oriented *Tentaciones* (left and "Conexión" spread opposite) and the Sunday *EPS*, which has a nationwide readership of 1.2 million. These are printed on low-grade newsprint, yet play to the strengths of the format and stock but are not confined by them. Gutiérrez was keen to design them as stand-alone magazines rather than as newspaper supplements, and the dynamism and panache with which he achieved this goal saw sales rocket.

On all these publications what is evident is Gutiérrez's ability to use design elements to express the title's identity and give readers an appropriate experience. Moreover, his work is infused with a cultural and national identity, which makes these magazines stand out from the crowd. On *Matador*, for which Gutiérrez plans to produce twenty-nine issues by 2022 (each annual issue being "numbered" with one letter from the Spanish alphabet, representing an homage to a different typeface), the key design elements are the high-quality stock, large-scale format, and the printing. These combine with a formalism in the layout (*see* below) to create a dramatic and distinctly unique publication. Themes focusing on identity are overtly about nationality, but other less obvious topics also keep the title's Spanish parentage in evidence.

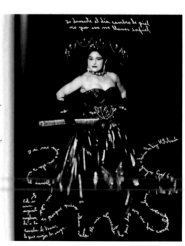

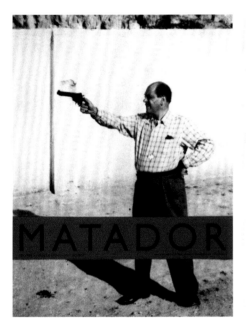

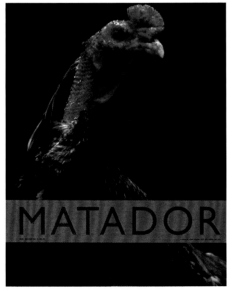

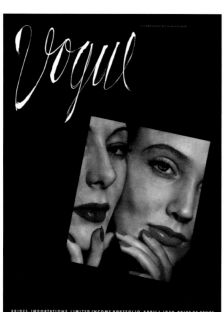

Cipe Pineles

Nowadays, it is a given that photographers, illustrators, artists, and editorial designers are allowed to interpret a story personally; indeed, it's a practice that virtually guarantees a result that, whether conceptual, impressionistic, expressionistic, or literal, will be original and unexpected. Its invention was the brainchild of Cipe Pineles, who in 1946 initiated the practice on *Seventeen* magazine when she began commissioning visuals for fiction.

Pineles began her career under M.F. Agha at Condé Nast, where in five years she learned enough to take her to *Glamour* in 1942 as the first autonomous female art director. Here, she took fashion shoots into galleries and open spaces, bled images off spreads, cleverly guided readers from four-color to two-color images, introduced drama and scale to photographs, and gave a personal twist to editorial design by integrating modernist principles of structure and abstraction with playful use of visuals and type. But it was on *Seventeen* (top left and opposite), the first magazine aimed at teenage girls, that she really came into her own.

Both Pineles and *Seventeen*'s founder and editor Helen Valentine viewed their readers as serious, intelligent young adults, and gave them serious, intelligent content. Pineles did so by introducing them to some of the most thought-provoking art of the time: the radical politics of Seymour Chwast and Ben Shahn, among others. She also introduced a system for the use of type to define and shape individual sections, and brought American figurative typography into the fashion and editorial spreads, replacing type with objects to create visual puns, and manipulating and interacting with letterforms (scratching, tearing, hand-lettering, and so forth) to add meaning and expression to a story. In this sense her work echoed what was happening in the American art world, where expression was moving away from the figurative to explore directions such as conceptualism and abstract art with the use of wildly varying media.

Pineles expanded her experimentation and intervention with type on *Charm* magazine in 1950. Once again, here was a thoughtful, intelligent publication, bearing the strapline "for women who work," which consciously and firmly located its readers in the context of a working and changing world in which women played a vital part. Pineles responded to the magazine's remit with a modern realism that was refreshing and new. Fashion shoots were conducted against city backdrops and freeways to reflect the country's industrial revolution, vernacular type expressed the two-dimensional realism of urban space, and typography was used to give impact and emphasis. Above all, it was Pineles's ability to find and work with artists and photographers, treating them as friends as well as professionals, that marks her as one of the great art directors. She won every major design award possible during her lifetime, illustrating the importance of strong productive relationships with contributors and the ability to communicate effectively.

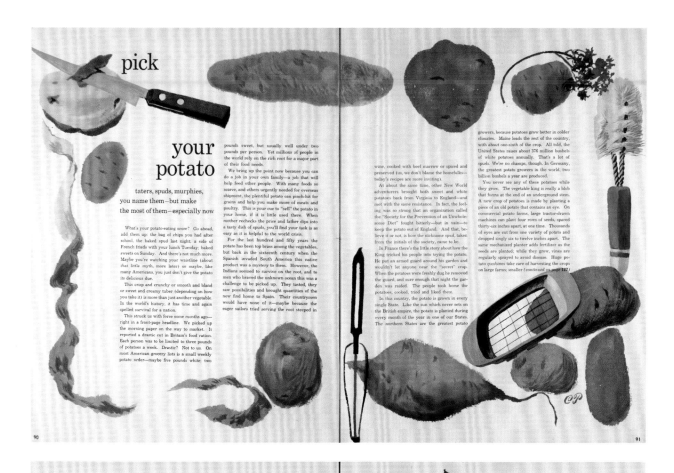

pick

your potato

taters, spuds, murphies,
you name them—but make
the most of them—especially now

What's your potato-eating score? Go ahead, add them up: the bag of chips you had after school, the baked spud last night; a side of French fries with your lunch Tuesday; baked sweets on Sunday. And there's not much more. Maybe you're watching your waistline (about that little myth, more later) or maybe, like many Americans, you just don't give the potato its delicious due.

This crisp and crunchy or smooth and bland or sweet and creamy tuber (depending on how you take it) is more than just another vegetable. In the world's history, it has time and again spelled survival for a nation.

This struck us with force some months ago—right in a front-page headline. We picked up the morning paper on the way to market. It reported a drastic cut in Britain's food ration. Each person was to be limited to three pounds of potatoes a week. Drastic? Not to us. On most American grocery lists is a small weekly potato order—maybe five pounds white; two

pounds sweet, but usually well under two pounds per person. Yet millions of people in the world rely on the rich root for a major part of their food needs.

We bring up the point now because you can do a job in your own family—a job that will help feed other people. With many foods so scarce, and others urgently needed for overseas shipment, the plentiful potato can pinch-hit for grains and help you make more of meats and poultry. This is your cue to "sell" the potato in your home, if it is little used there. When mother rechecks the price and father dips into a tasty dish of spuds, you'll find your task is as easy as it is helpful to the world crisis.

For the last hundred and fifty years the potato has been top brass among the vegetables, but back in the sixteenth century when the Spanish invaded South America this native product was a mystery to them. However, the Indians seemed to survive on the root, and to men who braved the unknown ocean this was a challenge to be picked up. They tasted, they saw possibilities and brought quantities of the new find home to Spain. Their countrymen would have none of it—maybe because the eager sailors tried serving the root steeped in

wine, cooked with beef marrow or spiced and preserved (us, we don't blame the homefolks—today's recipes are more inviting).

At about the same time, other New World adventurers brought both sweet and white potatoes back from Virginia to England—and met with the same resistance. In fact, the feeling was so strong that an organization called the "Society for the Prevention of an Unwholesome Diet" fought bitterly—but in vain—to keep the potato out of England. And that, believe it or not, is how the nickname spud, taken from the initials of the society, came to be.

In France there's the little story about how the King tricked his people into trying the potato. He put an armed guard around his garden and wouldn't let anyone near the "secret" crop. When the potatoes were freshly dug he removed the guard, and sure enough that night the garden was raided. The people took home the potatoes, cooked, tried and liked them.

In this country, the potato is grown in every single State. Like the sun which never sets on the British empire, the potato is planted during every month of the year in one of our States. The northern States are the greatest potato

growers, because potatoes grow better in colder climates. Maine leads the rest of the country, with about one-sixth of the crop. All told, the United States raises about 376 million bushels of white potatoes annually. That's a lot of spuds. We're no champs, though. In Germany, the greatest potato growers in the world, two billion bushels a year are produced.

You never see any of these potatoes while they grow. The vegetable king is really a blob that forms at the end of an underground stem. A new crop of potatoes is made by planting a piece of an old potato that contains an eye. On commercial potato farms, large tractor-drawn machines can plant four rows of seeds, spaced thirty-six inches apart, at one time. Thousands of eyes are cut from one variety of potato and dropped singly six to twelve inches apart. The same mechanized planter adds fertilizer as the seeds are planted; while they grow, vines are regularly sprayed to avoid disease. Huge potato combines take care of harvesting the crops on large farms; smaller (continued on page 122)

90 91

 放風箏 *

We're not being flip. We mean it literally. When the April wind is up and you feel if you stay indoors another minute you'll burst—go fly a kite! We can just hear you thinking, "Girls don't fly kites!" And we say, "Why not!" Why should one of the most exhilarating pastimes ever invented be limited strictly to males? For pure fun, it can't be beaten. It's a wonderful excuse for a spring picnic (see the party story on page 109), an unfailing source of delight at the beach in summer. Store-bought kites cost as little as they weigh; making a kite of your own may be just what your creative instincts yearn for. So get yourself a kite. The spirit to the tail and send them soaring into the upper air. You'll soon understand the enchantment kite-flying has exerted for something like twenty-five centuries.

The greatest "fliers" of ancient times were the Asiatic peoples—Chinese, Japanese, Koreans—and primitive tribes like the Maoris. The latter believed that kites protected them from evil spirits and often kept them flying from their roofs all night. Sometimes these kites were equipped with reed whistles which emitted a shrill note in the wind. The Korean child's counterpart for a letter to Santa Claus was a paper containing birthday requests, sent aloft via kite. It was assumed that if the kite got up high enough, the gods would read the paper and take note. The Chinese believed they could transfer their own troubles to the shoulders of the gods through the medium of a kite. An hour's flying would leave a hitherto harassed Chinese cheerful and relaxed! Kite-flying has always been so popular in China that shopkeepers run to the street with their kites in between customers! And every year the ninth day of the ninth month is known as Kites' Day, when every Chinese male takes a holiday to fly his most magnificent kite.

Everyone knows about Ben Franklin's kite experiment to prove that lightning contained electricity. Kites have been used for scientific purposes since the middle 1700's—for testing

weather conditions, taking aerial photographs, etc. And they have been employed in many interesting ways during wartime. Centuries ago, a Korean general sent a kite, with line attached, to the opposite bank of a river. A cable followed the line, forming the nucleus from which a bridge was built. The Japanese developed a man-carrying kite, invaluable in scouting the enemy's position. Many armies used to employ kites for signaling purposes. Now some airplane lifeboats are equipped with kites carrying a radio antenna which automatically signals an sos.

As the illustration shows, kites can be made in an amazing variety of shapes and sizes. Probably the most familiar to you is the two-stick, diamond-shaped kite (see directions on how to make and fly it on page 120). A kite similar to the "airplane" shown on the next page was used by the Navy for target practice—because of a special rudder it could be made to do nose dives and loop-the-loops in the sky. The box-kite can be flown to great heights and, due to its greater sturdiness, is the type most often used for carrying scientific instruments. The decorative Chinese and Japanese kites will fly at the slightest puff of air. The centipede floats with grace, the eagle's tail flutters, the fly's eyes spin round on their tiny bamboo axes as it soars through the sky.

Almost any paper can be used to make a kite, but tissue or a light wrapping paper is best. The sticks should be of spruce or bamboo and light cotton twine will be strong enough to fly a medium-sized kite. Tails provide wind-resistance and, while not always essential, are picturesque. They may be made by tying bits of paper or rag onto a piece of twine or by braiding thin strips of paper or rags.

Ready to fly? We'll wager you and your gang will find it's more fun than you've had in a month of windy days, and it won't be long before all the teens in town will be following your example, migrating to the open fields, and claiming their own share of the kite-lines.

Go fly a kite

BY BARBARA MOENCH

104

David Hillman

Newspaper designers rarely achieve the same level of fame and recognition as magazine art directors, but a notable exception is David Hillman, the British designer renowned for his audacity in putting content above the title and using two fonts for the logo when he redesigned *The Guardian* newspaper in 1988. Part of Hillman's strength is his involvement in the editorial as well as the design of a publication. On both *The Sunday Times* and *Nova*, which he joined in 1968, he not only art directed but also worked as section editor and deputy editor, and it is likely that this experience and understanding of editorial has played a significant role in a four-decade career that has involved designs and redesigns of titles worldwide, including *New Statesman and Society*, *Le Matin de Paris,* and *People* magazine.

However, it is above all for his work on *Nova* and *The Guardian* that Hillman is rightly lauded, and his redesign of the latter in 1988 is seen as a turning point in newspaper design. A close relationship with the paper's editor, Peter Preston, gave him an in-depth understanding of both the title and its future—a future that was assured through Hillman's work, which transformed a stuffy, old-fashioned newspaper into a modern, forward-looking publication and raised the 18- to 25-year-old readership by 30 percent. That it did so as much through the restructuring of its content as through Hillman's design was acknowledged by very few; but Hillman understood this completely, and it is this awareness of every aspect of editorial, and what the visual communicator can bring to it, that underpins his work.

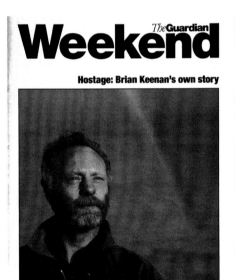

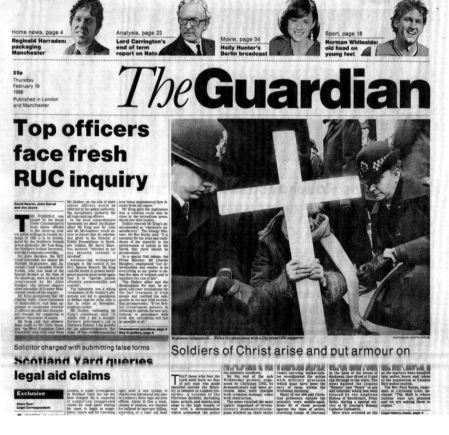

Nova

Founded in the U.K. in 1965, the radical women's monthly *Nova* saw its remit from the outset as being a women's version of a men's magazine—a title that would offer its readers intelligent conceptual content that went far beyond fashion and makeup. Art director Harri Peccinotti and editor Dennis Hackett were united in their determination to design a magazine that reflected this forward-looking stance, and drew on the American expressionist style developed by M.F. Agha and Alexey Brodovitch in the 1950s to do so. Covers, in particular, used a combination of unexpected image, space, and text to reflect confrontational and often explosive topics such as racism, abuse, sex, and politics. Photography was stark and expressive, both in content and cropping. But type was also innovative: Kickers in Times font covered half a page and demanded as much attention as the images. The legacy that Peccinotti left for David Hillman, who worked on *Nova* from 1969 until its demise in 1975, was ideal for documenting and exploring a period of intense social, sexual, and political upheaval through bold, in-your-face visual elements (in particular photography, which he was highly skilled at using as reportage).

Hillman's ability to take design beyond defining a publication's identity to expressing its content, tone, and stance was honed on *Nova*, highlighting the importance of being involved in all aspects of editorial. Acting as both deputy editor and art director, he was able both to interpret the magazine's identity as an uncompromising, individualistic title, breaking boundaries and taking risks, and to look at individual stories. Crucially, he believed photographs could tell stories, and commissioned many such "stories" from photographers with different perspectives and even opposing stances. As a result, the magazine consistently broke new ground, but always in a way that was entirely appropriate to its identity and content.

Fabien Baron

For Fabien Baron, art direction runs in the family. After just one year of art school at the École des Arts Appliqués in Paris, he started work with his father, who art directed a number of French newspapers (including Jean-Paul Sartre's radical left-wing newspaper *Libération*), later moving to *Self*, and then to *GQ* in the U.S. But it was on Italian *Vogue* in 1988, and then on *Harper's Bazaar* with Liz Tilberis, that he carved a reputation for strong, distinctive art direction that broke all the rules, including commercial ones. On Italian *Vogue*, for example, he simply ignored the accepted diktat of close-up figurative cover shots, and commissioned photographers such as Albert Watson to shoot arresting abstract portraits by reducing shapes to strong graphic devices that had real impact on the newsstand.

Baron's trademark style of bold graphic solutions was developed by minimizing the elements of design, as well as the range within those elements, drawing his color palette from primary colors used sparingly and to startling effect with big blocks of black. Similarly, his illustration style is reduced to a few select artists (on Italian *Vogue* he only ever used illustrator Mats Gustafson, who created *Interview* magazine's logo) and his photos are mostly black-and-white images cropped in unusual ways to create striking results.

Above all, it is his use of typography as a constructive architectural element that Baron is famed for. On Italian *Vogue*, his use of huge full-page headlines to open a feature, combined with a minimalist style and large amounts of white space, created a new modern aesthetic (below middle). His letterforms echoed elements of an image; scale combined with a shape, a curve, or a color would act as the cornerstone on which to build a typographic solution. These became visual responses and connections that were perfectly adjusted to the magazine. On *Interview* he used this approach to strengthen textual portraits of interviewees, constructing type to express a sense of the person visually. In both cases, Baron presented the reader with visual solutions that were always coherent and exuberant pieces of editorial design. More than a decade later, his work on *Vogue Paris* (above and bottom left) continues to do this, playing with image, text, space, and scale to express the movement, action, and vitality of fashion in a new century.

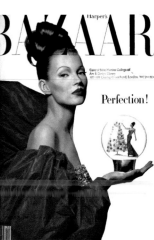

Merz and the New Typography

The influence of the prewar modernist art movements—Dada, futurism, and constructivism—on the postwar editorial design boom cannot be overstated, but if their tenets can be seen in any one publication, it is the Dada publication *Merz*. Designed by Kurt Schwitters in 1919 as a series of collages, then with El Lissitzky in 1924 as a magazine, *Merz* took the principles of these movements—in particular, the possibilities offered by mechanization—and applied them to all aspects of editorial design. Fundamental to this was the understanding that the shape, form, and makeup of the printed page could be radically reshaped, and ultimately liberated, by movement, dynamism, balance, and a new approach to typography (what would become known as the "New Typography"). These were all possible because of emerging production techniques such as lithography and lino-typesetting. But the most important transformation was the massive underlying shift in print that these innovations ushered in—the possibility of true expression, rational organization, and democratization in graphic design, all delivering more effective communication. Such work influenced not only the anarchic look of punk fanzines and of Neville Brody's work, but also in more subtle ways had an impact on the visual playfulness evident in many newsstand publications by art directors such as Fabien Baron.

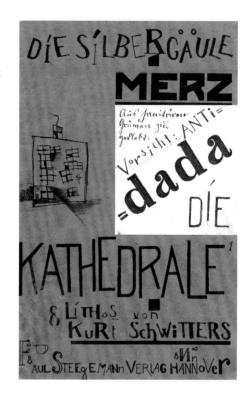

David King

David King's name surfaces regularly in British design. Mostly, it does so in conjunction with Michael Rand, with whom he revolutionized newspapers through their design for *The Sunday Times Magazine* in 1962 (below). This brought radical change to newspaper design, introducing color and a cinematic feel to the imagery through graphic effects and cropping that made the whole layout feel alive. They constructed cinematic photo sequences that stretched over three or four spreads (a luxury possible thanks to the low volume of advertising). This was a device based loosely on the style of the Russian filmmaker Sergei Eisenstein, who cut from long shots to close-ups to create a new style of filmmaking and editing that would reach beyond the medium of cinema, and on film noir, which used a similarly stark and dramatic narrative construct.

King worked as art editor of *The Sunday Times Magazine* from 1965 to 1975, where, with Rand, he produced some of the most eye-popping graphics of the era, and in the process raised sales by 150,000 in a year. Techniques such as halftones, silk screens, hand-coloring, and montage formed the basis for the graphics, which, constructed through pasteup to create a layered, textural effect, helped compensate for largely black-and-white photography. Illustration was, of course, color, and *The Sunday Times Magazine* made the most of this, commissioning illustrations for subjects that would now be visualized through photography.

Drama lay at the heart of all David King's work, even when he moved away from photography towards a more typographic language on *City Limits*, a London listings magazine that broke away from *Time Out*. The acrimonious split was rooted in a disagreement between management and staff over unionization, so for his covers King raided the constructivist cabinet for a style that was bold, dynamic, and, above all, political. The fact that the style was also cheap to produce was a bonus, and took King back to the knowledge and skills he had developed in print techniques while at *The Sunday Times Magazine*. King's love of visual history informed *City Limits* more than any of his other work, and would influence his subsequent career, in which political ideology and left-wing politics played a major part. Indeed, his interest in Soviet graphics and art has resulted in a collection that is the largest of its kind in the Western world, containing over a quarter of a million pieces.

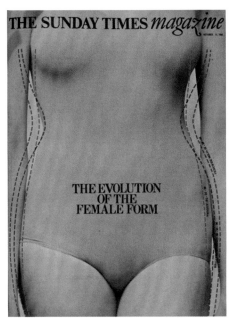

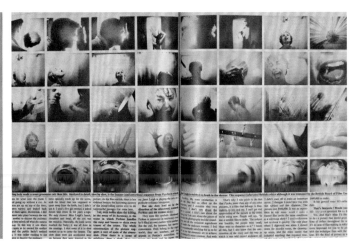

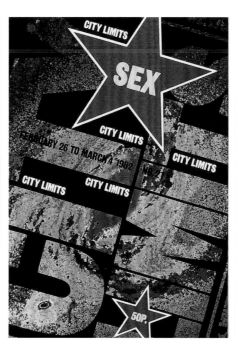

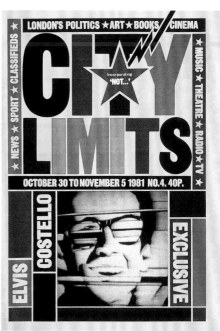

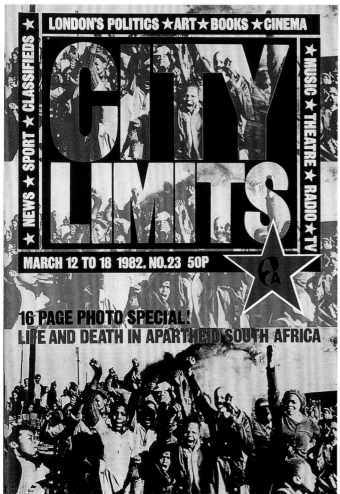

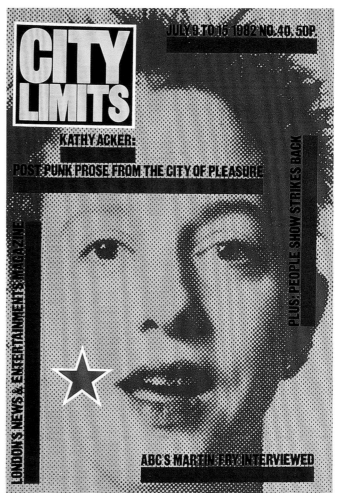

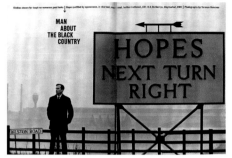

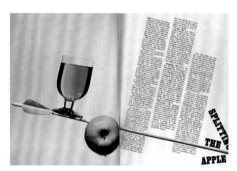

Tom Wolsey

Many of the big names of modernist design are Europeans who fled their homes to forge new careers and lives in America. A notable exception is Englishman Tom Wolsey, whose extraordinary art direction on tailor's magazine *Man About Town* (later *About Town*, then *Town*) during the early 1960s brought Swiss modernist ideals to the previously ornate, classical taste of English periodical publishing. His work was typified by the use of slab serifs and modern sans serifs such as Haas Grotesk—he aggressively combined the brute force of these faces with equally uncompromising, startling illustrations and set the two onto grid-free layouts that were all about horizontals and angles. The result was a form of design that had immediate and forceful impact but was never monotonous, thanks to Wolsey's rejection of the grid, occasional playful integration of display fonts, masterly use of picture placement, unerring ability to create movement and dynamism, and instinctive knowledge of good photography. He commissioned some of the best photographers of the decade, among them Don McCullin and Terence Donovan, and employed excellent print production to reproduce their work, setting the standards and styles for magazine design in the 1960s and on.

Elizabeth Smart

ETYMOLOGY DUBIOUS SAYS OED

To stuff? To satiate? From F. deriv. bourrer? Undecided. But certainly it's a word you can't go a day without hearing now. Even people who won't admit to being bored, when cross-questioned directly, use the word all day long. Listen and you'll hear it. What a bore! How boring!

That man / woman / child / film / play / book / TV / job / party bored me to death! Boredom! Boreable! Boreability! It's a street-cry of the times. Even if it's only lip-service. But is it? Even in the copy-cats and bandiers of catch-phrases there's an echo of anguish in the cry. Sometimes you actually hear people say (and they don't even seem to know how shocking they are):

COUNT BRIGHT EYES IN UNDERGROUND TOMORROW MORNING

Can you see anything similar to what Keats saw, even though bright headlines dance peppily before 4,052,713? Even though the pools beckon distractingly with treble chances and £300,000 for a penny, dropping like manna onto the lino of the Council kitchen? Even though you can book your passage to the moon and even farther? I can't. I fancy I see boredom. And not only in Undergrounds. In buses. Trains. Offices. In the pages of magazines and newspapers. In parks. At windy village corners. Who hasn't felt it oozing agonizingly from the wastes of Sunday streets?

JUST AWARENESS OF BOREDOM? Could the idea of boredom have just slipped into mass consciousness? That self-awareness has become so universal that we now *know* we're bored, while before we only felt bored; suffered in our unenlightenment 'a grief without a pang, void, dark, and drear. A stifled, drowsy, unimpassioned grief. Which finds no natural outlet, no relief. In word, or sigh, or tear'?

All the evidence points to the fact that it's Boredom itself alright, creeping infectiously round, as dangerous as any of our new-fangled lethal toys, or the sly new bugs that get themselves born just fast enough to outdistance pursuing scientists by a microscopic head, and keep *them* at least from being bored.

ARE WE MORE BORED THAN WE USED TO BE ?

Bored is a word you never heard on Victorian lips. A bored Elizabethan sounds like a mixed epithet. Boswell suffered from remorse, guilt, social frustrations, and pox; Johnson from sloth and spleen. But boredom? As a general idea it seems to have sprung up as unnoticed and ubiquitous as the other strange claims of the twentieth century; along with clipped diphthongs, idols, nylons, suburban architecture, virus infections, and bombs.

DURING THE WAR LIFE WAS NEVER BORING

Then there were no vacant faces pulling dully at slot-machines under the brutal neon glare. 'We felt we were really doing something then. We had a purpose. We were all in it together'. But does ... **BUT WHY? WHY? WHY?**

PEACETIME PURPOSE OBSERVED 180 YEARS AGO BY JOHN KEATS, 23

'I go among the Fields', he wrote in March 1819,' and catch a glimpse of a Stoat or a fieldmouse peeping out of the withered grass—the ... I go amongst the buildings of a city and I see a Man hurrying along—to what? The Creature hath a purpose and his eyes are bright with it'.

WHY? WHY? WHY? Could it be our amusements? But if it's Boredom, *why* are we bored? Is it because watching television, films, sport, and strip-tease are far less fun than a personal sing-song round the old piano, or making a set of petit-point dining-room chair-covers, or a scrap-book of pressed ... **Second guess:** Could it be the affluent society? Or is it because we're too

affluent – everything easy, laid on? ('Remember what fun we had, dear,' say nostalgic tycoons and lost-in-luxury film stars? 'in the good old days when we had to struggle to afford a meal out of spaghetti and meat balls?') **Third guess:** Could it be the alphabetical bombs? ... off? Might as well wait and see . . . so life has got riddled with a dentist's-waiting-room atmosphere?

Fortune

The business magazine *Fortune*, launched in 1930, ushered in a different style of magazine, one based on the concept that the visual dimension was as important as the editorial, and that an orderly, intelligent, and lively unification of the two could achieve something entirely new. To achieve this balance, *Fortune*'s publisher, Henry Luce, brought in designer Thomas Maitland Cleland to devise a format emphasizing bold illustration, commissioned photography, and beautifully printed information graphics. Cleland, in turn, recruited Eleanor Treacy as art director (a first for women in magazine production). This fertile partnership delivered content that celebrated America's greatness as a capitalist nation at a time when the country was experiencing one of its bleakest periods: the Great Depression.

Targeting the country's elite and priced accordingly, everything about *Fortune* was bold, not least its format: 160 to 220 pages at 14 x 11¼ in (36 x 28.5 cm) of heavy uncoated stock weighing 3 lbs (1.36 kg), delivered in a distinctive thick cardboard package. Subscribers were cherished, flattered, and respected; a lively mix of subjects from science and culture to business and politics, thoroughly researched and written by leaders in these fields, kept interest and loyalty.

Cleland used the best illustrators, photographers, and artists, including Margaret Bourke-White, Ben Shahn, Antonio Petruccelli, and Herbert Bayer, to ensure visual material was communicated with panache, style, and intelligence. For more abstract topics such as industrialization, science, and finance, *Fortune* relied on information graphics and illustration, but such visual devices were well suited to delivering the emerging art of marketing and statistics. It would have been easy to present pie charts and mathematical data familiar to all of us from school, but Maitland Cleland recognized the importance of graphics remaining in keeping with the magazine's urgent, forward-looking stance. Consequently, *Fortune* was full of dynamic bar charts that echoed America's emerging skylines and a style that expressed the changing role of the machine in society, which went on to influence the design of magazines and information design worldwide.

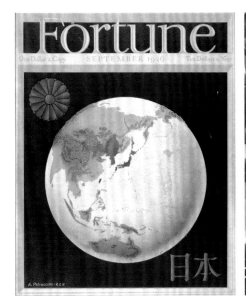
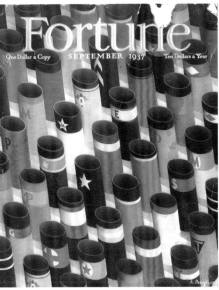
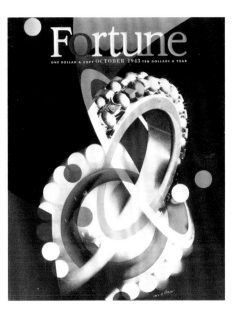

Oz

Radical psychedelic magazine *Oz* was first published in Sydney, Australia, as a satirical publication edited by Richard Neville and coedited by Richard Walsh and, crucially, artist, cartoonist, songwriter, and filmmaker Martin Sharp. It was Sharp who drove the design direction of the magazine in its second incarnation as a London hippie magazine (from 1967 to 1973), where it garnered artistic kudos in equal measure with establishment opprobrium, and in 1970 a prosecution that would result in (at the time) the longest obscenity trial in British legal history. For the London issues of *Oz*, Sharp was able to take advantage of new advances in printing, stock, and inks to design or show some of the most experimental and adventurous covers ever seen in editorial; many editions of the magazine included dazzling wraparound covers or pullout posters and were printed in metallic inks or on foil. With these covers and materials Sharp was pushing at the boundaries of print technology and offering a rich metaphor for *Oz*'s content, which was extending the limits of what was permissible by exploring accepted notions of pornography, libertarianism, obscenity, and radical thinking.

Formats and sizes changed frequently, with Sharp as happy to explore the possibilities of landscape formats as he was portrait ones, but what remained constant was the ability of *Oz* to reflect and express brilliantly a subculture's shift from antiauthoritarian, drug-fueled anarchy and experimentalism to dilution and eventual absorption in the establishment it had raged so hard against. It did this not just through its covers, but also through its design by Jon Goodchild. Working often with Sharp and other contributors, Goodchild turned the art room into "a theater of experiment," happily using pasteup to create collages and loose typographic layouts that moved editorial design away from the rigors and constraints of the prevailing Swiss style, with a lasting impact on graphic design.

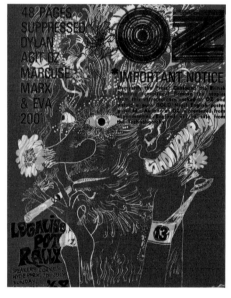

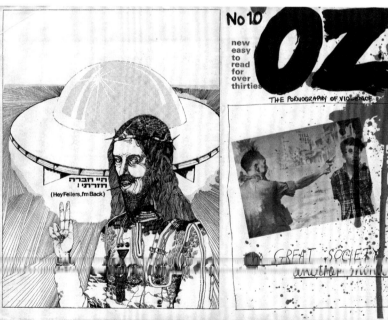

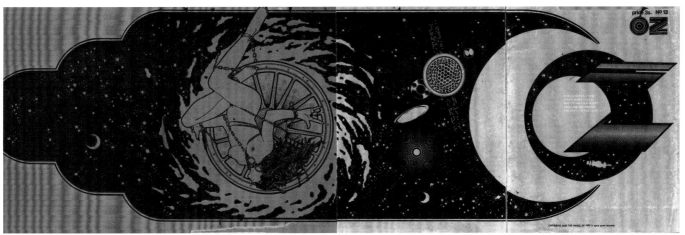

Looking forward

While it is almost impossible, and certainly foolish, to try and predict emerging trends in any field of endeavor, it is useful to touch on broader trends in graphic design. For some years, the future of graphic design has been one of widening horizons and a questioning by designers of what exactly graphic design is and what it means to be a graphic designer. Where previously the boundaries between different disciplines were almost impossible to cross, today's designer is a multi-disciplinarian, as likely to be taking the photos as art directing them, while also supervising the layout or even coding the Web site where they might appear.

The modern designer must therefore be part printer, part photographer, part coder, part editor, part art worker, part illustrator … but he or she must be more than the sum of all these parts. Increasingly, designers must be aware of economic, cultural, and technological shifts, and emerging trends in different media. The huge,

1 2

emerging "BRIC" markets (Brazil, Russia, India, and China) will offer publishers new readerships, but will also affect labor, distribution, printing, and production of editorial design worldwide. How does this affect the editorial designer?

Cutural shifts

Nova and *Twen* illustrated the explosive, experimental youth culture of the 1960s as much as Jimi Hendrix and acid; *The Face* and *i-D* are recognized as groundbreaking design because of their ability to deliver an antiestablishment punk attitude; David Carson's work on *RayGun* and *Bikini* emerged from a West Coast surfing culture; John Plunkett and Barbara Kuhr's work on *Wired* expressed the colorful energy and dynamic design of the Web; the antidesign style of *Loaded* reflected a men's culture that was all about hedonism and excess. Good editorial design, because of its periodical and its serial nature, reflects,

Below While it may not be an option to learn Chinese or Urdu, looking at cultural differences in design, at how and why they may occur, is bound to be useful and of real interest to the intellectually engaged visual communicator—these well-designed front pages come from Brazil's *Folha de S.Paulo* (**1**), (**2**), (**3**) and India's *Malayala Manorama* (**4**). And again, staying informed and abreast of world economies and their developments will make you a more desirable member of an editorial team.

1

2

Above *thelondonpaper*'s lilac color (used for the logo and in all the marketing material), combined with the use of lots of short stories and pictures, sans serif headlines, and elegant use of white space, gives the brand a youthful energy (**1**), (**2**). Interacting with the reader through the use of seemingly personal, conversational items makes the paper appear friendly and personal. It provides a useful function in design terms, too, breaking up the page into segments and offering short, user-friendly places for the eye to rest. These are all elements inherited from Internet design.

responds to, and is intertwined with culture. One of the biggest cultural shifts currently underway is again related to the Internet, but this time in a far wider-reaching way.

In designing pages for the Internet, designers have always had to take account of issues such as the unwillingness of younger readers to read lengthy articles, the discomfort of reading large chunks of text on a screen, constraints on typography, the limitations of the landscape-based format of most monitors, and the need for more display material, and these have all played their part in shaping the layout of the online page. But they are increasingly shaping the layout of printed editorial, too. This is most clearly visible in the gossip magazines and free newspapers, a trend which could well be the publishing model of the near future.

In London, 2006 saw the publication of two competing new free newspapers, *London Lite* and *thelondonpaper*. Both new titles have lifted a number of features from the Net, including the "citizen reporter" model that devotes much of the title to reader contributions and offers readers many more "interactive" elements than a real newspaper would, aping the blogs, chat rooms, and community feel of the Net, and also the emphasis on "celebrity" over real hard news. Both titles are made up of lots of short, snappy articles, and both borrow design features from Web pages. On *thelondonpaper*, color is used liberally on display features such as boxes, information graphics, subheads, straplines, rules, and pull-quotes; white space and delicate rules make the page look clean and contemporary; and a sans serif face gives the design a firmly modern stance that is youthful, a key requirement for the younger readers the paper is hoping to attract.

Technological shifts

It is incredibly hard to predict how fast-changing technology will impact on editorial design. Roll-up computer screens and holographic keyboards already exist, which could seriously impact on the survival—or otherwise—of printed matter, in particular newsstand titles. Conversely, improving digital printing and

Internet distribution could see independent publishing continue to grow, offering exciting design possibilities and directions for editorial designers. There's little the designer can do to prepare for such shifts, but staying in touch with technological developments through research (in magazines such as *Computer Arts*, *Wired*, *New Scientist*, *Scientific American*, *MacUser*, and *PC*) will keep you ahead of the game and help you develop and pursue strategies and skills for the future. At the time of writing, two key technological shifts are the emergence of both Print on Demand (POD) and eBooks or other portable computer screens. The immediate effects of these will be felt more on books than magazines and newspapers, but there are profound implications for all publishing, and for editorial designers. By enabling an exact number of copies of publications to be printed, POD will do away with the existing arcane publishing model that necessitates the printing and distribution of thousands of unwanted copies of a publication with the aim of bringing down the cost per issue. With POD, publishers will be able to "take orders" that can be dictated by the number of subscribers, the number of retail outlets available to them, or any other set of criteria. The importance of circulation figures may consequently be challenged by other, more targeted figures, which might lead to designers being able to design for a much more clearly defined reader.

Electronic

"Paper displays" on devices such as the Sony eReader may have the opposite effect. Lightweight and boasting "paper" that is reflective, daylight-readable, adjustable for magnification, and with a near 180-degree viewing angle, could these readers spell the death knell for good editorial design? It's hard to say, but what is definite is that they will change the face of editorial design in ways that are impossible to predict at the moment. The way in which designers use typefaces, images, and display elements to lay out pages might be severely restricted. Users might determine which pictures they want to see with which story, or indeed which story they want to see, eventually becoming the designer in much the same way that they have become publishers, or part of publishing communities, online. So designers would do well to keep abreast of technological shifts and developing software in order to stay ahead of their game. And learning new skills remains important for the graphic designer; these can keep your training as a graphic designer relevant and desirable in an increasingly crowded profession.

Emerging trends in different media

Blogs, Web sites, podcasts, vodcasts, and interactive media are all areas in which interactivity, screen-based rather than print-based, restricted typographic uses, limitations imposed by the delivery and download speeds, and so on. But it is not simply a question of physical differences; technology is enabling new economic and distribution models, and these impact on design issues, too—things are moving so fast that anything printed on the pages of this book is

3

Above What will the impact of the eReader (**3**) be on editorial design? It is impossible to say now, but designers must be ready to meet fast-changing technological shifts that may see publications move to much smaller formats or begin to incorporate video, podcasts, and interaction.

liable to be out-of-date by the time the book is published! There are, however, trends developing now that show no signs of abating.

Multitasking creatives

Over time, many graphic designers have been adept in skills such as photography, illustration, type design, writing, collage, and other visual areas that help them communicate to their audiences, but contemporary designers need to be even more multiskilled. Already it is useful for designers to be digital photographers, but as the boundaries between media continue to blur, the best graphic designers are likely to be those who can also make videos, construct audio–visual sequences and art pieces, create animations, code script, and write and tell stories.

Multitasking users

Just as designers of print will need to learn skills to make them designers of interactive publications, so, too, users and consumers are taking on different roles; as the success of Web 2.0 phenomena like blogs, YouTube, Wikipedia, and MySpace has shown, users are increasingly also becoming editors, filmmakers, reporters, designers, and artists. How the role of the designer will need to shift to incorporate these new users' needs, and how the two will interact, is anybody's guess!

The impact of the Internet and digital media on editorial design

There are many examples of ways in which Web site design has already shaped recent trends in editorial design, including the use of color and boxes, the busyness of newspaper and magazine news pages, packed with many short, lively stories, and the physical dimensions of publications altering. This Net/print crossover will continue apace, though, as Jeremy Leslie has shown with *Carlos*, by taking just some of the trends (in this example, size), and vigorously leaving

Below and right *Another Magazine* (**1**) successfully translates its print offering online by changing very little in the design. This is a bold attitude that reflects the brand and shows confidence in both media. *Carlos* (**2**) cherry-picks online design ideas such as size but marries them with other design elements unique to print, such as the use of metallic inks.

1

2

The Bible alerts us to wonderful events ahead. It also warns of a coming global upheaval in human institutions. For us to benefit and to avoid calamity, positive action is urgent...

V3

V3

unmastered session 3

01 **Lark** *Grey Evening*
token from the forthcoming album 'MOUTH OF MY'

02 **Plush** *Jet Life*
token from the album 'All That Is Should Be'

03 **Diesel Whores** *Girls For Islam*
token from the album 'The Real'

04 **Velve** *Fallen*
token from the album 'Weed Angel'

05 **Fokofpolisiekar** *Lugsteuring*
token from the album 'Lugsteuring'

06 **The New Acedemics** *Spiral*
token from the demo album 'Spiral'

07 **The Bloodflowers** *Doughnut*
exclusive to Sub_Urban

08 **The Andy Jamieson Band** *Step Song*
token from the album 'Emotional Engineering'

FRESH NEW TUNES FROM THE BASEMENT
NO USER SERVICEABLE PARTS INSIDE
REFER SERVICE TO QUALIFIED PERSONNEL ONLY

V3 IMAGERY

LIFE
DUTY
37.00
PLAY

warren lewis - collage

THE BASEMENT V3

LARK

Ammomanes

WORDS BY DOMINIQUE GAWLOWSKI
PHOTOGRAPHY AND DESIGN BY NIGEL MOORE

Above and left South African CD-ROM magazine *Sub_Urban*, art directed by Nigel Moore, used traditional print design elements for its publication, which was laid out and navigated like a magazine, but made the most of the possibilities inherent in digital media. Turning a page might bring you to a music video, short film, original electronic composition, or audio story, but underpinning the whole style and talent ethos was a great design sensibility.

aside others (color, busy boxes, etc.), a skillful designer can make a publication stand out from the crowd and still look contemporary and stylish.

Achieving individuality

There is an ever more sophisticated requirement for individuality in design to make print stand out from the Internet or television. As Mario Garcia points out, "As everyone increasingly gets their news via faster media (Internet, television, etc.) than newspapers, news has to be refined." This is equally true for print design, which has to stand out from the immediacy its competitors can deliver. Stock, special print techniques, inventive and surprising use of imagery, and good printing will all play a part here.

Smaller publications

Whether on paper, laptop screen, or handheld reader, publications are likely to get smaller. This is already happening with newspapers, which are responding to the design elements imposed or directed by the dimensions of the screen and the shorter attention span of many younger readers. It is possible that it will also happen increasingly in magazine design, as paper costs are likely to rise and more publications are likely to take the virtual route. Mario Garcia believes there are benefits here for the designer: "Smaller canvases allow for better movement of elements, and make the designer more focused and decisive in terms of what images to play in a protagonistic role, which allows space for type to tell the story in a narrative format." However, "Designers will need to be more focused and direct in creating hierarchy," he warns.

User-driven design

As Western populations become older, it is likely that graphic designers will need to cope with accessibility issues far more than they do currently. Color use, type selection and sizes, brightness of stock, and clarity of layout will all be affected, and possibly even dictated, by the needs of older readers. It is possible that best-practice guidelines will be brought into use that match the Internet ones as set by the World Wide Web Consortium (W3C). Designers will need to be aware of these shifts and changing needs.

Many more trends will emerge. The knowledgable, interested, and curious designer will be aware of them as they emerge, and will be ready to react, respond, and reject them as necessary and as appropriate to individual preferences and methodology. All shifts offer opportunities, and all real creatives will keep abreast of these shifts and be ready to embrace these opportunities, whether they be technological, cultural, or economic. For the graphic designer, there has never been a more interesting convergence of all three than there is today.

Additional material ● ● ●

Mini biographies

This book would not have been possible without the help of the following designers and editorial staff, who patiently took the time to give us a huge amount of valuable insight into and information about their work.

KOBI BENEZRI art director
Key design work featured in this book: *I.D.* magazine.
Look at this work for: scale; photography; white space; relationship between design and content.

GARY COOK director
Cook Design
www.cookdesign.co.uk
Key design work featured in this book: *FT The Business* newspaper supplement.
Look at this work for: illustration; information graphics; covers; photography.
Other key works by this designer: *Creative Review* magazine, *Time* magazine.

LEE CORBIN art director
JIM TURNER creative director
www.flaunt.com
Key design work featured in this book: *Flaunt* magazine.
Look at this work for: stock; photography; decorative fonts.
Other key work by these designers: *Detour* magazine.

IVAN COTTRELL art director
Key design work featured in this book: *Inner Loop* magazine.
Look at this work for: lo-fi aesthetic; monochrome spreads; use of typography; strong user-centered branding.

JEFFREY DOCHERTY art director
Key design work featured in this book: *Inside* magazine.
Look at this work for: photography and illustration; typography; scale; grids; dynamic layouts.

JANET FROELICH art/creative director
Key design work featured in this book: *The New York Times Magazine* newspaper supplement, *The New York Times "T:Travel" Magazine* newspaper supplement.
Look at these works for: photography; grids; negative space; cover design.
Other key works by this designer: *Daily News* magazine; *Daily News Tonight* newspaper (principal designer).

VINCE FROST designer
www.frostdesign.com.au
Key design works featured in this book: *Zembla* magazine, *Big* magazine, *The Independent on Saturday* newspaper supplement, *FT The Business* newspaper supplement.
Look at these works for: typography as illustration; scaling and cropping; image use; use of black-and-white.
Other key works by this designer: *Little Z* magazine supplement; Chris Boot and Andrew Cross, *5453 Trains*, Lakewood, New Jersey: Prestel, 2000; Lakshmi Bhaskaran, *Frost* (Sorry Trees)*, Sydney: Published Art, 2006; David Jury, *About Face*, Hove, Sussex: RotoVision, 2004.

MARIO GARCIA CEO and founder
Garcia Media
www.mariogarcia.com
Key redesigns featured in this book: *The Wall Street Journal* newspaper; *Die Zeit* newspaper, *The Observer* newspaper, *Liberation* newspaper, *Fohla de S.Paulo* newspaper, *Malayala Manorama* newspaper.
Look at these for: vertical and horizontal design solutions; different formats; typography; color; different approaches to newspaper and supplement design; design as branding.
Other key works by this designer: *The Miami Herald* newspaper, *The Philadelphia Inquirer* newspaper, *Handelsblatt* newspaper, *El Tiempo* newspaper.

FERNANDO GUTIÉRREZ designer and partner
Pentagram
www.pentagram.com
Key design works featured in this book: *Vanidad* magazine, *Tentaciones* magazine, *Matador* magazine, *Colors* magazine.
Look at this work for: scale and cropping; stock; printing; type as illustration; flexibility of grids; restraint in font use; illustration; photography.

CRISWELL LAPPIN creative director
www.metropolismag.com
Key design work featured in this book:
Metropolis magazine.
Look at this work for: photography;
scale; grids; imaginative combining of
graphic elements; illustration.
Other key works by this designer:
Robert Polidori, with Martin C. Pedersen
and Criswell Lappin, *Robert Polidori's
Metropolis*, New York: Metropolis
Books, 2004.

JEREMY LESLIE creative director
John Brown Citrus Publishing
www.jbcp.co.uk
www.magculture.com
**Key design works featured in
this book:**
M-real magazine, *Carlos* magazine,
Time Out magazine (1990–93).
Look at these works for: illustration;
innovative design solutions; idiosyncratic
approaches and expression.

MARTIN LÖTSCHER and IRIS RUPRECHT
coeditors
www.soda.ch/magazin
Key design work featured in this book:
soDA magazine.
Look at this work for: unusual materials,
stock, and formats; typography;
photography, printing, and production
techniques; no-grid design.

MARK PORTER creative director
Guardian Media Group PLC
Key design work featured in this book:
The Guardian newspaper and
supplements.
Look at this work for: balance; grids;
type; illustration; typographic elements.
Other key works by this designer:
ES Evening Standard newspaper
supplement; *Wired* magazine (U.K.);
Colors magazine.

MARTIN VENEZKY designer
www.appetiteengineers.com
Key design work featured in this book:
Speak magazine.
Look at this work for: typography as
illustration; ephemera and unusual
materials as graphic components;
illustration; color and its relationship
to the grid and layout.
Other key works by this designer:
Barry Gifford and David Perry,
Bordertown, San Francisco: Chronicle
Books, 1998; Sundance Film Festival
literature and branding; Martin Venezky,
It is Beautiful . . . Then Gone, New York:
Princeton Architectural Press, 2005.

LISA WAGNER HOLLEY tutor and
graphic designer
Key design work featured in this book:
Fishwrap magazine.
Look at this work for: illustration;
display type; brand unity without
uniformity; hand-drawn elements.

MICHA WEIDMANN art director
www.michaweidmann.com
Key design work featured in this book:
Time Out magazine (London, 2005–2006).
Look at this work for: how to break
up dense copy; typography and
photography; color; listings design;
integrating a large number of
graphic elements.
Other key works by this designer:
redesign and art direction of biannual
womenswear magazine *The Fashion*;
Tate Modern campaign, exhibition
and catalogue design for "Common
Wealth" show.

Type foundries

There are hundreds of independent digital type foundries, many of which distribute their fonts via the big one-stop shops. But don't discount smaller foundries, which will often specialize in particular types of fonts, or will showcase the work of contemporary designers who set the trends in editorial design. Below are the best of both worlds.

ADOBE
www.adobe.com/type/index.html

More than 2,200 typefaces and efficient online purchasing make the Adobe type showroom a great one-stop shop for fonts. A good browse facility enables you to search by name of font or designer, plus its use, style, theme, and type classification, making this site very useful if you're looking for a particular type of font.

BITSTREAM
www.myfonts.com

The first independent digital type foundry was established in 1981 and now incorporates more than 45,000 fonts, all available via the Bitstream subsidiary MyFonts. A key feature of the site is WhatTheFont, the one-of-a-kind font identifier that enables you to upload a scanned image of your desired font for identification or closest matches.

EMIGRE
www.emigre.com

Established in 1984, Emigre developed into a preeminent font foundry, and now holds exclusive license to more than 300 original typeface designs created by such contemporary type luminaries as Rudy VanderLans and Zuzana Licko (Emigre's founders), Bob Aufuldish, Jonathan Barnbrook, Edward Fella, Christian Schwartz, P. Scott Makela, and Barry Deck.

THE FONT BUREAU, INC.
www.fontbureau.com

The Font Bureau was founded in 1989 by editorial designer and consultant Roger Black and type designer David Berlow to serve the emerging needs of independent magazine and newspaper publishers looking for bespoke typographic identities. Since then, the foundry has designed over 1,000 fonts, most of which have become part its retail library.

FONTFABRIK
www.fontfabrik.com

This Berlin-based foundry headed by renowned type designer Luc(as) de Groot offers original and custom typefaces on a great site.

FONTFONT
www.fontfont.com

The FontFont Library claims to be the world's largest collection of original, contemporary typefaces. In among over 4,000 faces is a vast range of styles, from elegant text faces to distinctive display fonts, all by the top names of typography, including Neville Brody, Erik Spiekermann, David Berlow, Max Kisman, Erik van Blokland, Just van Rossum, Tobias Frere-Jones, and many, many more.

FONTSHOP
www.fontshop.com

FontShop is arguably the best one-stop font shop around. There are thousands upon thousands of fonts here, and all the best independent foundries are represented, including 2Rebels, Baseline, Emigre, P22, Club-21, Carter & Cone, and Typotheque. Browse facilities are excellent (and include a useful "browse for free fonts" facility), and features such as "what's new" and "most popular" columns help locate trends and current favorites.

HOEFLER & FRERE-JONES
www.typography.com

Two of the most successful font designers of the 1990s, Jonathan Hoefler and Tobias Frere-Jones joined forces in 1999. Their prestigious foundry, Hoefler & Frere-Jones, is a regular port of call for custom type designs and off-the-peg fonts for major publications and design studios—they have accumulated nearly 1,000 designs in their library.

INTERNATIONAL TYPEFACE CORPORATION
www.itcfonts.com

The International Typeface Corporation's online font shop is the ITC Library, an industry staple for creative professionals for more than thirty-five years. Here you'll find 1,500 fonts ranging from classics to contemporary designs, including a nice selection of display fonts in the DesignFonts collection.

LINOTYPE

www.linotype.com

The oldest type foundry listed here, Linotype dates back to the 1890s, when the Mergenthaler Linotype Company was founded on the back of the first linecasting machine. It now offers more than 6,000 typefaces and some excellent search facilities, including browsing by categories, themes, inspirations, and usage.

MONOTYPE

www.fonts.com

Monotype Imaging owns Fonts.com, a vast fonts library that incorporates the output of many smaller foundries. The site is huge and it takes a while to familiarize yourself, but once you have, it's easy to use and a valuable one-stop type resource.

PORCHEZ TYPOFONDERIE

www.typofonderie.com

Type designer Jean François Porchez launched his foundry in 1994, and his first retail typefaces in 1995. Porchez specializes in typefaces for newspapers, and has been joined by a small group of other designers who also sell faces on the site.

P22

www.p22.com

P22 creates computer typefaces inspired by art, history, and sometimes science, and as such offers some wonderfully unusual fonts. As befits its hip status, P22 also offers merchandise and a "Top of the Pops" chart of fonts based on the previous month's sales. The lovely Web site gives lots of information on the design of the fonts.

2REBELS

www.2rebels.com

2Rebels is a small but determinedly modern foundry, which distributes its fonts through a selection of suppliers (listed on the site). A good range of European designers can be found here, and while there are few really big names, the range of work by excellent up-and-coming designers is always worth checking out.

T.26

www.t26.com

Carlos Segura's type foundry contains a fantastic array of contemporary fonts submitted by type designers. A great feature is the Typesetter, where you can see the piece of type you want to set in the font you're thinking of using.

Glossary

Barcode A printed machine-readable code, usually in the form of vertical stripes of variable width, found on the cover of books and magazines and used for inventory control and pricing.

Baseline An imaginary line on which the letters of a word sit. By extension, the baseline grid is made up of a series of baselines across the page. *See also* leading.

Bleed (or full-bleed) When an image is printed to the very edge of a page. This effect is traditionally achieved by printing the image beyond the trim edge (the area that is lost when the page is cut).

Body copy The main element of a piece of editorial text (as opposed to the headline, kicker, or caption).

Book Traditionally used to describe a bound publication of 48 pages or more with a stiff or heavy cover. Less usually used to refer to a magazine.

Box An editorial element on a page that carries supplementary or related material, usually with a border to separate it from the body copy. For example, a travel feature on Brazil might have a box with key facts about the country such as population, currency, average temperatures, and so on.

Broadsheet The largest size of newspaper page, usually twice the size of a tabloid (although sizes vary in different countries).

Bullet point A dot or similar character placed to the left of a line of text to denote that it is part of a list. Each item in the list will be similarly denoted.

Byline The writer's credit that appears with a news story or editorial feature. It can be as simple as the author's name or can extend to a short biography with an image of the writer.

Calibration Adjustments to highlights, shadows, and midtones of images to ensure optimum print results.

Caption Descriptive text that accompanies an image or photograph.

CMYK Cyan, magenta, yellow, and black: the components of the four-color printing process. The K stands for "key," being the key color to which all other colors are aligned in the printing process.

Compositor Traditionally the compositor was the person who set the metal type. The term is now used for any typesetter.

Cover lines The lines of text on a magazine's front cover that are written to draw in potential readers and alert them to its contents.

Cover mounts Items given away with a magazine of newspaper. Usually these are mounted and displayed prominently on the front cover. Recent years have seen DVDs and CDs as the most popular cover mounts.

Cromalin An extremely high-quality color proof that comes close to replicating the final printed product.

Crosshead A subordinate heading used in a long piece of body copy to break it up. *See* subhead.

Cutline An alternative term for captions (usually used for newspapers).

Cutout A photograph with the background behind the object or person removed.

Deck A headline is made up of decks, each set in the same style and size of type. Hence a one-deck headline occupies one line, a two-deck headline two lines, and so on. Confusingly, in the U.S. "deck" is used to refer to the text between a headline and the body copy (*see* kicker) and a multideck headline is a combined headline and kicker, each set in its own size and style of type.

Desktop publishing The introduction of page layout software and the personal computer in 1985, which changed the nature of publishing design.

Die-cut A hole or cutout shape punched into heavy paper or card.

Dingbat A set of decorative type characters that can be used individually or repeated to produce decorative patterns.

Display type Type larger than body copy used to attract the reader's attention.

Dpi Dots per inch: a way of defining the resolution of an image made up of dots or pixels.

Drop cap A large capitalized letter used at the start of a body of text, which drops down to occupy several lines. Derived from the manuscript tradition, in which the first letter of the first word was highly decorative and marked the beginning of a text.

Dummy The pages of a magazine in the planning stage used to demonstrate what the finished product might look like. Prelaunch, or during redesign, a magazine or newspaper will produce countless dummies as a way of testing new ideas and designs.

Duotone A form of printing using two colors, one of which is usually black.

Embossing Paper stamped so that the printed image appears in shallow relief above the surface of the page. Blind embossing is when the paper is embossed, but without any printed image.

End icon A character or decorative element used at the bottom of a paragraph to denote the end of a text.

Fanzines Used to refer to self-published magazines on a specific subject or interest. Despite the fact that fanzines usually have amateur and not-for-profit connotations, many have grown into commercially successful publications.

Feature well The middle section of a magazine.

Fifth (or spot) color Refers to the use of a fifth color (the first four being cyan, magenta, yellow, and black) in four-color offset process printing. It would be used when, for example, a metallic, fluorescent, or nonstandard offset ink is required. As each spot color requires its own lithographic film, there are cost implications.

Flatplan A plan of a publication's contents showing which pages and content go where. The flatplan is the backbone of managing the production of a magazine or newspaper.

Folio The page number as displayed on a layout.

Font Originally a complete set of type in a particular size and style. Nowadays used to denote a single weight or style of a typeface.

Galley Generally used today to refer to a column of text within a page layout, more commonly used in newspaper design.

Grid A plan or blueprint formed by horizontal and vertical lines that define areas in a layout; a plan for designing pages.

Gutter The space between columns of text in a layout.

Hot type A term encompassing a range of nineteenth-century technologies associated with letterpress printing.

Icon A pictorial, typographic symbol that conveys information or instruction: for example, an arrow directing the reader to turn the page.

Infographics Visual representation of information, data, or knowledge.

ISBN International Standard Book Number: a unique, machine-readable code used to identify individual book titles.

Jumpline A continuation link (usually a turn arrow or similar icon) for articles that are set over more than one page.

Justified text Text that has been set to align on both right and left sides.

Kerning The process of closing up (or opening out) the space between two text characters to produce a balanced effect.

Keylines Lines on a template that show where graphic elements should be placed.

Kicker A body of text that accompanies the headline and expands on it, giving more information about the article and guiding readers into it. Also known as sell, slug line, or intro.

Knockout text White text printed out of a color background. Also known as a WOB or "white on black."

Laserjet proofs Proofs produced by laser printers.

Laying out Putting together graphic elements to compose a whole page.

Leading The space from one baseline to the next in lines of type.

Lead time The period in which the publication is put together before going to print.

Letterpress Printing from a raised surface, such as wood or metal, directly onto paper.

Ligature Two or more letters that are joined to form a combined character.

Lithography The process of making prints using greasy ink from a stone or metal plate directly onto paper.

Livery Graphic elements used to convey a publication's house style. This might include a color palette, icons, bespoke fonts, and logos.

Logo Short for logotype. The name of the publication as run on the cover and sometimes reproduced inside the publication. Sometimes called a masthead (*see* below).

Lowercase Small letters (as opposed to capital or uppercase letters)

Makeup The process of laying out a page in a publication.

Masthead A magazine's or newspaper's masthead contains contact information about the publication, such as staff members, frequency of publication, advertising rates, and so on. It usually appears on a magazine's contents page. Also occasionally used to refer to a publication's logo (*see* above).

Microzine An independent publication that often covers style or art and is printed in small quantities for selective distribution.

Moiré The disruptive visual effect when a halftone print is rephotographed through another screen.

Montage Making a composite image or collage by cutting and juxtaposing different images together. Also known as photomontage.

Motion graphics Graphics that use animation or video to create motion, usually found in multimedia projects such as Web sites or interactive displays.

Negative space (white space) The area of a page without text, images, or other elements.

Offset When the ink of a printed sheet marks the next sheet; usually occuring within a stack of freshly printed sheets.

Op-ed Opinion and editorial pages of a newspaper.

Orphan Single word at the top of a page or text column.

Pagination The system by which pages of a publication are marked with consecutive numbers to indicate the proper order of the pages.

PDF Portable document format: file transfer system which retains the formatting of printable documents.

Perfect binding Trimmed single sheets of paper bound with glue to produce a publication with a flat spine.

Photomontage The process (and result) of making a composite picture by cutting and joining a number of photographs.

Pilot issue A prelaunch issue of a magazine or newspaper used for marketing and design purposes. For a new mass-market publication, a number of pilot issues may be produced before the title is launched. Also known as dummy issues or dummies.

Prepress The stages before a publication goes to print.

Press run The number of copies printed during one printing—also known as a print run or run.

Process colors Yellow, magenta, cyan, and black. *See also* CMYK.

Proof Page produced from the artwork or film to be used for platemaking. Proofs enable a page to be checked for mistakes before it is produced in quantity. Also known as comps.

Proofing Checking for spelling and grammar, but also ensuring that copy fits the house style.

Pull-quote A quote or excerpt from an article that is used as display text on the same page to entice the reader, highlight a topic, or break up linearity.

Ragged left/right (aligned left/right) The alignment of text on a printed page. Ragged left (or aligned right) aligns text to the right and staggers it on the left, ragged right (or aligned left) aligns text to the left and staggers it on the right.

Register (registration) Accurate superimposition of colors in multicolor printing; exact alignment of pages so that they back one another precisely. Colors or pages that are not accurately aligned are said to be "out of register."

RGB Red, green, and blue additive primary colors. Colors used in monitors.

Roman Normal upright typeface, as distinct from italic or bold typefaces.

Rule Printed line used either horizontally or vertically to separate layout elements such as columns of text, text from images, etc.

Rule book Instructions for typesetting, also known as a style guide (*see* below).

Runaround Area of body copy that wraps around an inset image.

Running head Heading that is repeated page after page, usually (but not always) at the top of the page. A running headline is usually a longer, more descriptive version of a running head.

Saddle stitching Binding method that uses metal staples on publications (usually no bigger than 64 pages) to bind printed sections inside each other.

Sans serif Typeface with no serifs.

Screen calibration Adjustment of monitor settings to produce as accurate a screen image as possible.

Self-cover Cover printed on the same stock as the inside pages.

Serif Small finishing strokes of a roman letter found at its terminals or stems.

Set flush Text set at the full width of a column with no indentation.

Show-through Condition where printing on one side of the paper can be seen from the other.

Sidebar Short piece of text or element of article related to main article and run nearby.

Signature A printed section of a publication, usually made up of a multiple of 16 pages. This is folded down to page size, trimmed, and bound with other signatures or sections to create the whole publication.

Sign off To approve a page for printing, literally by signing or initialing the proof.

SIP Special interest publication.

Slug line *See* kicker.

Soft return Forcing a word or part of a word over onto a new line to avoid unwanted hyphenation or to create a better shape in a column of text.

Spine The side of a publication's cover visible when it is stacked vertically on a shelf.

Split-fountain inking A method by which two or more inks emerge from the same source.

Spot color A ready-made color not made up from the CMYK process. *See* fifth color.

Spread Two facing pages of a publication.

Stock Paper or card to be printed.

Strap or strapline A line of text that emphasizes, identifies, or explains a title, section, or feature.

Style guide/style sheets Printed sheets with instructions on typesetting, margins, makeup, treatment of headings, body copy, indents, captions, etc. Accompanying style sheets or guides will exist for proofreaders dealing with body copy, headlines, etc.

Subhead Short headline or descriptive line of text in body copy.

Swatch book Color sample books showing the colors available from the CMYK process and spot colors.

Tabloid A publishing term for a smaller newspaper format (usually 14 x 12 in [35.5 x 30.5 cm]).

Tagline A short, memorable line of cover text that sums up the tone of the publication.

Template Pages made up using a desktop publishing program onto which layouts are mapped.

Thumbnail A small version of a page, allowing all the pages of a publication to be printed out and viewed at once, showing the flow of the publication.

Tracking Tightening or opening up the space between characters, words, or passages of text.

Trapping The creation of small overlaps between abutting colors in order to compensate for registration/alignment imperfections that may occur in printing.

Turnaround The time between signing off on the proofs and delivery of the printed publication.

Turn arrow A device used on a page to show that an article continues on another page.

Typeface A set of fonts make up a complete typeface.

Unjustified text Text settings in which lines can align right or left, producing lines of different widths. Also called ragged text.

Uppercase Capital letters.

UV varnish High-gloss varnish.

Varnish Thin, protective coating applied to a printed sheet, usually used for protection.

Widow A single word on a line ending a paragraph.

WOB White on black: white text out of black or colored background. *See also* knockout text.

For more detailed definitions of print terms, *see* http://www.printgraphics.com.au

Further reading

EDITORIAL ART DIRECTION

Conover, Theodore E. Revised by William W. Ryan. *Graphic Communications Today*, fourth edition. Clifton Park, New York: Thomson Delmar Learning, 2004.

Duperray, Stephane, and Raphaele Vidaling. *Front Page: Covers of the Twentieth Century*. London: Weidenfeld and Nicolson, 2003.

Fawcett-Tang, Roger, ed. *Experimental Formats: Books, Brochures, Catalogues*. Hove, Sussex: RotoVision, 2001.

Feierabend, Peter, and Hans Heiermann. *Best of Graphis: Editorial*. Corte Madera, California: Gingko Press, 1995.

Foges, Chris, ed. *Magazine Design*. Hove, Sussex: RotoVision, 1999.

Johnson, Sammye, and Patricia Prijatel. *The Magazine from Cover to Cover: Inside a Dynamic Industry*. Lincolnwood, Illinois: NTC, 1999.

King, Stacey. *Magazine Design That Works: Secrets for Successful Magazine Design*. Gloucester, Massachusetts: Rockport Publishers, 2001.

Leslie, Jeremy. Foreword by Lewis Blackwell. *Issues: New Magazine Design*. Corte Madera, California: Gingko Press, 2000.

Leslie, Jeremy, ed. *MagCulture: New Magazine Design*. New York: HarperCollins, 2003.

Moser, Horst, *Surprise Me: Editorial Design*. Translated from the German by David H. Wilson. West New York, New Jersey: Mark Batty Publisher, 2003.

Owen, William. *Magazine Design*. London: Laurence King Publishing Ltd., 1991.

Pedersen, B. Martin, ed. *Graphis Magazine Design*, volume 1. New York: Graphis Press, 1997.

White, Jan V. *Designing for Magazines: Common Problems, Realistic Solutions*, revised edition. New York: Bowker, 1982.

———. *Editing by Design: For Designers, Art Directors and Editors— The Classic Guide to Winning Readers*. New York: Allworth Press, 2003.

Yamashita, Kaoru, and Maya Kishida, eds. *Magazine Editorial Graphics*. Tokyo: PIE Books, 1997.

TYPOGRAPHY

Baines, Phil, and Andrew Haslam. *Type and Typography*. New York: Watson-Guptill Publications, 2002; revised edition, 2005.

Balius, Andreu. *Type at Work: The Use of Type in Editorial Design*. Corte Madera, California: Gingko Press, 2003.

Bringhurst, Robert. *The Elements of Typographic Style*. Vancouver: Hartley and Marks, 1997.

Dair, Carl. *Design with Type*. Toronto: University of Toronto Press, 2000.

Heller, Steven, and Mirko Ilic. *Handwritten: Expressive Lettering in the Digital Age*. New York: Thames and Hudson, 2004.

Jury, David. *About Face: Reviving the Rules of Typography*. Gloucester, Massachusetts: Rockport Publishers, 2002.

Lupton, Ellen. *Thinking with Type: A Critical Guide for Designers, Writers, Editors, & Students*. New York: Princeton Architectural Press, 2004.

McLean, Ruari. *The Thames and Hudson Manual of Typography*. New York: Thames and Hudson, 1980; reprinted 1997.

Poynor, Rick, ed. *Typography Now: The Next Wave*. London: Booth-Clibborn Editions, 1991.

Robinson, Andrew. *The Story of Writing: Alphabets, Hieroglyphs and Pictograms*. New York: Thames and Hudson, 1995.

Spiekermann, Erik, and E. M. Ginger. *Stop Stealing Sheep & Find Out How Type Works*. Berkeley, California: Adobe Press, 1993; second edition, 2002.

There are many great sources for typographic inspiration on the Web. The photo-sharing Web site Flickr (www.flickr.com) has numerous groups devoted to type, such as the excellent Typography and Lettering group to be found at: www.flickr.com/groups/type.

LAYOUTS

Ambrose, Gavin, and Paul Harris. *Layout*. Lausanne: AVA Publishing, 2005.

Carter, David E. *The Little Book of Layouts: Good Designs and Why They Work*. New York: Harper Design, 2003.

Dabner, David. *Graphic Design School: The Principles and Practices of Graphic Design*. New York: Thames and Hudson, 2004.

Elam, Kimberly. *Grid Systems: Principles of Organizing Type*. New York: Princeton Architectural Press, 2004.

Finke, Gail Deibler. *White Graphics: The Power of White in Graphic Design*. Gloucester, Massachusetts: Rockport Publishers, 2003.

Hurlburt, Allen. *The Grid: A Modular System for the Design and Production of Newpapers, Magazines and Books*. New York: John Wiley, 1982.

Knight, Carolyn, and Jessica Glaser. *Layout: Making It Fit—Finding the Right Balance Between Content and Space*. Gloucester, Massachusetts: Rockport Publishers, 2003.

Roberts, Lucienne. *The Designer and the Grid*. Hove, Sussex: RotoVision, 2002.

Samara, Timothy. *Making and Breaking the Grid: A Graphic Design Layout Workshop*. Gloucester, Massachusetts: Rockport Publishers, 2003.

IMAGERY

Ambrose, Gavin. *Image*. Lausanne: AVA Publishing, 2005.

Cotton, Charlotte. *The Photograph as Contemporary Art*. New York: Thames and Hudson, 2004.

Dyer, Geoff. *The Ongoing Moment*. New York: Pantheon Books, 2005.

Hyland, Angus, and Roanne Bell. *Hand to Eye: Contemporary Illustration*. London: Laurence King Publishing Ltd., 2003.

Ingledew, John. *The Creative Photographer: A Complete Guide to Photography*. New York: Harry N. Abrams, 2005.

Kelby, Scott. *The Photoshop CS2 Book for Digital Photographers*. Indianapolis, Indiana: New Riders, 2003.

Klanten, Robert, and Hendrik Hellige, eds. *Illusive: Contemporary Illustration and its Context*. Berlin: Die Gestalten, 2005.

Kress, Gunther, and Theo van Leeuwen. *Reading Images: The Grammar of Visual Design*. New York: Routledge, 1996.

Sontag, Susan. *On Photography*. New York: Farrar Straus and Giroux, 1977.

———. *Regarding the Pain of Others*. New York: Farrar Straus and Giroux, 2003.

Wiedemann, Julius. *Illustration Now!*. Cologne: Taschen, 2005.

Zeegen, Lawrence. *The Fundamentals of Illustration*. Lausanne: AVA Publishing, 2005.

INSPIRATION

Blackwell, Lewis, and Lorraine Wild. *Edward Fella: Letters on America*. New York: Princeton Architectural Press, 2000.

Blackwell, Lewis, and David Carson. *The End of Print: The Grafik Design of David Carson*, revised edition. San Francisco: Chronicle Books, 2000.

Carson, David, *Trek*: *David Carson—Recent Werk*. Corte Madera, California: Gingko Press, 2003.

Crowley, David. *Magazine Covers*. London: Mitchell Beazley (Octopus Publishing Group Ltd.), 2006.

Fletcher, Alan. *The Art of Looking Sideways*. London: Phaidon Press, 2001.

Hollis, Richard. *Swiss Graphic Design: The Origins and Growth of an International Style, 1920–1965*. New Haven, Connecticut: Yale University Press, 2006.

de Jong, Cees W., and Alston W. Purvis. *Dutch Graphic Design: A Century of Innovation*. New York: Thames and Hudson, 2006.

Kalman, Tibor, and Maira Kalman. *Colors: Issues 1–13*. New York: Harry N. Abrams, 2002.

Kruger, Barbara. *Barbara Kruger*. Cambridge, Massachusetts: MIT Press, 1999.

McAlhone, Beryl, and David Stuart. *A Smile in the Mind*, revised edition. London: Phaidon Press, 1998.

The Society for News Design. *The Best of Newspaper Design 27*. Gloucester, Massachusetts: Rockport Publishers Inc., 2006.

Venezky, Martin. *It Is Beautiful . . . Then Gone*. New York: Princeton Architectural Press, 2005.

PRINTING AND COLOR USE

Albers, Josef. *Interaction of Color*, revised and expanded edition. New Haven, Connecticut: Yale University Press, 2006.

Eiseman, Leatrice. *Pantone Guide to Communicating with Color*. Cincinnati, Ohio: Grafix Press, 2000.

Gatter, Mark. *Getting It Right in Print: Digital Prepress for Graphic Designers*. New York: Harry N. Abrams, 2005.

Itten, Johannes. *The Art of Color: The Subjective Experience and Objective Rationale of Color*, revised edition. New York: John Wiley & Sons Inc., 1997.

Kuno, Naomi, and FORMS Inc./Color Intelligence Institute. *Colors in Context*. Tokyo: Graphic-sha Publishing, 1999.

Pipes, Alan. *Production for Graphic Designers*, fourth edition. London: Laurence King Publishing Ltd, 2005.

Rogondino, Michael and Pat. *Process Color Manual: 24,000 CMYK Combinations for Design, Prepress, and Printing*. San Francisco: Chronicle Books, 2000.

Sawahata, Lesa. *Color Harmony Workbook: A Workbook and Guide to Creative Color Combinations*. Gloucester, Massachusetts: Rockport Publishers Inc., 2001.

JOURNALISM AND COMMUNICATION

Evans, Harold. *Editing and Design*, five volumes. London: William Heinneman (Random House Group Ltd.), 1972–78.

———. *Essential English for Journalists, Editors and Writers*. London: Pimlico (Random House Group Ltd.), 2000.

Quinn, Stephen. *Digital Sub-Editing and Design*. Oxford: Focal Press (Elsevier Ltd.), 2001.

Sharples, Mike. *How We Write: Writing as Creative Design*. Oxford: Routledge (Taylor & Francis Books Ltd.), 1998.

GENERAL DESIGN BOOKS

Berger, Joshua, and Sarah Dougher. *100 Habits of Successful Graphic Designers: Insider Secrets on Working Smart and Staying Creative*. Gloucester, Massachusetts: Rockport Publishers Inc., 2003.

Fiell, Charlotte and Peter. *Graphic Design Now*. Cologne: Taschen, 2005.

Graham, Lisa. *Basics of Design: Layout and Typography for Beginners*. Clifton Park, New York: Thomson Delmar Learning, 2001.

Hollis, Richard. *A Concise History of Graphic Design*, revised edition. New York: Thames and Hudson, 2002.

Itten, Johannes. *Design and Form: The Basic Course at the Bauhaus*, revised edition. London: Thames and Hudson, 1975.

Johnson, Michael. *Problem Solved: A Primer in Design and Communication*. London: Phaidon Press, 2002.

Lupton, Ellen, and J. Abbott Miller. *Design Writing Research. Writing on Graphic Design*. New York: Kiosk Press, 1996.

Newark, Quentin. *What Is Graphic Design?* Gloucester, Massachusetts: Rockport Publishers Inc., 2002.

Poynor, Rick. *Design Without Boundaries. Visual Communication in the Nineties*. London: Booth-Clibborn Editions, 2000.

Shaughnessy, Adrian. *How to Be a Graphic Designer, Without Losing Your Soul*. London: Laurence King Publishing Ltd., 2005.

Tufte, Edward R. *Visual Explanations: Images and Quantities, Evidence and Narrative*. Cheshire, Connecticut: Graphics Press, 1997.

Index

Photo credits

The author, Central Saint Martins College of Art & Design, and Laurence King Publishing Ltd. would like to thank all the publishers, art directors, and designers who have supplied material and granted permission to reproduce images in this book. Every effort has been made to contact all copyright holders, but should there be any errors or omissions, Laurence King Publishing Ltd. would be pleased to insert the appropriate acknowledgement in any subsequent printing of this publication.

Numbers refer to pages

6l *FT The Business*. Photograph Gareth Munden; **6m, 34l, 39b, 111bm, 123r** Courtesy Time Out Group; **7m** Publications Condé Nast S.A. Photograph Jean-Baptiste Mondino © *Vogue Paris*; **7r** Courtesy *Heat* magazine; **9, 144m** Courtesy *Amelia's Magazine*. Art Director: Amelia Gregory, Illustrator: Rob Ryan; **10b** Courtesy *Le Figaro*; **11, 16, 37, 39tl, 48b, 57l, 64t, 79, 81t, 82t, 86b, 96tl, 99b, 114, 121, 133tl, 148** *The New York Times Magazine*. Courtesy Janet Froelich; **14, 70br, 111t, 144tl, 190r** Courtesy *Carlos* magazine; **15, 35l, 125** Courtesy *M-real* magazine; **18** Courtesy *The Guardian*. Photograph © www.lfi.co.uk; **19l** Courtesy *The Guardian*. Photographs Darren Kidd and Eric Ogden/Retna; **19r** Courtesy *The Guardian*. Photograph M.J. Kim/Getty Images; **20, 48t, 51, 80t, 136tr, 138b, 139** Courtesy *Zembla* magazine; **21** Courtesy *Speak* magazine. Illustrations by Mette Brix and Brad Holland; **31t, 103** *Wired*. Design by John Plunkett, Plunkett+Kuhr, copyright Condé Nast 2007. Illustration by Mark Sommers; **31b** *Wired*. Creative Director John Plunkett, copyright Condé Nast 2007; **33** Nick Knight/*Vogue* © Condé Nast Publications Ltd.; **34r, 128l, 171l** Courtesy *The Independent*; **35** Courtesy *Pop* magazine; **36tl, 40** Courtesy www.adbusters.org; **36tr, 56tl, 61t, 85tr, 101t, 129br** Courtesy *WAD* magazine; **36b, 56tr, 95, 120t, 136b, 155tl, 155tr** Courtesy *(inside)* magazine; **38** Courtesy Hearst Communications and George Lois; **41tl, 41tr, 56b, 62b, 87t, 88–89, 102t, 126r, 132b, 140** Courtesy *Flaunt* magazine; **41b** *Interview* magazine, August, 1972, Liza Minnelli photographed by Berry Berenson. Designed by Richard Bernstein. Courtesy Brant Publications, Inc.; **42, 54bl, 54br** Courtesy *Boston Sunday Globe*; **45, 70t, 87b, 170, 178br** Courtesy Hearst Communications; **43** Courtesy *The Guardian*, Photograph Reuters/Namir Noor-Eldeen; **46r** *FT The Business*. Photograph Sandro Sodano; **48br, 57r, 86tl, 86tr, 100b, 119b, 134** Courtesy *Metropolis*; **49bl, 129tr, 182** Collection Tony Quinn; **52** Bill Graham/Nic Tenwiggenhorn/Kunsthaus Bregenz, D.R.—Publications

Condé Nast S.A. © *Vogue Paris*; **53** *Wired*. Design by John Plunkett, Plunkett+Kuhr, copyright Condé Nast 2007; **55tl, 91t** Vogue par Sofia Coppola, Sofia Coppola—Publications Condé Nast S.A. © *Vogue Paris*; **60r, 66l, 82b, 92r, 157r** Courtesy *Het Parool*; **62t, 120b, 158** Courtesy *The Observer*; **63tr** Courtesy *The Observer*, Photograph propaganda-photo.com; **64b** Courtesy *Speak* magazine. Photograph by Ira Nowinski; **65r, 72tr, 72bl, 72br, 96b, 97, 100t, 101br, 117, 156** Courtesy *I.D.* magazine; **68** Courtesy *soDA*. Photograph by Diane Scheunemann; **69t** Courtesy *The Guardian*. Photograph Allsport/Getty Images; **69b** Courtesy *Metropolis*. Photograph Sean Hemmerle; **70bl** Courtesy *The Guardian*. Illustration Marian Deuchars; **71** Courtesy *Metropolis*. Illustration Christopher Silas Neal; **76t** Courtesy *The Observer*. Photograph Murdo MacLeod; **77, 137t** Courtesy *Inner Loop*; **80, 136, 154l** Courtesy *Speak* magazine; **84t** Courtesy *Garageland* magazine; **85br** Cliché BNF, illustration from the book *Trésors de la Bibliothèque Nationale de France, Mémoires et Merveilles, VIIIè–XVIIIé siècle*—Publications Condé Nast S.A. © *Vogue Paris*; **91b** *FT The Business*. Photograph Sasha Gusov; **93l, 129bl, 130tr** Courtesy *Die Zeit*; **93r, 130b** Courtesy *Corriere della Serra*; **96tr** Courtesy *Metropolis*. Photograph Michelle Litvin; **99t** Courtesy *Esopus*. Photograph © 2004 David Michalek; **102b** Courtesy *Dazed & Confused*; **103** Courtesy *Metropolis*. Photographs Conrad Kiffin; **106b** Courtesy *Speak* magazine. Illustration Brad Holland. Photograph Steve Sherman; **108, 150b, 186, 187r** Courtesy *Folha de S.Paulo*; **110t** Courtesy *soDA*. Photograph Hans-Jörg Walter; **110m** Courtesy *soDA*. Bastien Aubry and Dmitri Broquard; **110b** Courtesy *soDA*. Happypets, Marc Kappeler, Norm, Martin Woodtli; **111bl** Courtesy *soDA*. Benjamin Güdel and Marc Kappeler; **119t** Courtesy *soDA*. Visionlab by Soyana; **122, 176** Courtesy *The Guardian* News & Media Ltd.; **123l, 130tl** Courtesy Mirrorpix; **126l** Courtesy *soDA*. Marc Kappeler; **128m** Courtesy *Tank* magazine. Thierry Van Biesen; **128r, 133b** Courtesy *Emigre* magazine; **129tl** Publications Condé Nast S.A. © *Vogue Paris*; **135tl** Courtesy *The Guardian*, Photograph Getty Images; **135bl** Courtesy *The Guardian*. Photograph Francesca Yorke 2006; **135br** Courtesy *The Guardian*. Photograph J. Watts/Du Bin 2006; **137b, 141, 172b, 173** Courtesy Fernando Gutiérrez; **138t** *FT The Business*. Courtesy Alan Kitching; **143, 184t, 184br, 185t** Courtesy Martin Sharp; **144tr** Courtesy *Dazed & Confused*. Photograph Rankin; **144br** Courtesy *Esopus*. *Ghost Form*, 2004 © Willian Christenberry; **147t** Courtesy *Cabinet*. Photograph Lynne Roberts-Goodwin; **147b** Courtesy *Garageland* magazine. Illustration Paul Murphy;

149tl, 149tm Courtesy *Radio Times* © BBC Worldwide Limited; **149tr** Courtesy *Radio Times* © BBC Worldwide Limited. Illustration Lyn Gray **149b** Courtesy *Radio Times* © BBC Worldwide Limited. Illustration Richard Draper; **151t** Courtesy *The Guardian*. Grundy Graphics 2006; **151b** *Wired*. Copyright Condé Nast 2007; **152t** Photograph Vincent Laforet/Polaris; **152br** *Stern*. Photograph: Volker Hinz; **153tl, 153tr, 153br** Courtesy *Time*; **153br** Courtesy *The Economist*; **154r** Courtesy *Speak* magazine. Illustration Austin Cowdall; **155bl** Courtesy *soDA*. Photograph Hans Meier; **155br** Courtesy *soDA*. Fabian Roth; **157l** Courtesy *The Observer*. Photograph © PA Photos; **163bl** Courtesy Hearst Communications. Archives and Special Collections, RIT Library, Rochester Institute of Technology; **163t, 163br** Courtesy Hearst Communications (Collection of R. Roger Remington); **169t** Courtesy *i-D* Magazine. Photography and concept Nick Knight, translated to video by Eamonn McCabe; **169bl** Courtesy *i-D* magazine; **169br** Courtesy *i-D* magazine. Photography by Nick Knight, styling by Simon Foxton; **171bl, 171br** Courtesy Vince Frost; **174t, 175** Archives and Special Collections, RIT Library, Rochester Institute of Technology; **174b** © 1939, Condé Nast Publications Inc. Reprinted by permission; **178t** Sofia Coppola par Mario Testino—Publications Condé Nast S.A. © *Vogue Paris*; **178bl** Agenda, Tate/Courtesy Marlborough Graphics/DACS 2004, D.R.—Publications Condé Nast S.A. © *Vogue Paris*; **178bm** *Vogue Italia*. Photograph Steven Meisel; **179t** Kurt Schwitters Archive, Sprengel Museum Hannover, photograph Michael Herling/Aline Gwose—© DACS 2007; **179b** V&A Images/Victoria and Albert Museum—© DACS 2007; **180t, 181** David King Collection. Design: David King; **181bl** Photograph by Snowdon/Camera Press, London; **181br** Frames from *Psycho* (Universal Pictures); **183br** © Herbert Matter Estate (Collection R. Roger Remington); **185m** Michael English—www.michaelenglishart.com; **185b** Hapshash & the Coloured Coat; **187r** Courtesy Mario Garcia; **188** Courtesy thelondonpaper; **191tl** Courtesy Sub_Urban. Design: Nigel Moore. Illustration: Kim Town; **191tr, 191b** Courtesy Sub_Urban. Design: Nigel Moore. Illustration: Appropriated; **191ml** Courtesy Sub_Urban. Design: Nigel Moore. Illustration: Warren Lewis; **191mr** Courtesy Sub_Urban. Design & Photography: Nigel Moore

Diagrams by Amelia Gainford. Library photography by Jennie Crisp. Additional photography by Richard Dean (**33, 34r, 39tr, 46tl, 46bl, 47r, 58t, 69t, 72tl, 171t**) and Christopher Makos (**161**). Thank you also to Pentagram for all their help in supplying images.

Acknowledgments

I never cease to be amazed by the generosity of design creatives, who will happily give up valuable time to share their knowledge and experience with others. So huge thanks go to my contributors (*see pp.194–5*) for their valuable thoughts and input into the book, and for their unflagging patience and enthusiasm during its writing. Behind the scenes another group of people worked equally enthusiastically and patiently, and I am grateful to them also: Patricia Batley, who persevered with picture research despite the monumental task it

became; everyone at Laurence King for their patience, assistance and support, and in particular my editor John Jervis; Ishbel Neat at Central Saint Martins; Corinna Farrow for her help in writing the book and her hard work on designing it alongside Mark Holt; Peter Hall, Mike Harding at *Time Out*, Michael Watts, Pentagram, Gabriela Mirensky at the AIGA, and Greg Klee at *The Boston Globe* for their suggestions and advice; Don Cornelio and Batfoy for their unflagging support; Paul Murphy for stepping into the photography breach

when no one else would; and finally to my family for always supporting me and encouraging me in everything I've chosen to do (despite not always knowing what it is I do!).

DEDICATION
To Paul Murphy—artist, partner, and all-round good guy—for always believing in me and for his unfailing encouragement, good humor, support, and love.